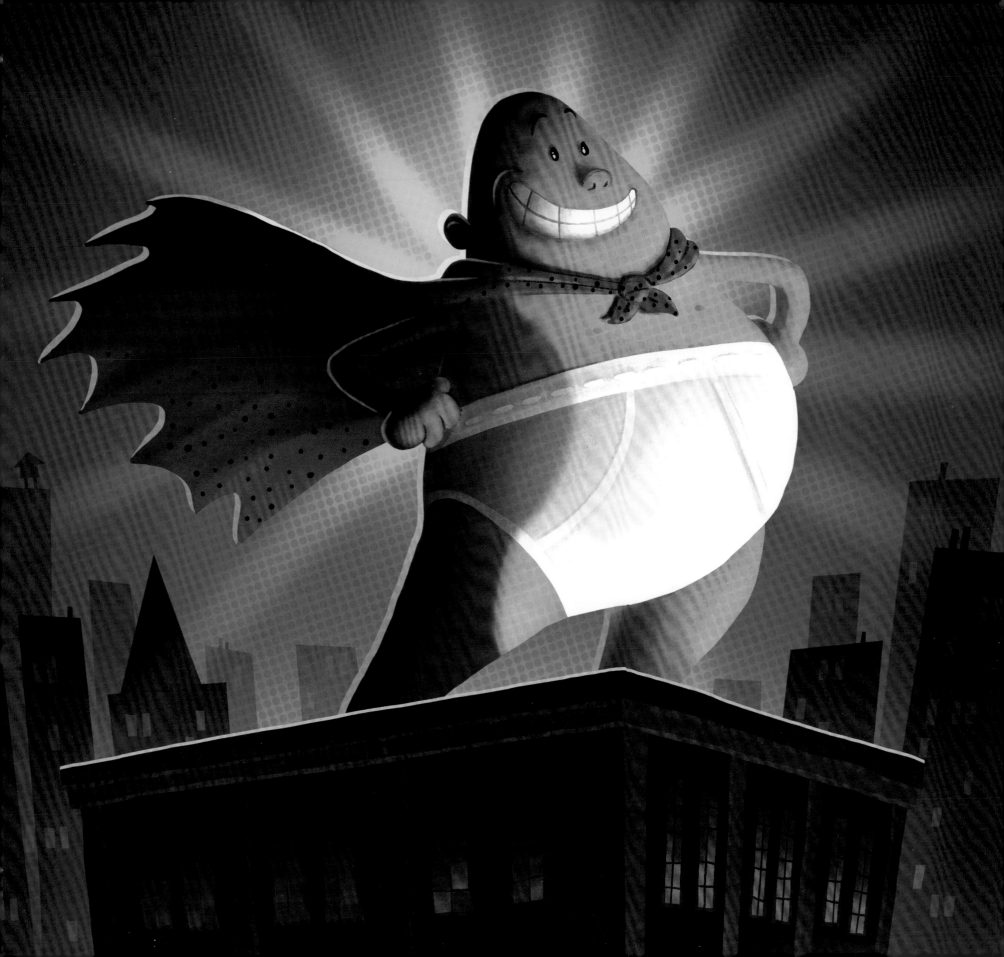

The Art of DreamWorks Captain Underpants
ISBN: 9781785652905

Published by Titan Books
A division of Titan Publishing Group Ltd.
144 Southwark St., London, SE1 0UP

First edition: May 2017
10 9 8 7 6 5 4 3 2 1

To receive
advance information,
news, competitions, and
exclusive offers online, please
sign up for the Titan newsletter
on our website: www.titanbooks.com

Did you enjoy this book? We love to hear
from our readers. Please e-mail us at:
readerfeedback@titanemail.com
or write to Reader Feedback
at the above address.

A CIP catalogue record for this title
is available from the British Library.

Printed and bound in China.

Designed by Iain R. Morris

 CAMERON + COMPANY

6 Petaluma Blvd. North
Suite B-6, Petaluma, CA 94952

707-769-1617 • www.cameronbooks.com

[PAGE 1] Nate Wragg
and Rune Bennicke
[RIGHT] Nate Wragg
[PAGES 4-5]
Christopher Zibach
and Rune Bennicke

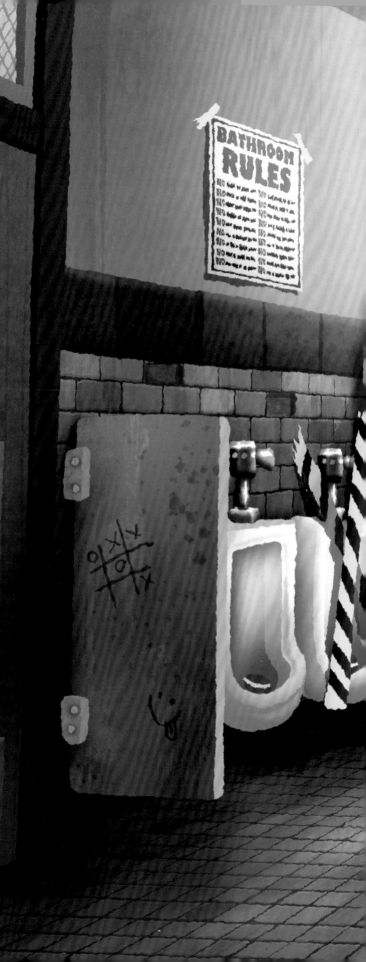

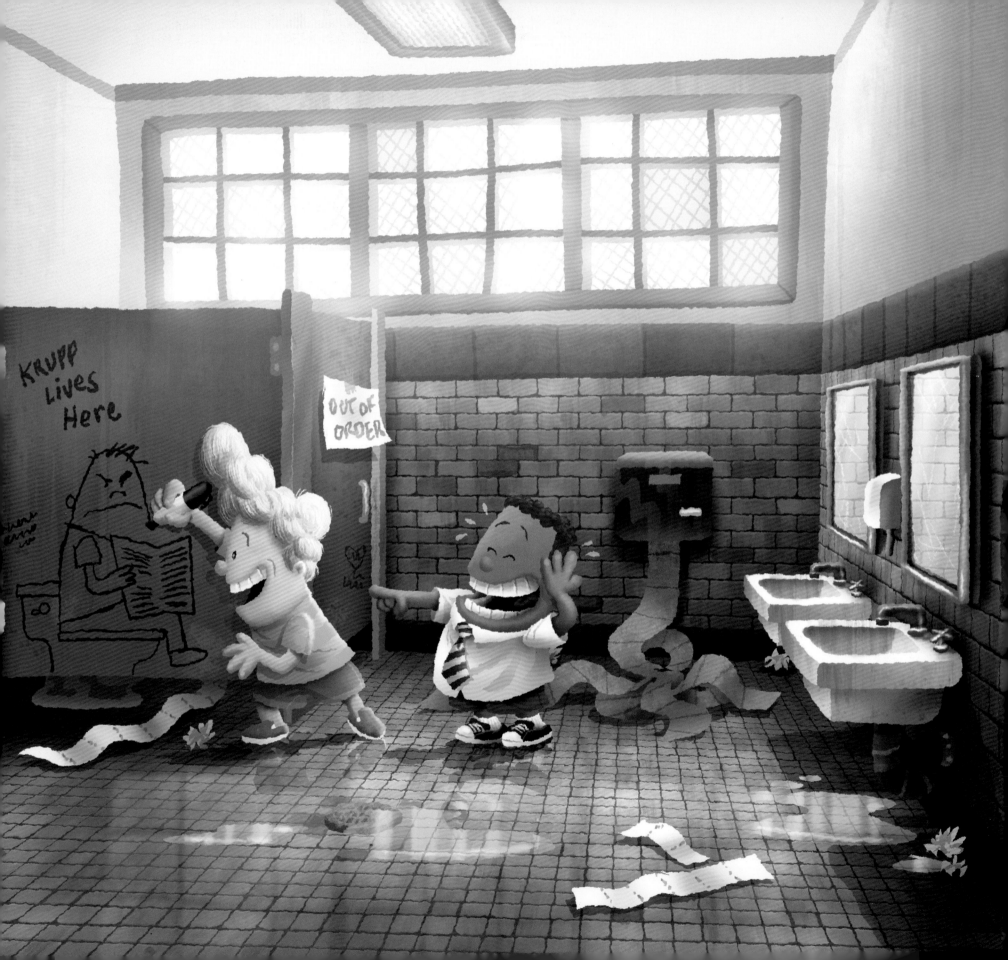

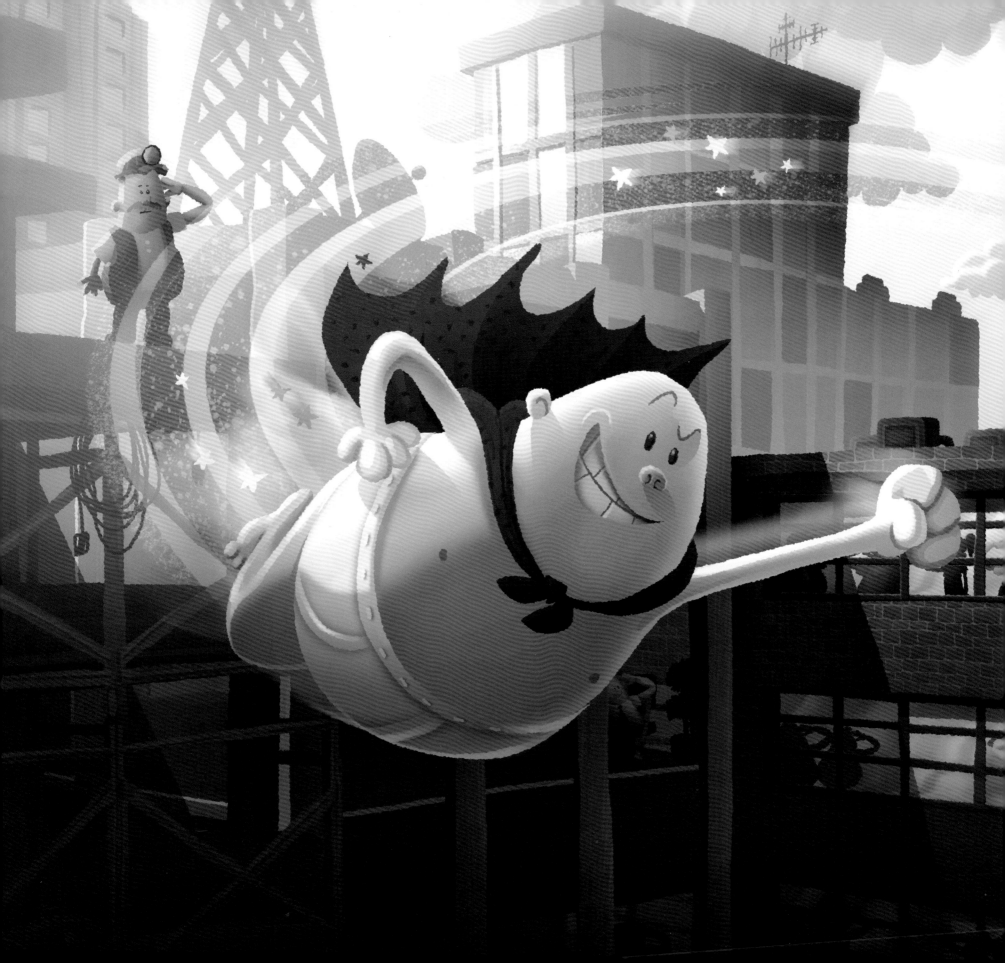

The Art of
DREAMWORKS
CAPTAIN
UNDERPANTS
THE FIRST EPIC MOVIE

Foreword by **Dav Pilkey**

Written by **Ramin Zahed**

TITAN BOOKS
LONDON

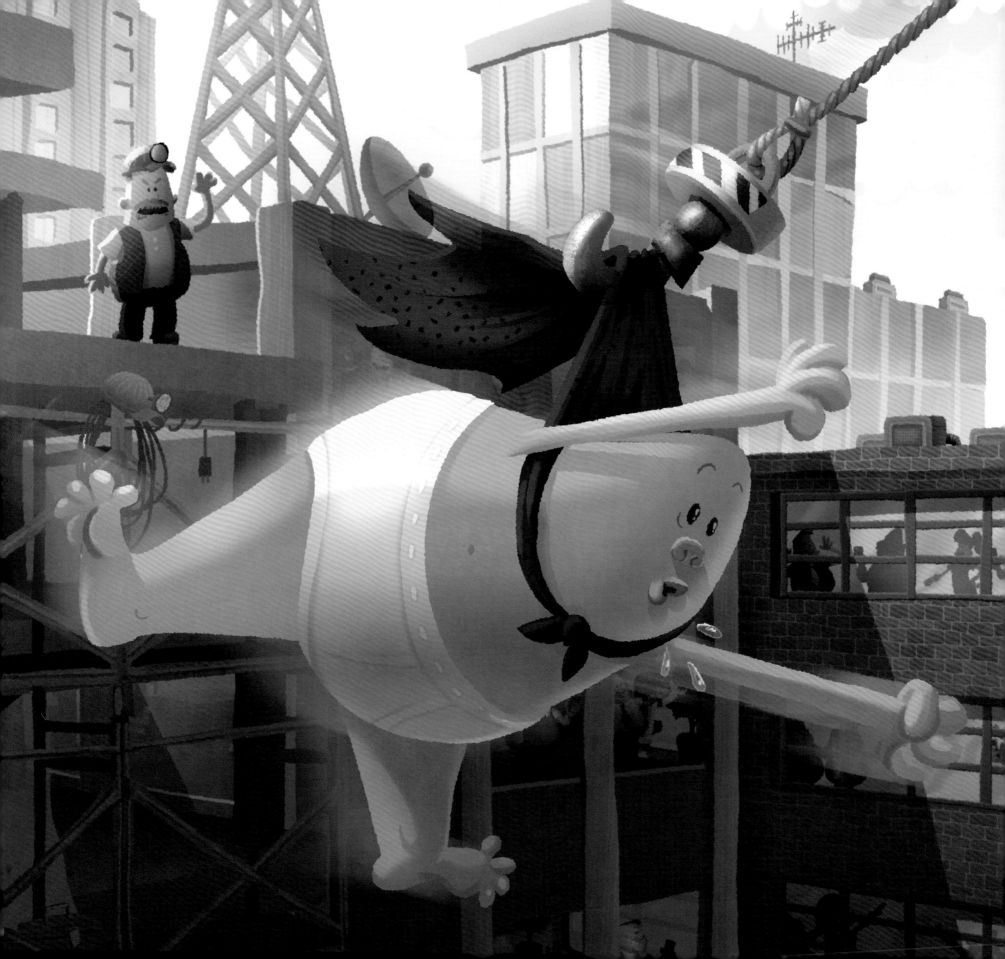

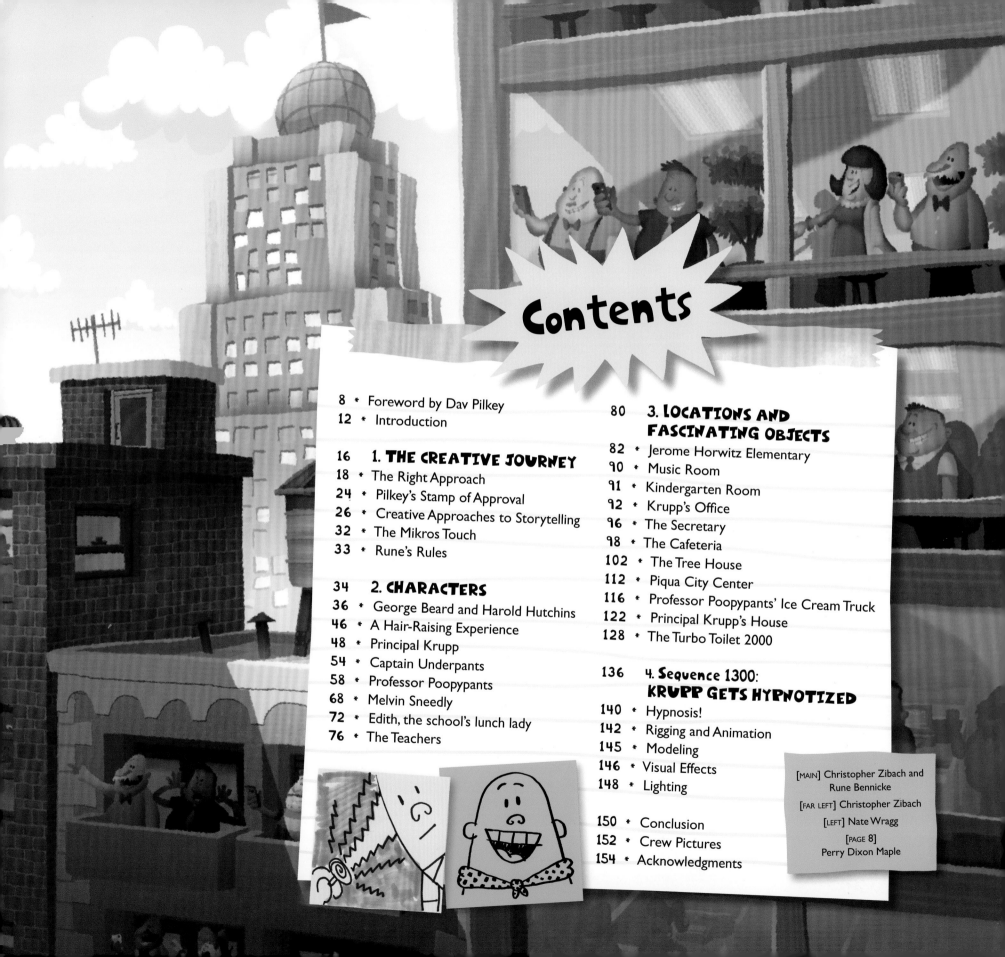

Contents

[MAIN] Christopher Zibach and Rune Bennicke

[FAR LEFT] Christopher Zibach

[LEFT] Nate Wragg

[PAGE 8] Perry Dixon Maple

FORM 7B6

DETENTION SLIP

Pilkey
Last Name

Dav
First Name

Date __11/12__

Room __102__

How Badly Behaved was this Child?

Reason __having fun while on school grounds!__

Krupp
Signiture

First Detention Slip Given

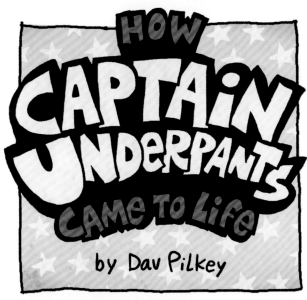

HOW CAPTAIN UNDERPANTS CAME TO LIFE

by Dav Pilkey

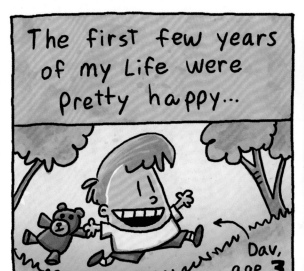

The first few years of my life were pretty happy...

Dav, age 3

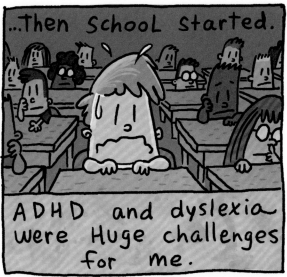

...Then school started.

ADHD and dyslexia were Huge challenges for me.

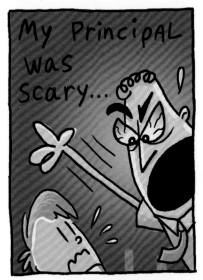

My principal was scary...

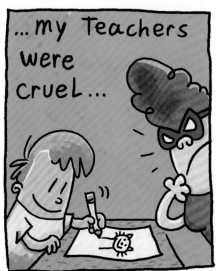

...my Teachers were cruel...

SNATCH

RIP RIP RIP RIP RIP

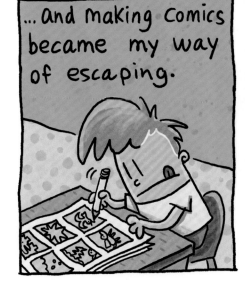

...and making comics became my way of escaping.

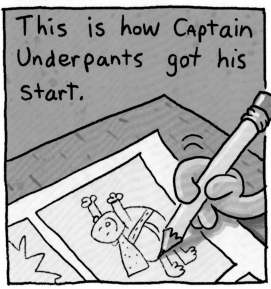

This is how Captain Underpants got his start.

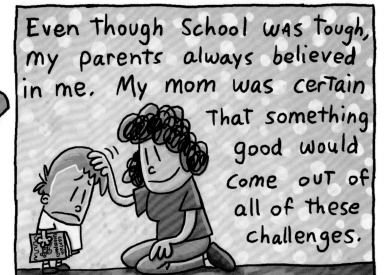

Even though school was tough, my parents always believed in me. My mom was certain that something good would come out of all of these challenges.

And she was right. As an adult, I worked hard at turning those early school troubles into tales of friendship and heroics.

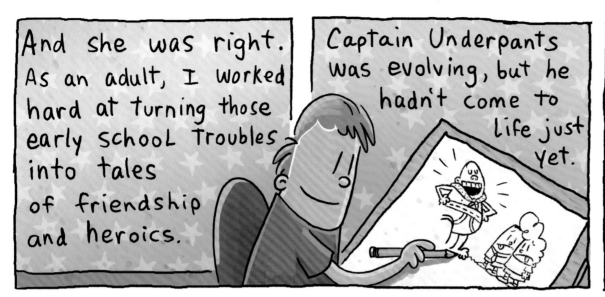

Captain Underpants was evolving, but he hadn't come to life just yet.

As with Pinocchio And The Velveteen Rabbit, becoming "real" would take some time.

That time finally came when I teamed up with DreamWorks Animation...

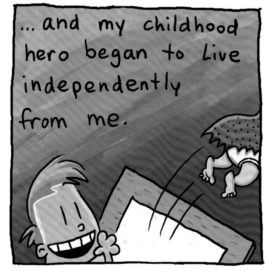

...and my childhood hero began to live independently from me.

With the vision and guidance of Director David Soren...

...And the inspiration of a talented team of artists, writers, and musicians...

...CAPTAIN UNDERPANTS LIVES...

...and George and Harold have become real boys!

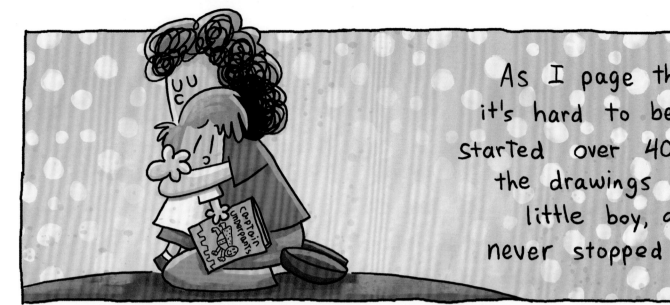

As I page through this book, it's hard to believe that it all started over 40 years ago with the drawings of a discouraged little boy, and a mom who never stopped believing in him.

People sometimes ask me if it was hard to let go of my characters.

It was not.

NOW SHOWING!
TAKE YOUR KIDS TO THE CAPTAIN UNDERPANTS MOVIE

It is the greatest reward to see them live and grow and flourish in a world that is bigger and more beautiful than I could ever have imagined.

THANK YOU DREAMWORKS ANIMATION!

Introduction

[PAGES 9-11]
Dav Pilkey and Christopher Zibach

"George and Harold each had a 'silly streak' a *mile* long....And once it got them into big, *BIG* trouble. But before I can tell you that story, I have to tell you *this* story."

— THE ADVENTURES OF CAPTAIN UNDERPANTS by Dav Pilkey (1997)

Every once in a while, a children's book is born that is so delightful, wacky and irreverent that it seems to be the answer to every mischievous school kid's prayer. Author and illustrator Dav Pilkey's *The Adventures of Captain Underpants*, which was first published in 1997, and has been translated into 20 languages and sold over 70 million books worldwide, was certainly one of those dreamed-about publishing phenomena.

The illustrated book, and its 11 sequels, centers on the adventures of George and Harold, two mischievous fourth graders who hypnotize their principal and turn him into a goofy superhero who runs around in his tighty whiteys. Kids were delighted by the simple and expressive illustrations, the offbeat humor, and the clever plotlines, while parents loved the fact that the books made their children beg to read more. So, it wasn't surprising that the property caught the attention of the development team at DreamWorks Animation, and inspired the studio's thirty-fifth animated movie.

Producer Mark Swift's face lights up when he talks about the first time he came across Pilkey's books. "I used to read to my two older boys, and sometimes, I would find it hard to keep my eyes open after a long day at work," says Swift, who has produced features such as *Madagascar: Escape 2 Africa*, *Madagascar 3: Europe's Most Wanted* and *Penguins of Madagascar* during his successful career at DreamWorks Animation. "Then we discovered *Captain Underpants* together, and everything changed. I was thrilled because these books were really

[LEFT] Dav Pilkey, [BELOW] Christopher Zibach
[RIGHT] Rune Bennicke, [OPPOSITE] Nate Wragg

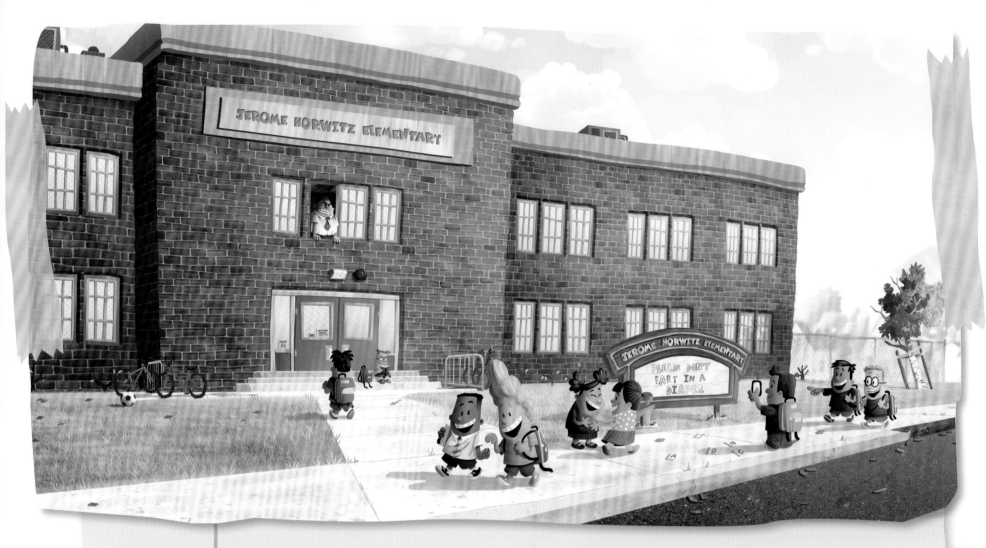

funny, inventive, creative and subversive. I became a big fan of the series and really looked forward to reading them with my sons."

For Mireille Soria, DreamWorks' co-president of feature animation and the film's producer, *Captain Underpants* offered a chance to experiment with new storytelling techniques and creative ways of using the medium. "I am proud of the unique voice, style and personality we've been able to bring to this movie," she says. "It's also a story that celebrates a friendship that is based on creativity and imagination. In a way, it's also about kids who say, I'm not going to accept abusive authority."

Director David Soren has fond memories of the first time he came across Pilkey's books. "It was twenty years ago, I had just moved to Los Angeles, and I discovered the first Captain Underpants book at a bookstore. I picked it up and read half of it right there in the aisle," he recalls. "Years later, once I had kids of my own, we read it again together, then the next book, and the next, until we'd devoured the entire series and were sore from

laughter. Needless to say, when I was approached to direct the movie, I was all in!"

Soren and the producers share the same affection for Pilkey's universe, where the two boys spend hours creating their own comic books in their beloved tree house. Soren points out that one of the most appealing aspects of the books is that they are told through the boys' unusual perspective. "Although the books are called Captain Underpants, they really are about George and Harold and their friendship," he explains. "The boys are telling their story, it's their narrative. I wanted the movie to feel like they were the filmmakers. During the story process, we found this approach to be incredibly successful. So much so, that whenever we committed to that philosophy, the moments landed beautifully, and whenever we got lazy with our point of view, it didn't work nearly as well."

Soria, who also worked with Swift on the *Madagascar* movies at the studio, says she is especially pleased with the project's

[BELOW] Dav Pilkey, [RIGHT] Christopher Zibach
[FAR RIGHT] Rune Bennicke, [OPPOSITE] Christopher Zibach

diversity of visuals. "Here at DreamWorks, we don't have a singular house style," she notes. "There is a great breadth and range of artistic vision, and our movies reflect the different voices our filmmakers bring to each project. For *Captain Underpants*, we were able to build on Dav Pilkey's hilarious and unique style and visuals. Everything about this movie—the characters, the designs, the sets, the animation, the storyline—has a mischievous note and a twinkle in its eye."

The film's production designer Nate Wragg, a longtime DreamWorks veteran, whose credits include *Puss in Boots*, *The Croods*, *Mr. Peabody & Sherman* and *Home*, says when he first joined the project in 2012 he immersed himself in Pilkey's world to make sure he clearly understood the tone of the Captain Underpants universe. "The big challenge was that the books' drawings are quite simple," he notes. "They are absolutely charming and appealing in their own way, so we had to figure out how to translate them to a different medium. At first, you look at the drawings and notice that they're loosely drawn and fun, but then you really come to understand the language—this unique style that is consistent in all the books."

Wragg says one of the most important aspects of his job was preserving Pilkey's particular brand of humor in the design. "One of the things that stood out to me when I read the books is just how silly the world is," he points out. "The cars, buildings, store names are always silly and whimsical in the way they are drawn and portrayed in the books. Once we started using that logic as a base for all our designs, we really began to find the style of the world for our CG adaptation."

After taking a complete crash course in Pilkeyland and experimenting with different storylines and visuals, the DreamWorks team zeroed in on the best possible way to bring the characters to life. Their fresh approach and loyalty to the source material aim to put big smiles on the faces of die-hard fans of the books as well as general movie audiences.

[PAGES 16-17] Perry Dixon Maple and Rune Bennicke

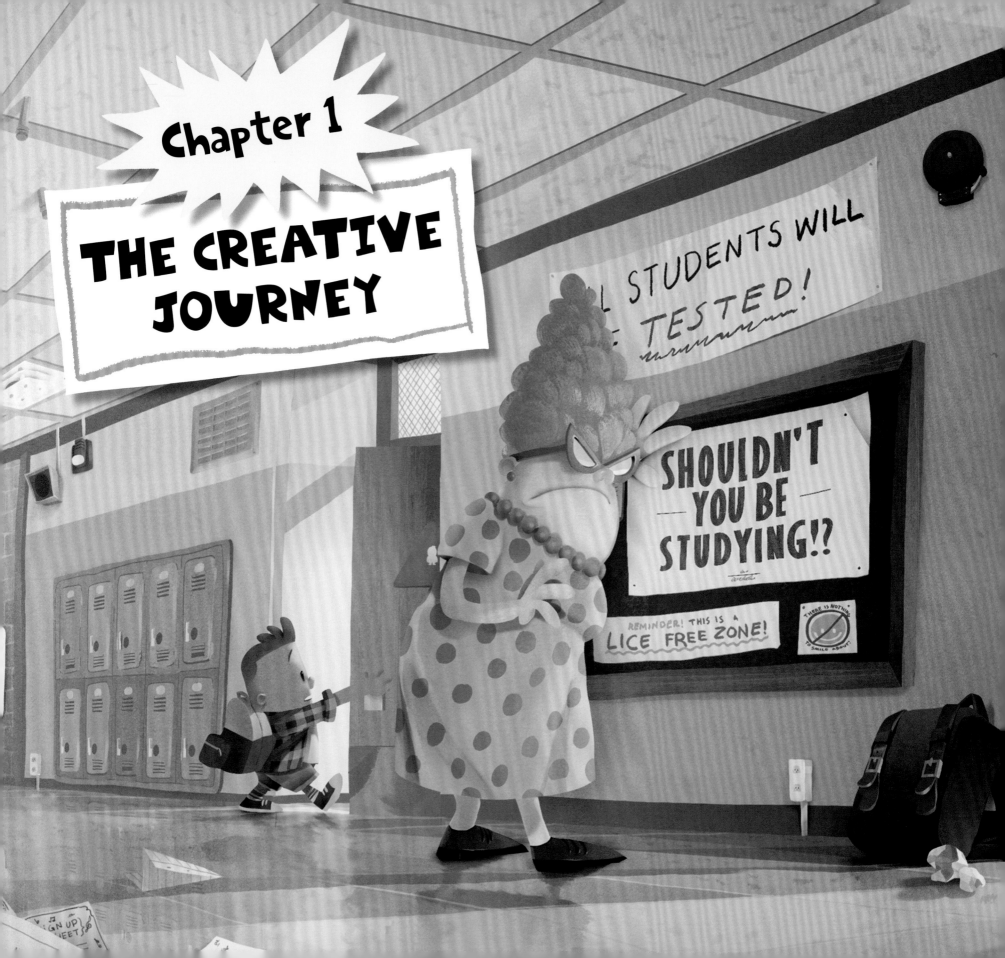

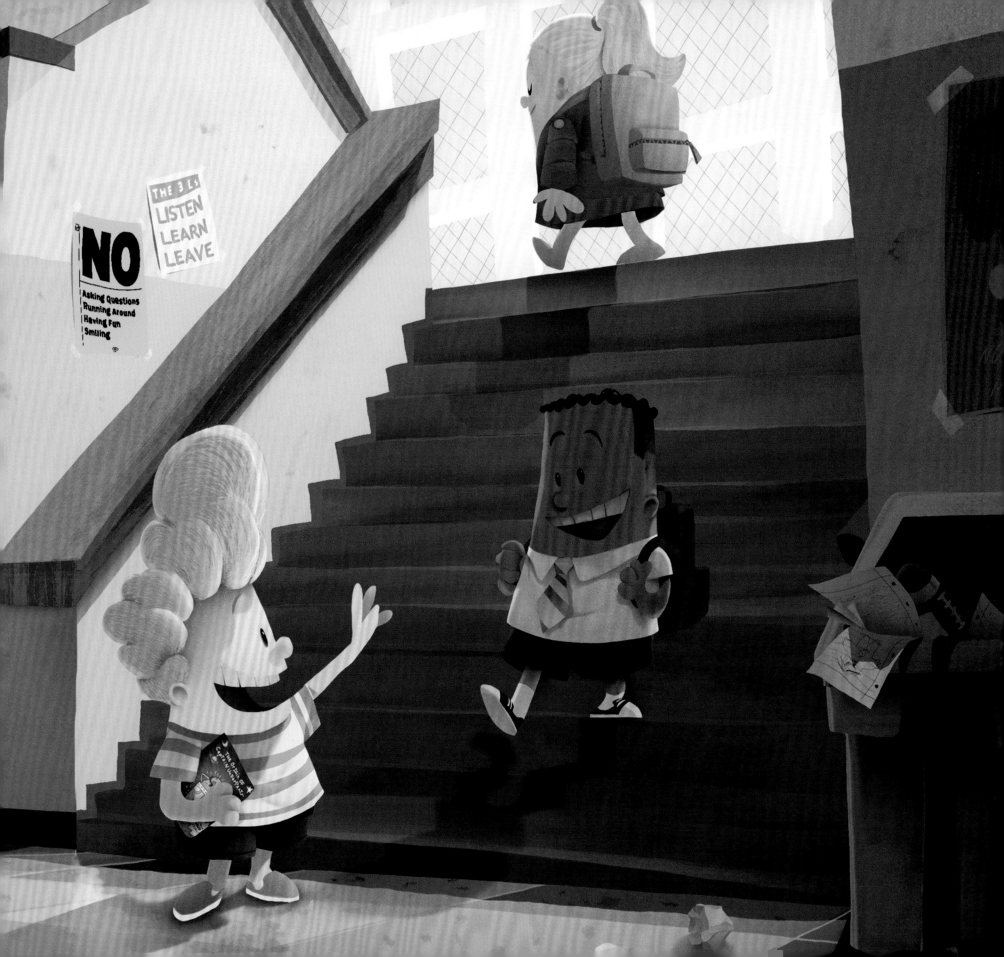

The Right Approach

The team was able to source various elements of the movie from different books. For example, the boys hypnotize Mr. Krupp in the first book. They face off against evil talking toilets that are featured in the second book. While the movie's villain Professor Poopypants doesn't make his appearance until the fourth book.

For the artistic team, one of the main challenges of the movie was finding just the right CG look that would retain the charm and whimsy of Dav Pilkey's original illustrations while blowing it up for the big screen. To help make that translation as smooth as possible, the filmmakers tapped Rune Brandt Bennicke, a veteran character designer and animator. Bennicke, whose impressive credits include *Mulan, The Tigger Movie, Lilo & Stitch, Asterix and the Vikings* and *Kung Fu Panda 3*, delivered some killer early 2D animation tests that defined the tone of the characters right out of the gate.

David Soren recalls, "We would constantly go back and look at those tests whenever we needed to show the actors or a new crew member what we were striving for. They also laid the groundwork for our animation style in general and were instrumental to the translation of the characters into our CG world."

Bennicke was inspired by clean silhouettes and simple designs from comic strips like Mort Walker's *Beetle Bailey*, Charles M. Schulz's *Peanuts* and Bill Watterson's *Calvin and Hobbes*. The main objective was to cut down the level of detail in the designs. "When I first came on board, I discovered that we needed to look at these characters as symbols, and not worry about actual anatomical details," explains Bennicke. "They are cartoon characters. They have dot eyes. They don't need realistic hair."

The character designer recalls the very first two animation tests he put together for the project. The first was one of Principal Krupp turning into his alter ego Captain Underpants. The second one, which involved Professor Poopypants, turned out to be a revelation.

"It all happened very easily," says Bennicke. "The Professor asks the class what they think is the most exciting thing about robots, and Melvin, the teacher's pet, says it's the mathematics behind robots. The Professor gets so excited that he floats in the air, and as soon as he finishes talking, he comes back down and lands. It's a very odd notion, and it defies the laws of physics, but it works in a traditional cartoony world. I was a bit scared to show it to the team, but they

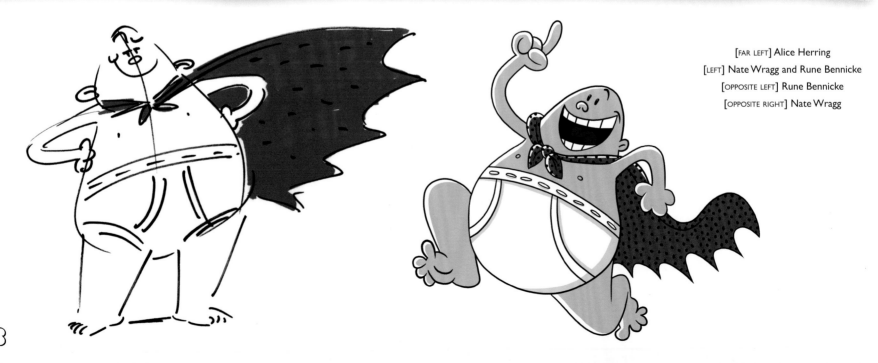

[FAR LEFT] Alice Herring
[LEFT] Nate Wragg and Rune Bennicke
[OPPOSITE LEFT] Rune Bennicke
[OPPOSITE RIGHT] Nate Wragg

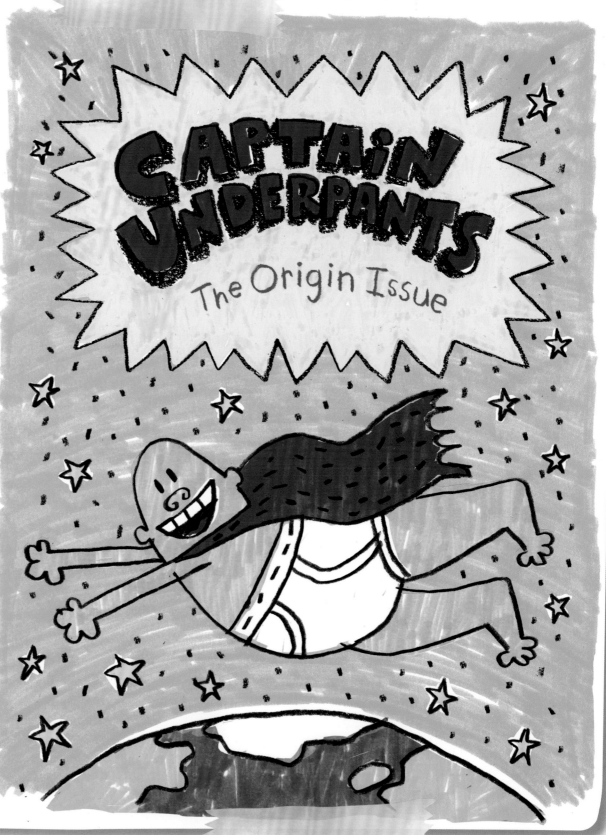

loved it and we decided to go for it. It's a perfect example of how things moved very smoothly for us when we were on the right path."

Production designer Nate Wragg recalls a particular Pilkey illustration in the first book that really helped him and his team get the right visual style for the movie. "It was an illustration of Principal Krupp, looking angry as can be, sitting at his desk," he says. "What struck me as important about this image was that it has a memorable character in an important location—united by the same tone. If you look closely at the illustration, we don't see a lot of detail as it was pretty stripped down and simple, but it was impactful. We wanted to keep things simple, maintain the iconic details like the pencil and pen holder sitting on top of Krupp's desk. We looked at his desk as more of a symbol of his disciplinary captain's chair and treated the space as more of an interrogation room. This was something that we would build on the illustration as we designed the set, all while staying true to the tone of the illustration and the story it was telling."

Pilkey's shaky illustrative line was another key element the team pulled from the illustration as they began the design process. "If you look at the chair, the desk, the pencil holder, there are no straight lines in what he draws," explains Wragg. "There is a wobble and shake to his line quality that we felt we needed to include in our modeling to get as close as we could to his illustrative style. So we built and modeled that wobble into every prop and asset in the film. If you look closely, you won't see any straight lines in the models, but you will see

Pilkey's shaky line in everything we designed and it really helped us adapt his drawings into the CG world. In many cases, if you look at a single prop in our movie on its own, the prop often looks broken or too wobbly. But when composed in a set surrounded by all the other wobbly props, everything blends together to form a really charming and appealing style."

Avoiding the rigid rules of the real world and stepping inside a more cartoony universe also proved to be a liberating experience for the film's visual development artist Christopher Zibach. "A lot of our sets are designed free of hardcore logic," he says. "We always try to find the funniest joke for any given object or circumstance. The goal is to find out what makes a prop funny or childish. Of course, the audience still needs to recognize what the object is. A water gun should look like what people think of as a water gun, but you have to make sure it's silly and funny on top of it."

Many of the movie's sets and objects follow the loose logic introduced by Pilkey in his books. As Zibach explains, "When you look at the books, there is no rhyme or reason why certain gadgets do what they do. Let's say there's a time machine or a special ray gun that enlarges everything: You don't have to know how they really work. You just have to capture that playful spirit that you had as a kid, that your imagination has no bounds. That's what we tried to capture in our design work!"

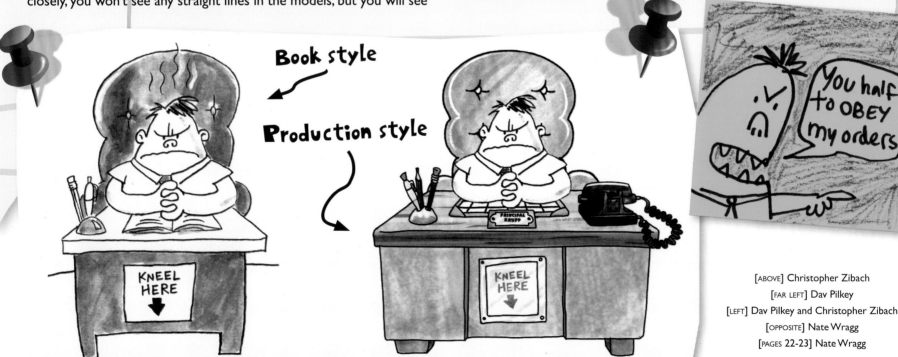

Book style

Production style

[ABOVE] Christopher Zibach
[FAR LEFT] Dav Pilkey
[LEFT] Dav Pilkey and Christopher Zibach
[OPPOSITE] Nate Wragg
[PAGES 22-23] Nate Wragg

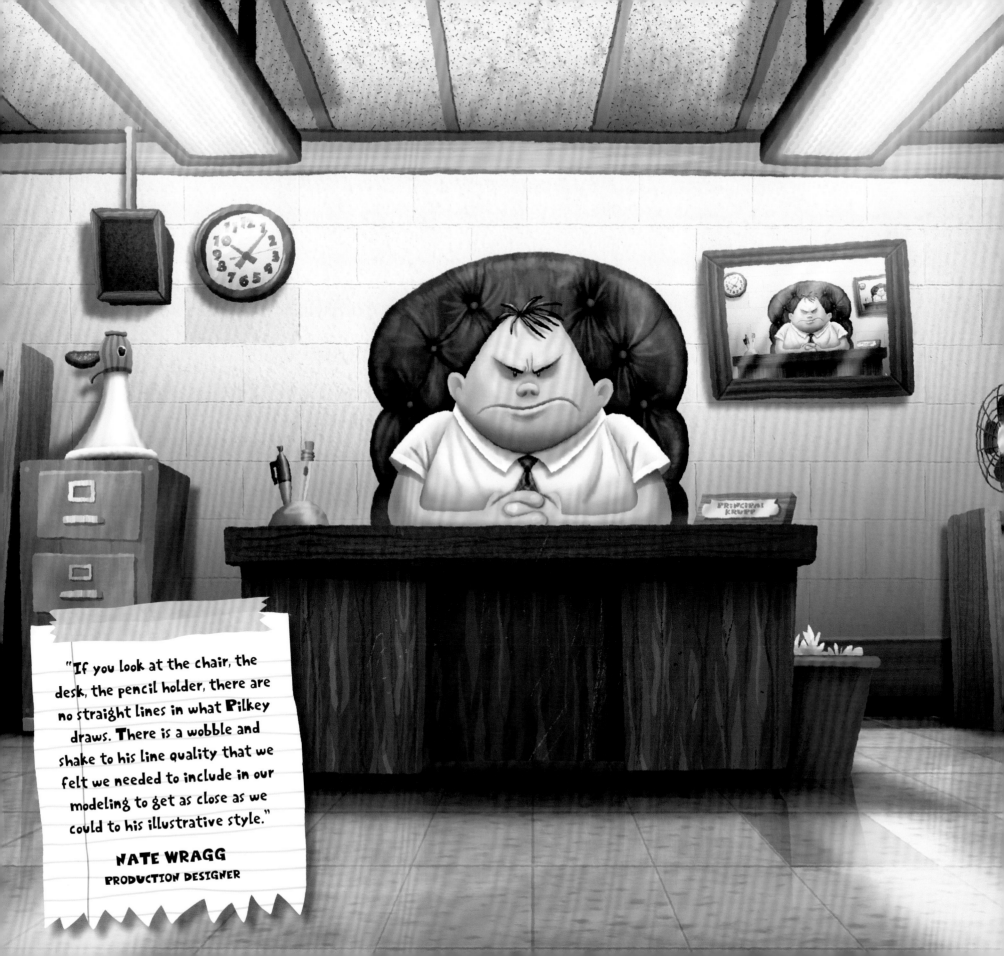

"If you look at the chair, the desk, the pencil holder, there are no straight lines in what **Pilkey** draws. **T**here is a wobble and shake to his line quality that we felt we needed to include in our modeling to get as close as we could to his illustrative style."

NATE WRAGG
PRODUCTION DESIGNER

Pilkey's Stamp of Approval

Some believe that the best compliment an author or property creator can give a movie's director and producers is to leave them in complete charge of the adapted material. And that's exactly what Captain Underpants creator Dav Pilkey chose to do. "Dav came around the studio a couple of times," says Swift. "He has a very interesting perspective. He doesn't really like movies that are exact interpretations of books, word by word, and don't bring anything new to the mix. He had a really good connection with our director, David Soren. They both see the world in the same way. They felt like kindred spirits. Pilkey felt confident leaving the movie in David Soren's hands."

Soren says he and Pilkey connected quite quickly because they had the same artistic influences when they were young. "We both taught ourselves how to draw by studying the work of [*Peanuts* creator] Charles M. Schulz," notes the director. "We both loved *The Little Rascals*. We shared many of the same influences. I think that's a big reason why the tone of the books and the movie feel in sync with each other. Dav seemed very appreciative, even relieved, that we understood that the friendship and chemistry between George and Harold was central to the success of the series."

Pilkey was also happy with the fact that the DreamWorks artists understood his visual intent and wanted to capture the spirit of his books with the movie. It was also a novel experience for him to see that so many talented artists at the studio were drawing and playing with the characters that he spent so many years imagining and creating in a solitary way. "He has been supportive of the movie in the best possible way," says Soren. "He's trusted us."

[LEFT AND ABOVE] Nate Wragg

[OPPOSITE] Rune Bennicke

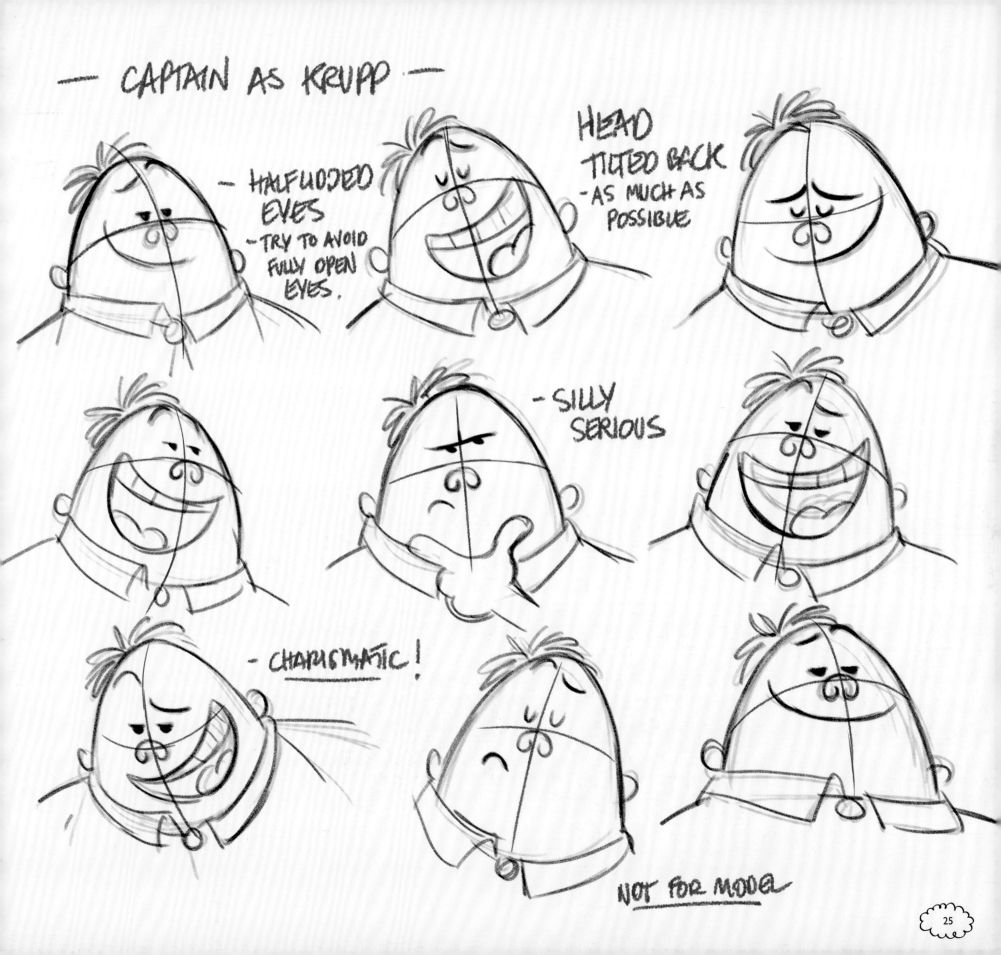

Creative Approaches to Storytelling

One of the delightful ways *Captain Underpants* stands apart from other CG-animated movies of recent years is in how it utilizes several different visual styles and formats to capture the boys' adventures. The filmmakers have included various types of animation and even live-action sock puppets, just as the books incorporate comics created by George and Harold and Flip-O-Rama—a traditional "flipbook" method that uses illustrations on consecutive pages.

"We wanted the comic-book sequences in the movie to be hand-drawn, our version of what a couple of fourth graders would draw," explains David Soren. "That meant limiting our tools to better resemble those used by a child. Using a cruder, limited animation style, colored with markers or pencil crayons, all composited in a simple way that could have been taught in an Animation 101 class. The idea was to start the comic book sequences using primarily still imagery, and the deeper we go into the actual adventures within the comics, the more immersive and graphic we get."

A more graphic and stylized type of 2D animation was also used for the sequence that shows Professor Poopypants trying to get rid of the boys' *Huffaguffawchuckleamulus*—the enigmatic part of the brain that appreciates humor! "This section is more fully animated and rendered than the comic-book sequences," explains Soren. "So we feel like we're actually inside George and Harold's brains."

The film moves into its Flip-O-Rama sequences when there is a major fight scene or confrontation involved. "There's a battle scene between the giant Turbo Toilet 2000 and Captain Underpants, so George and Harold rush in and pause the madness," says the director. "They say, 'The following sequence has scenes that are so intense, violent and expensive, that we can only show it using a technology known as Flip-O-Rama,' then Harold's CG hand comes in and flips the pages back and forth to create the illusion of movement. It couldn't be more basic. Ironically, animated movies are really just incredibly time consuming, elaborate, expensive Flip-O-Ramas."

Another visual treat is the use of live-action sock puppet animation, created by acclaimed Los Angeles-based studio Screen Novelties for a scene that illustrates how Harold imagines their lives would be if Principal Krupp manages to put them in separate classes. "The boys are in their treehouse, traumatized by Krupp's threat. It's raining outside. Their shoes and socks are lying around. The sock puppet fantasy came organically from the situation they were in. It was the perfect way to visualize their fears. It also opened the door for all the other playful techniques we use in the movie," notes Soren.

[LEFT, BELOW AND OPPOSITE]
Nate Wragg

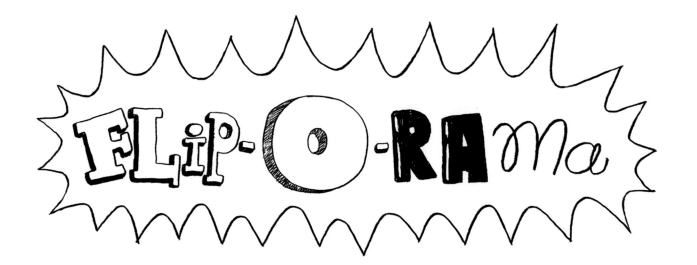

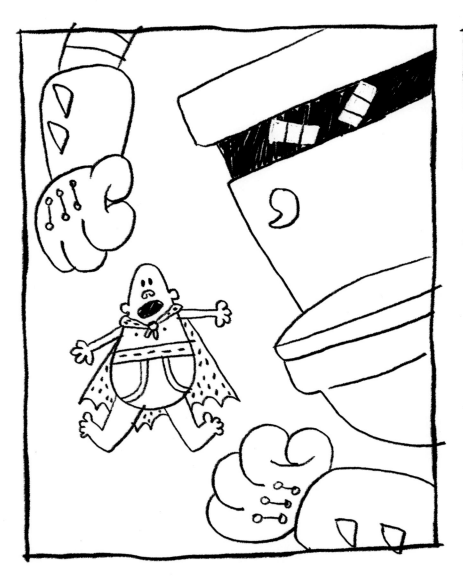

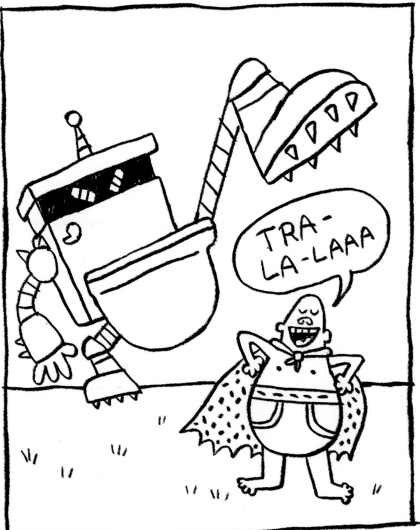

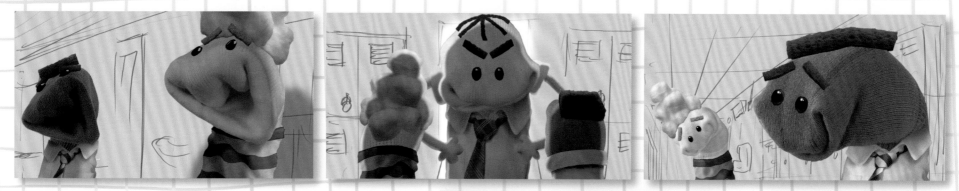

"The books play with the literary form in all kinds of fun, unconventional ways. We wanted to do the cinematic equivalent. That meant mixing mediums, breaking the fourth wall, and sock puppets!"

DAVID SOREN, DIRECTOR

[ABOVE] Alice Herring and Todd Kurosawa, [RIGHT AND OPPOSITE] Nate Wragg
[BELOW] *SOCK PUPPETS* by Robin Walsh/Screen Novelties

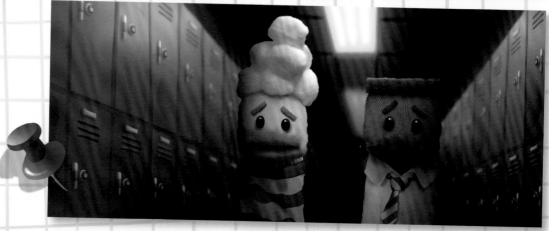

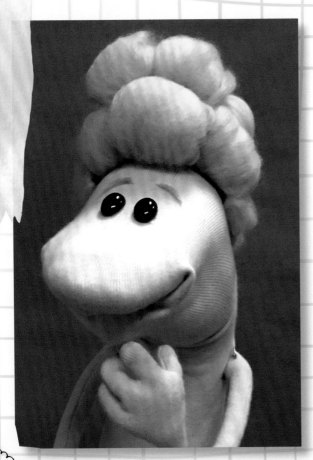

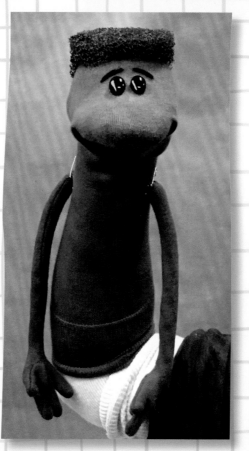

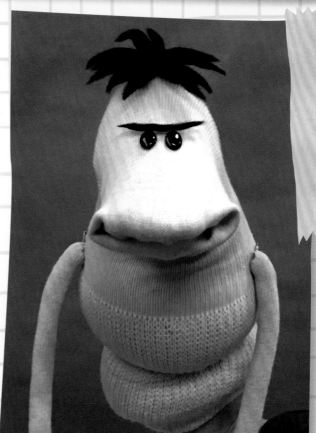

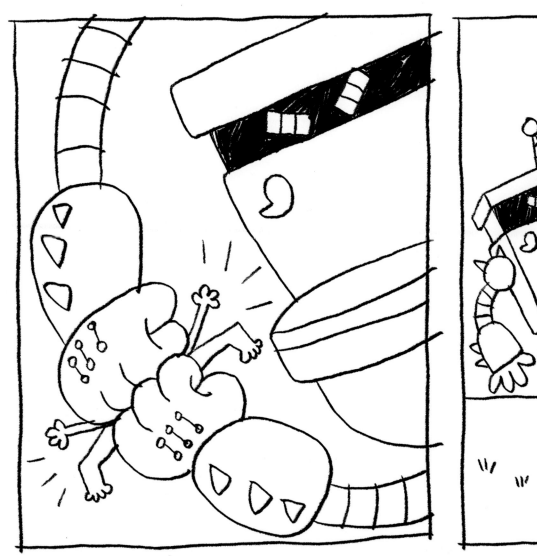

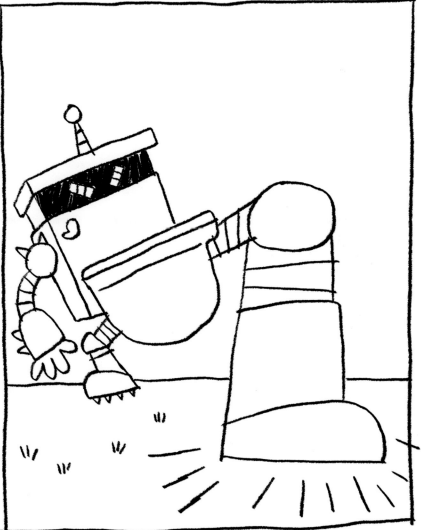

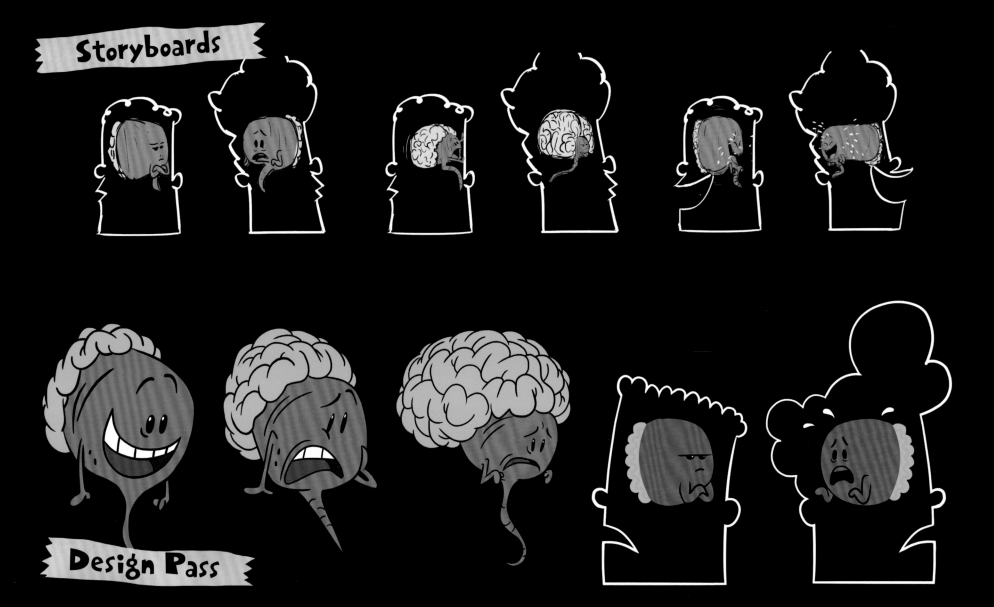

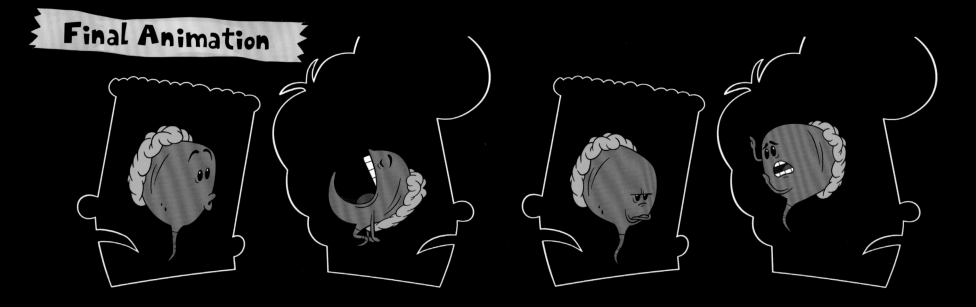

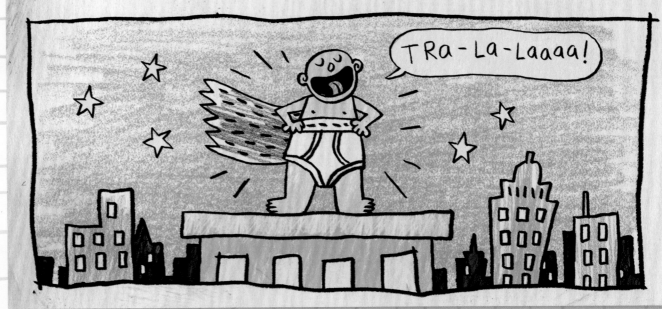

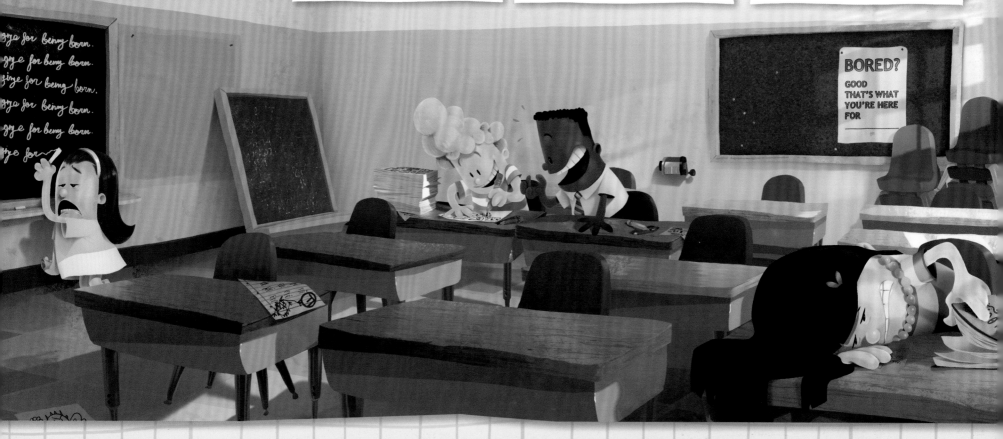

The Mikros Touch

Captain **Underpants** marks the first time in DreamWorks Animation's history that the studio is producing a feature film in partnership with an outside studio.

"We searched for a studio that shared our artistic sensibility," says Swift. "I came across the amazing work that Mikros Image studio had done in recent years. I was very impressed with the work they had done on *Asterix and Obelix: Mansion of the Gods* (2014) and knew that they were working on *The Little Prince* (2015). The quality of their animation really drew me to them. It has been a wonderful collaboration—we are handling the designs, rough layouts, and the story, and they are doing all the CG steps—from modeling, animation, crowds, cloths, textures, effects, and lighting. We were very lucky to have them as our partners on this journey."

"I grew up watching the old Warner Bros. cartoons, so working on a movie that celebrated the spirit of classic animation was a wonderful opportunity for us," says David Dulac, the film's visual effects supervisor at Mikros, who has worked on a wide range of movies, such as *The Matrix*, *Moulin Rouge!* and *Valiant*. "It really goes back to what I think animation can do and should be as an art form."

As Sébastien Bruneau, head of character animation at Mikros points out, "The design and animation style of this movie is really unique. We work with this really graphic, clean design, which allows us to experiment in new directions. There's an additional level of quality that is close to what we can do in 2D animation."

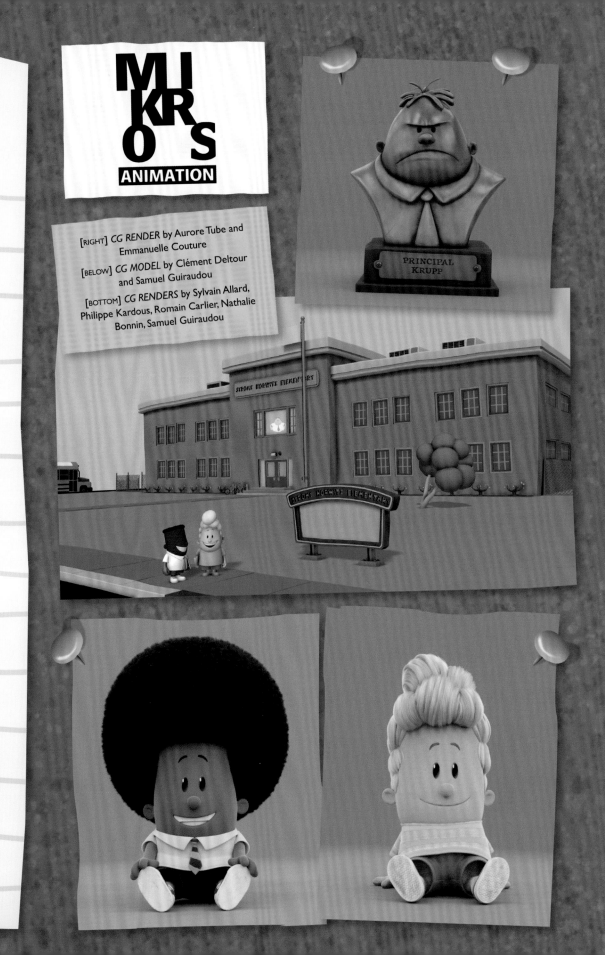

[RIGHT] *CG RENDER* by Aurore Tube and Emmanuelle Couture

[BELOW] *CG MODEL* by Clément Deltour and Samuel Guiraudou

[BOTTOM] *CG RENDERS* by Sylvain Allard, Philippe Kardous, Romain Carlier, Nathalie Bonnin, Samuel Guiraudou

Rune's Rules

To bring the freewheeling, loose illustrations of Dav Pilkey into the more complex CG-animated world of the movie, production designer Nate Wragg and character designer Rune Bennicke came up with a process of determining what would and what wouldn't fit into this imaginative universe. "The book series has art on every page, so we had so much reference in front of us," says Bennicke. "In the beginning, it took us some time to decode. For me, it was the void of information, the shaky line, and the cruddy wonky angles that made every drawing so charming and fun to paint."

"The books are filled with visual jokes, and it was fun to include all the humor seen in posters, graphics and signs all over the town," adds Wragg. "When we began the project, we were accustomed to designing things with lots of detail—where everything had to function logically. Ideas that were born from that place felt off, because the tone didn't feel as fun as the books. We eventually abandoned that approach and embraced the way Pilkey captures childlike drawings and ideas."

Wragg and Bennicke also strove hard to include as many of Pilkey's beloved characters as possible throughout the movie. "The thing that clearly jumps out in the Captain Underpants universe is the funny, diverse cast of characters that live in it," explains Wragg. "From the school kids to the teachers and the town's local TV news reporter, we loved them all and wanted to find a way to include as many of them in the design of our film as we could. That meant mining all of the books in the series to make sure no character got left behind!"

[RIGHT] Rune Bennicke

[PAGES 34-35] Christopher Zibach and Rune Bennicke

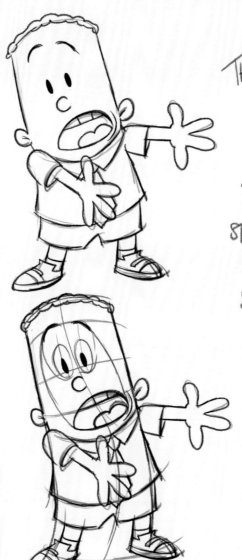

THINK ABOUT THE UNDERLYING FLOW & STRUCTURE WHEN DESIGNING YOUR POSES.

BY MAINTAINING AN UNDERLYING STUCTURE & LOGIC WITHIN THE POSE & THE SHOT WE MAKE SURE EVERYTHING FEELS CONNECTED AND PART OF A WHOLE.

THINK ABOUT —

- HOW EVERY PART AFFECTS EVERY OTHER PART.
- WHAT'S PULLING/PUSHING ON WHAT.

- THE PROGRESSION OF THE LINES OF ACTION.
 - THE GRADUAL CHANGING OF THE CURVES AND ANGLES.

THERE ISN'T ONE RIGHT WAY TO DO THIS OR THINK OF THIS. DO WHATEVER WORKS FOR YOU THE IMPORTANT THING IS THAT THERE IS CONSISTANCY WITHIN THE POSE/SHOT.

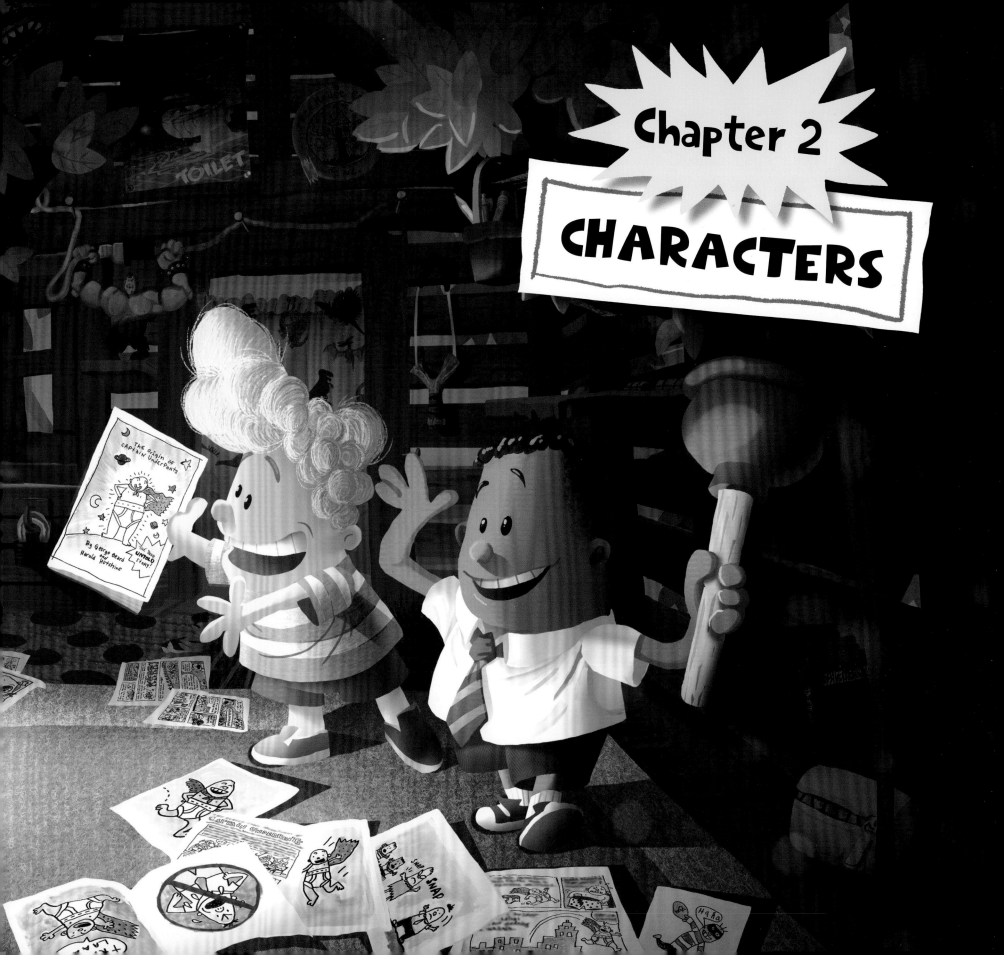

George Beard and Harold Hutchins

George Beard and Harold Hutchins are the goofy, mischievous centers of the Captain Underpants universe. (According to Pilkey himself, they were named after characters from the author's favorite children's books—*Curious George* and *Harold and the Purple Crayon*.) The friendship between the two boys is the heart and soul of the books and the movie. George is the writer and Harold is the artist. Together, they hang out making comics in their tree house as an escape from the drudgery of school.

"They may be pranksters, but they're good kids at heart. They only stand up to authority when the authority in question is, well… questionable. And nobody is more deserving to be pranked than Principal Krupp," explains director David Soren.

George (voiced by Kevin Hart) is more of the instigator, while Harold (voiced by Thomas Middleditch) takes a little more

[BELOW LEFT] Nate Wragg and Rune Bennicke

[BELOW] Rune Bennicke

[ABOVE, BELOW AND BOTTOM] Colin Jack
[RIGHT AND BOTTOM RIGHT] Andrew Erekson

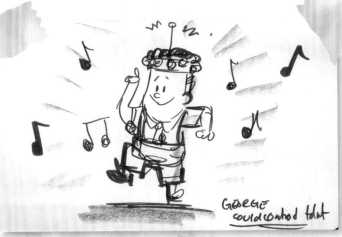

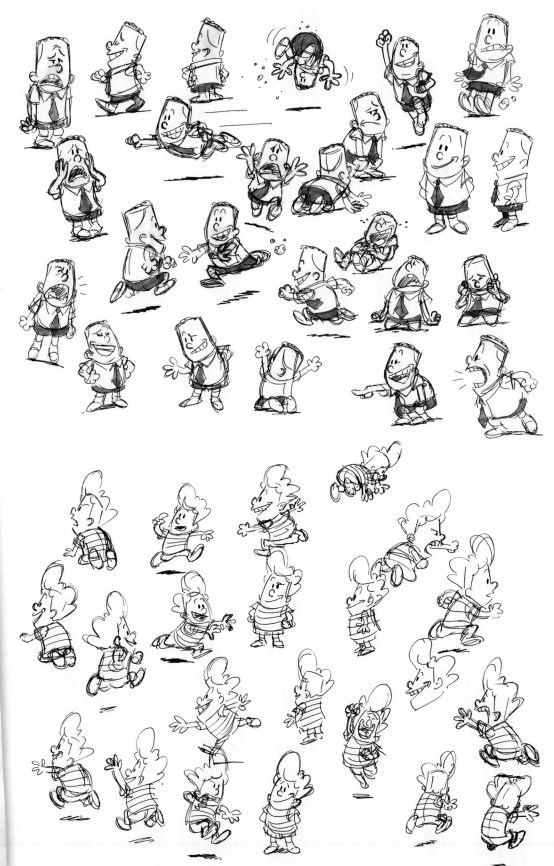

convincing, but he gets on board quite quickly. "In their minds they are the last line of defense against the injustice of their terrible principal," adds Soren.

The character designs of the two boys were obviously inspired by the books' illustrations. "The challenge was to adapt Pilkey's drawings into CG without losing any of their appeal," says Soren. "Our goal was not to change things, but to take cues from what he has created. We felt strongly that the designs should retain the same graphic language as the illustrations in the books. Rune is incredibly gifted at translating the appeal of Pilkey's drawings and actually elevating it for our CG world."

Bennicke says when he looks back at the early sketches of the boys for the movie, he notices a great evolutionary arc. "They have gone through a little bit of a transformation from the first few takes," he notes. "I can definitely see how they have changed in the process, and I love the fact that there's evolution in the design. It's like when you look back at one of the long-running animated TV shows, like *The Simpsons*. You change things around until you get the right proportions in the end."

[ABOVE] Alice Herring, [BELOW LEFT] Dav Pilkey, [BELOW MIDDLE] Rune Bennicke, [BELOW] *CG RENDER* by Anne-Claire Leroux, Caroline Lobato, Mathieu Gautier, Philippe Kardous

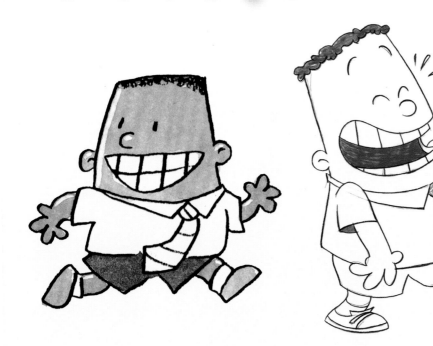

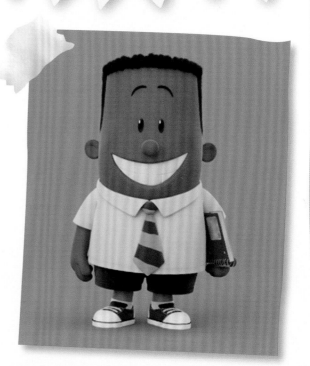

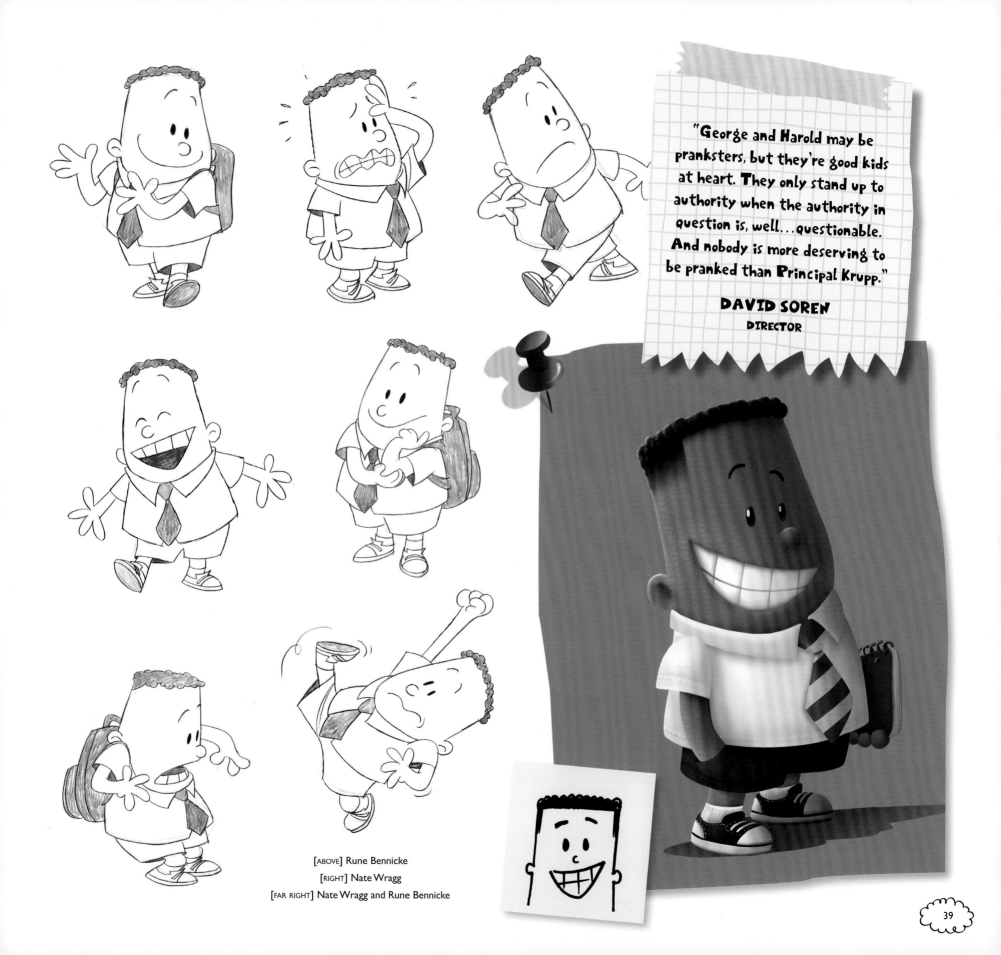

"George and Harold may be pranksters, but they're good kids at heart. They only stand up to authority when the authority in question is, well...questionable. And nobody is more deserving to be pranked than Principal Krupp."

DAVID SOREN
DIRECTOR

[ABOVE] Rune Bennicke
[RIGHT] Nate Wragg
[FAR RIGHT] Nate Wragg and Rune Bennicke

39

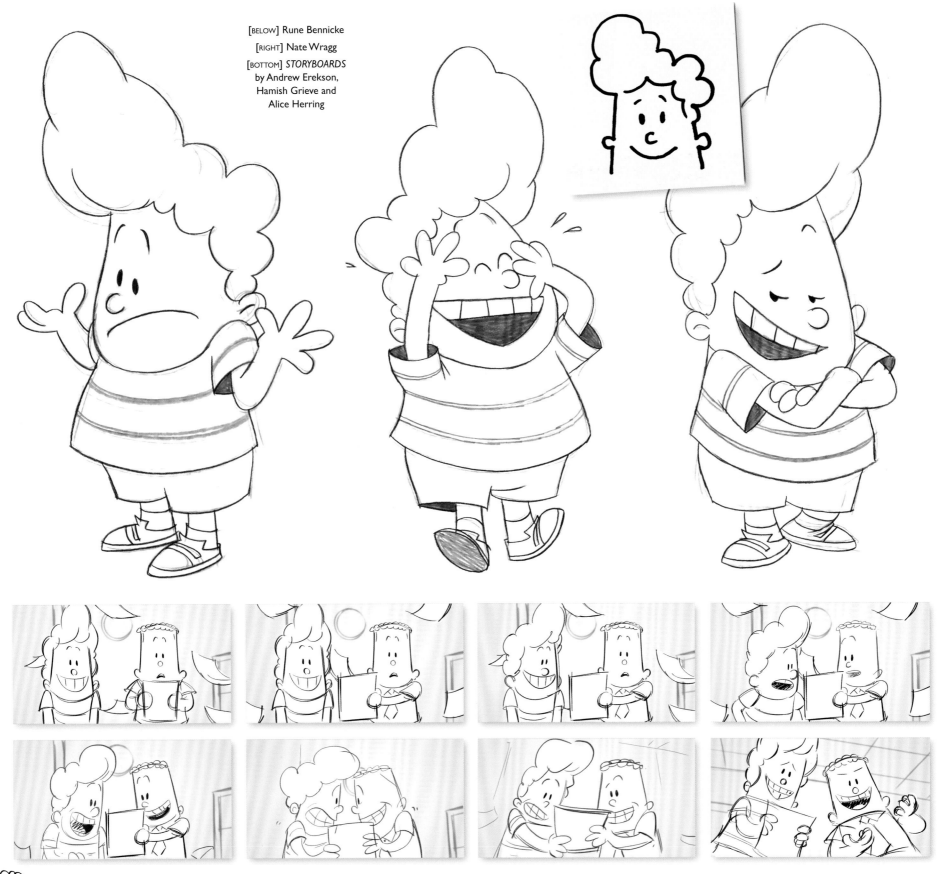

[BELOW] Rune Bennicke

[RIGHT] Nate Wragg

[BOTTOM] *STORYBOARDS* by Andrew Erekson, Hamish Grieve and Alice Herring

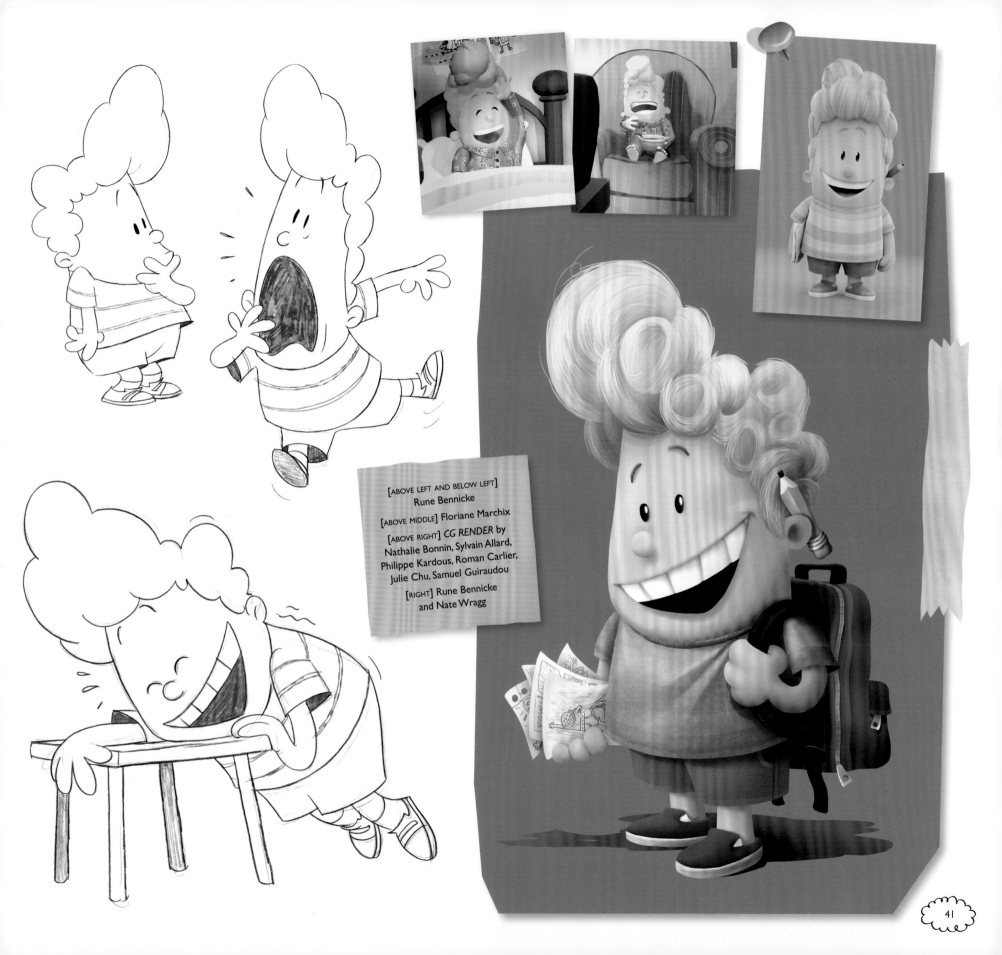

[ABOVE LEFT AND BELOW LEFT]
Rune Bennicke

[ABOVE MIDDLE] Floriane Marchix

[ABOVE RIGHT] CG RENDER by
Nathalie Bonnin, Sylvain Allard,
Philippe Kardous, Roman Carlier,
Julie Chu, Samuel Guiraudou

[RIGHT] Rune Bennicke
and Nate Wragg

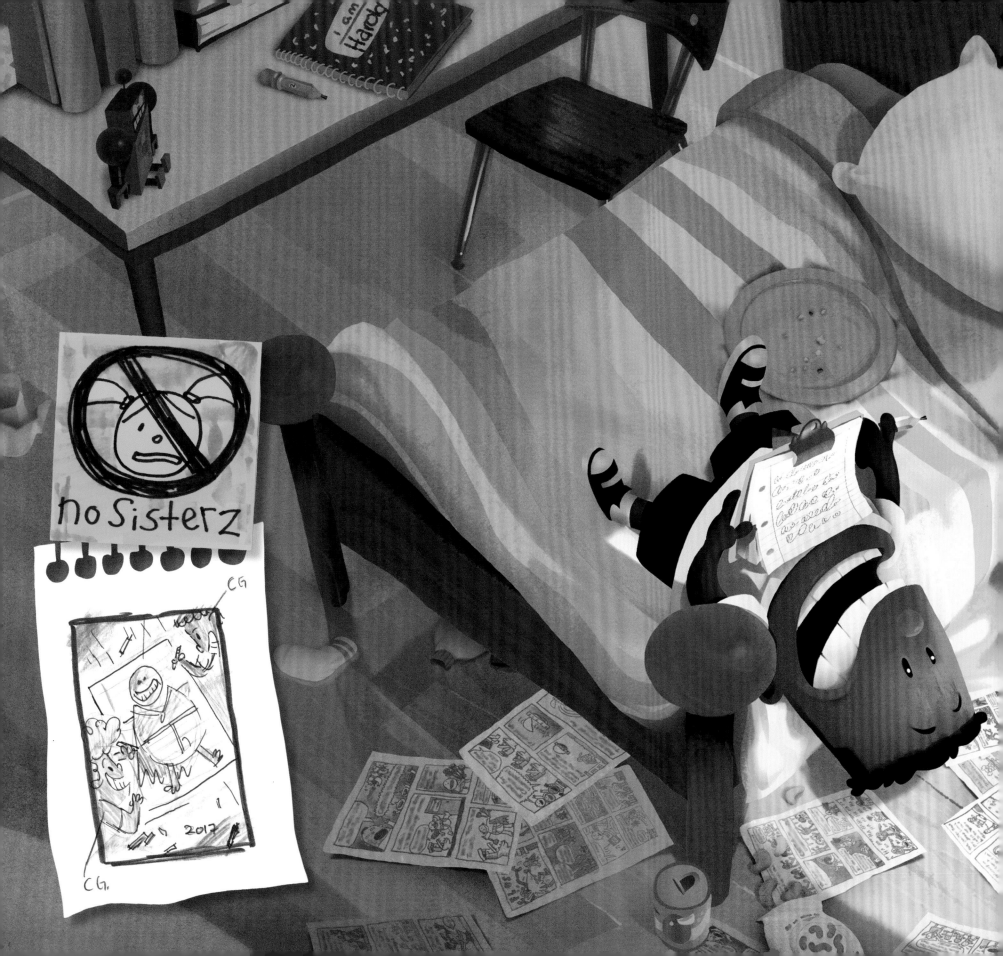

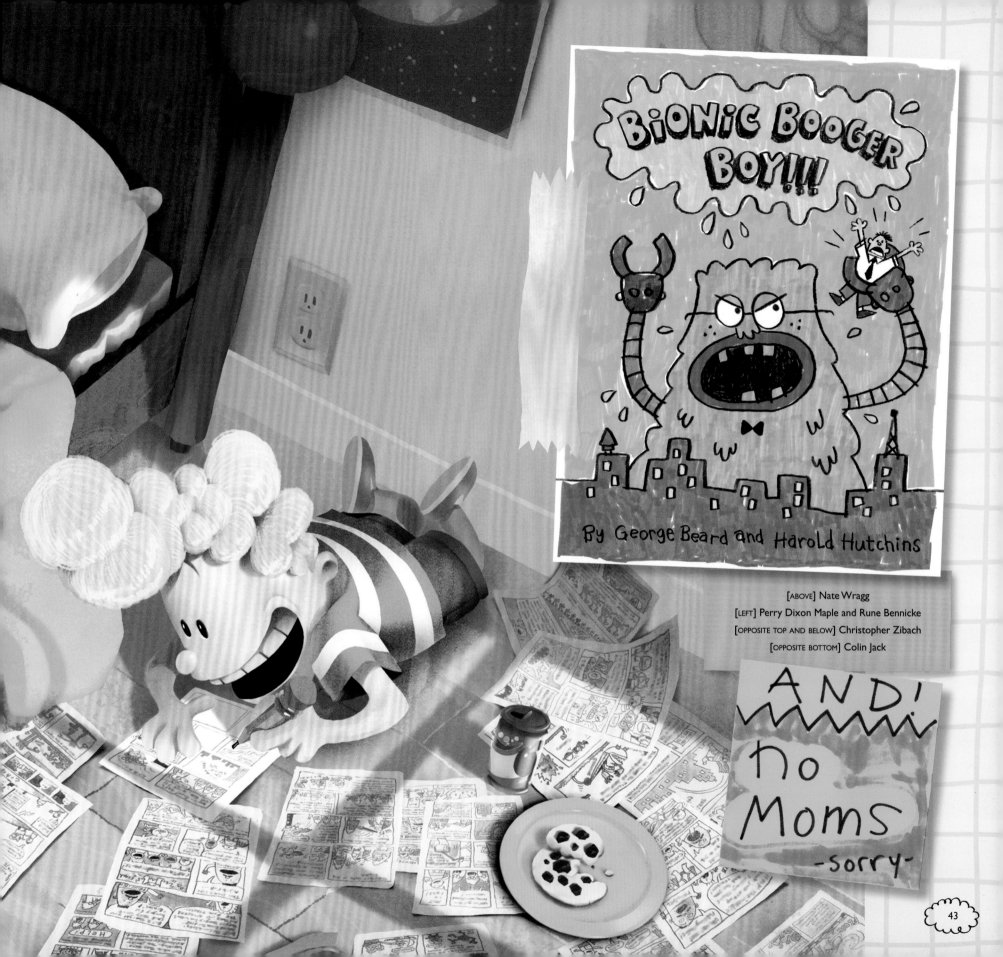

By George Beard and Harold Hutchins

[ABOVE] Nate Wragg
[LEFT] Perry Dixon Maple and Rune Bennicke
[OPPOSITE TOP AND BELOW] Christopher Zibach
[OPPOSITE BOTTOM] Colin Jack

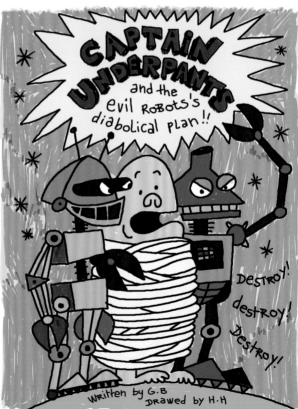

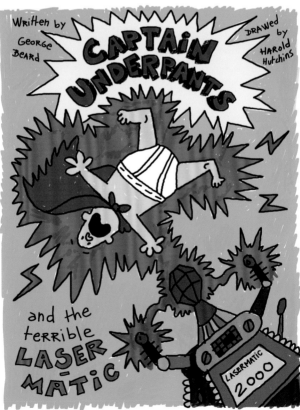

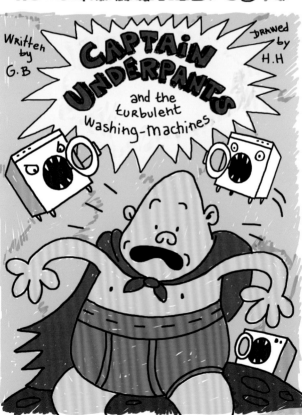

TO THE RESCUE!!

He Found A Bunch of Plungers.

CRASH

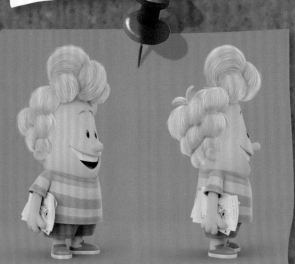

Hair Style Guide
Hair Silhouettes

Overall hair design should have a strong, clear silhouette

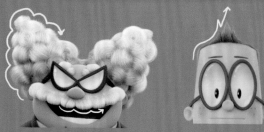

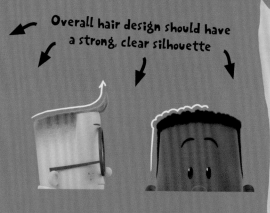

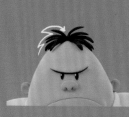

[ABOVE LEFT] Dav Pilkey

[LEFT, RIGHT AND BELOW] Nate Wragg

[ABOVE, OPPOSITE TOP AND OPPOSITE BOTTOM]
CG RENDERs (HAIR STYLISTS) Nathalie Bonnin,
Caroline Lobato, Julie Chu, Romain Carlier,
Cathy Boisvert

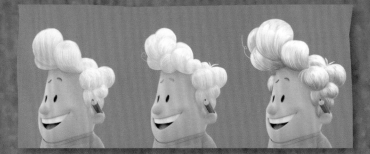

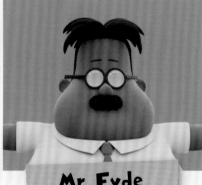

Mr. Fyde

Ms. Ribble

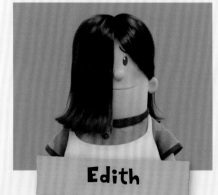
Edith

Miss. Anthrope

A Hair-Raising Experience

One of the biggest challenges of delivering CG versions of Pilkey's illustrations was creating Harold's hair—which is usually drawn as this big yellow cloud-like squiggle in the books. "We needed to bring the looseness and cartoony feel that the hair has in the original illustrations, and that took us a lot of research and time to achieve," says producer Mark Swift. "I love how the hair turned out in the end. It really captures the fluffy mess. You can cheat the details in 2D, but in CG, it's a lot more complicated."

The design team knew from the very beginning that they needed to come up with a unique and creative way to deliver the characters' hair in the movie. "We were aware of the fact that we couldn't do realistic hair," notes character designer Rune Bennicke. "We tried it in the beginning, and it wasn't pretty. We also knew that we couldn't opt for the helmet-hair approach, like some other recent CG animated movies had done. It had to be something in between, and I think we found an interesting middle ground. It keeps the design and actually represents cartoony hair in a believable way."

The team at Mikros used grooming material to simulate the hair using their proprietary hair system. "We used the same workflow we used for another recent movie we did—*Asterix and Obelix: Mansion of the Gods*," explains CG supervisor Guillaume Dufief. "There was a lot of back and forth about the look of the hair, but in the end, we were very happy with the way the CG version echoed the original drawings. It was cartoony, less realistic, and definitely not easy to do!"

Principal Krupp

The first time readers meet Principal Krupp in Pilkey's first book, he is growling at the boys through his office window. He is described as "the meanest, sourest old principal in the whole history of Jerome Horwitz Elementary School. He hated laughter and singing. He hated the sounds of children playing at recess. In fact, he hated children altogether!" (*The Adventures of Captain Underpants* by Dav Pilkey, 1997).

Of course, Krupp hates George and Harold most of all! "He is probably the worst principal of all time," says director David Soren. "He desperately wants to make the school a drone-like beehive and saps all the fun out of it. He cancelled the school's art and music program so that he could install a magnetic automatic door closer to his office."

The boys, however, discover another side to their favorite antagonist in the movie. "Underneath all of that, there's a deep loneliness that we discover after the boys visit his house," notes Soren. "From the outside, the place looks like a house of horrors, but then on the inside, it looks like a sweet old lady's home. It's a revelation that humanizes Krupp in their eyes. He's not a monster; he's just lonely."

Beautifully voiced by Ed Helms, Krupp was a tricky character to design because he also has to become Captain Underpants, and then a third variation, which is Captain Underpants disguised as the Principal—the secret identity the boys assign him so he doesn't wander around the school in his underwear.

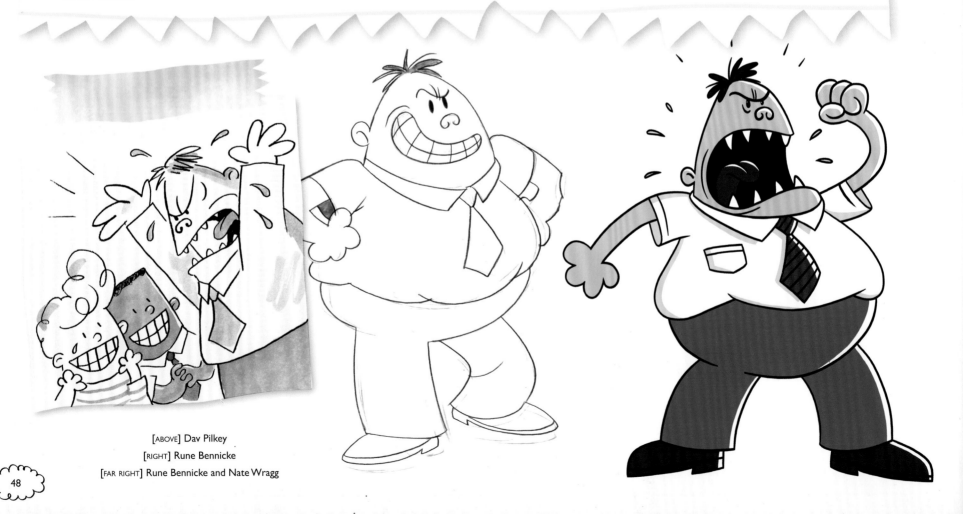

[ABOVE] Dav Pilkey
[RIGHT] Rune Bennicke
[FAR RIGHT] Rune Bennicke and Nate Wragg

48

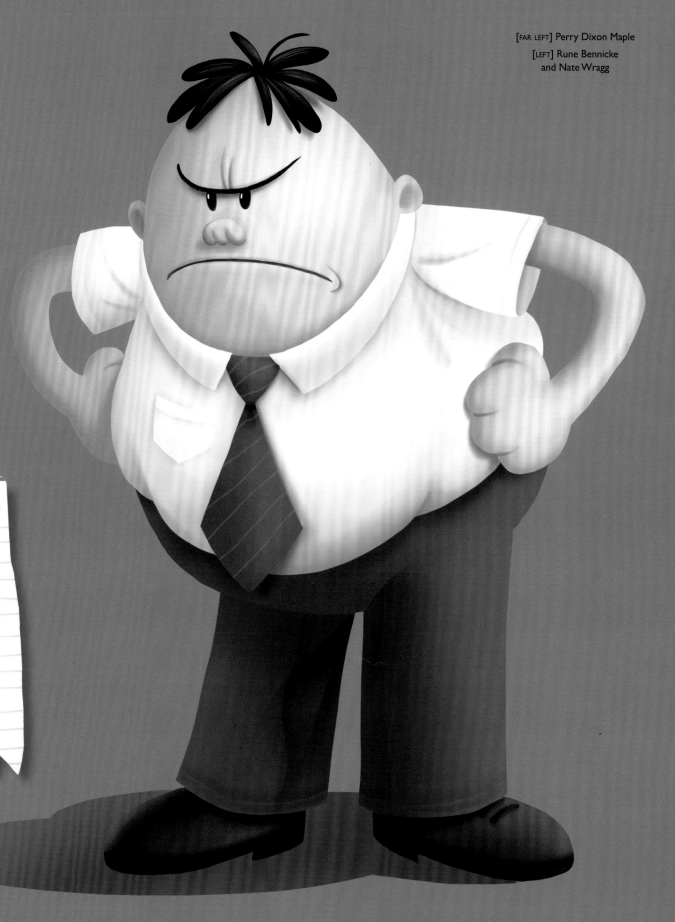

REMINDER

IF YOU AREN'T
TALL ENOUGH
TO READ THIS
SIGN YOU'RE
NOT
IN CHARGE

FUN TRIVIA POINT!
Krupp's name was inspired by
the 1934 *Our Gang/The Little
Rascals* short *Shrimps for a Day*,
which features an evil, grouchy
old man named Mr. **Crutch**.
However, **P**ilkey remembered
the name incorrectly, and
Mr. **Crutch** became Mr. **Krupp**
in the books!

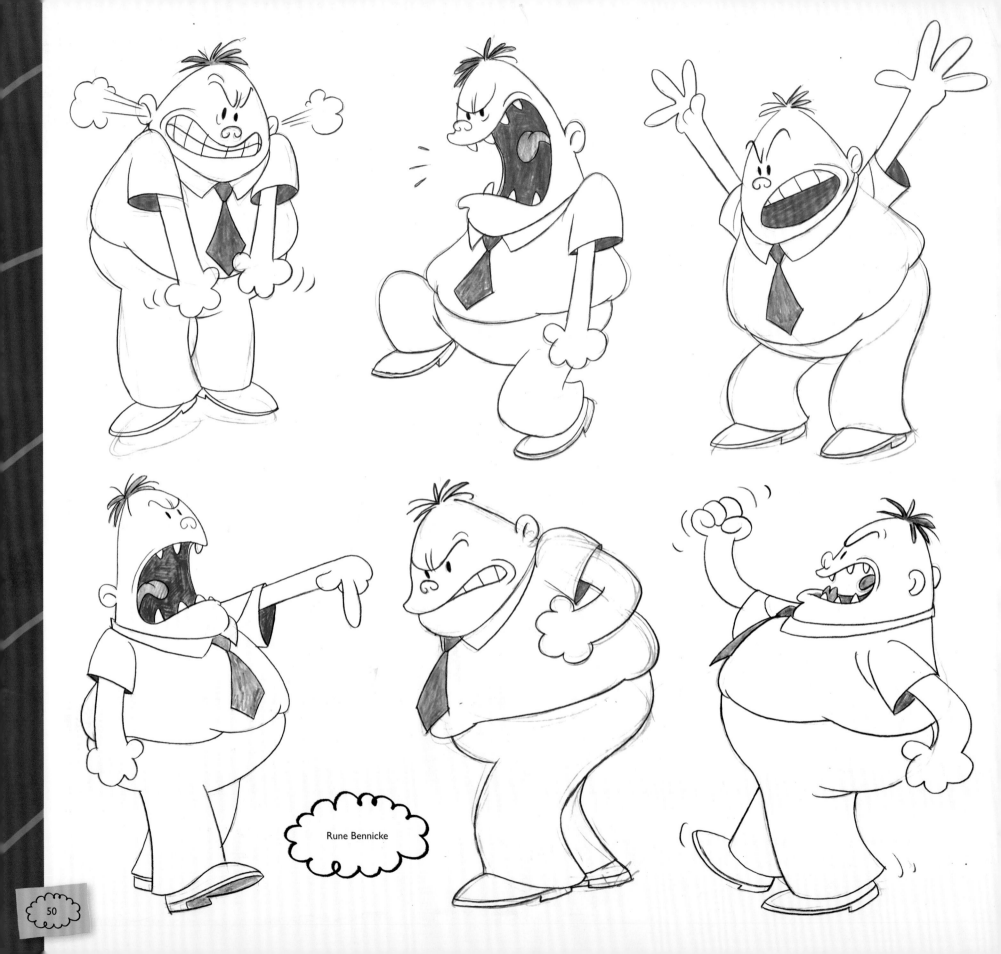

Rune Bennicke

Our PrinSiPaL

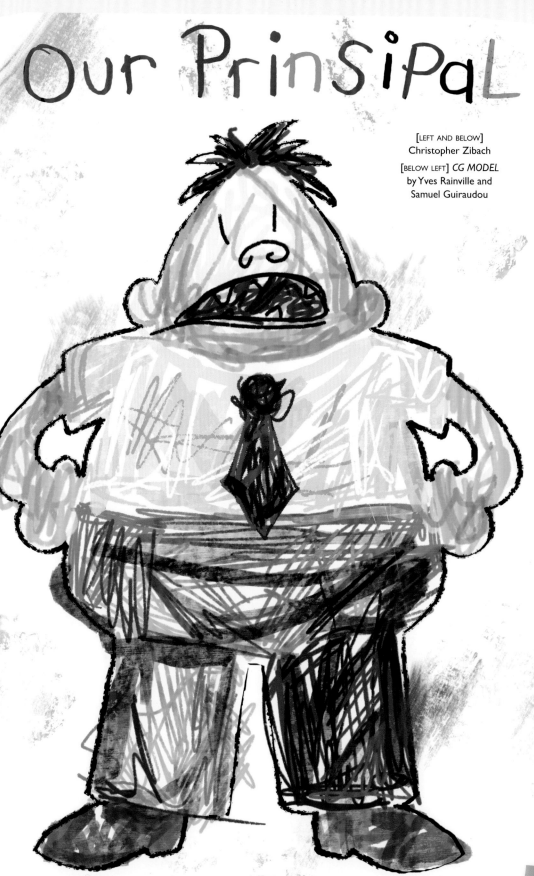

[LEFT AND BELOW]
Christopher Zibach

[BELOW LEFT] *CG MODEL*
by Yves Rainville and
Samuel Guiraudou

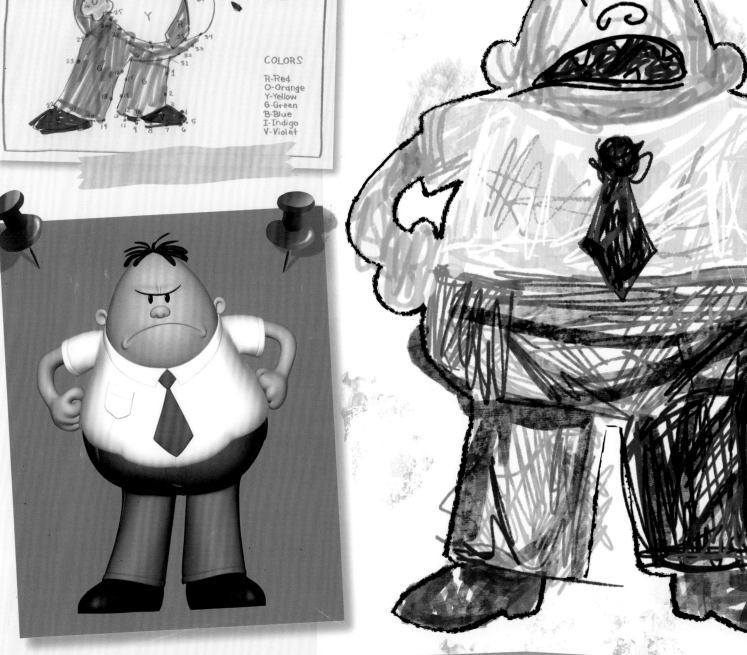

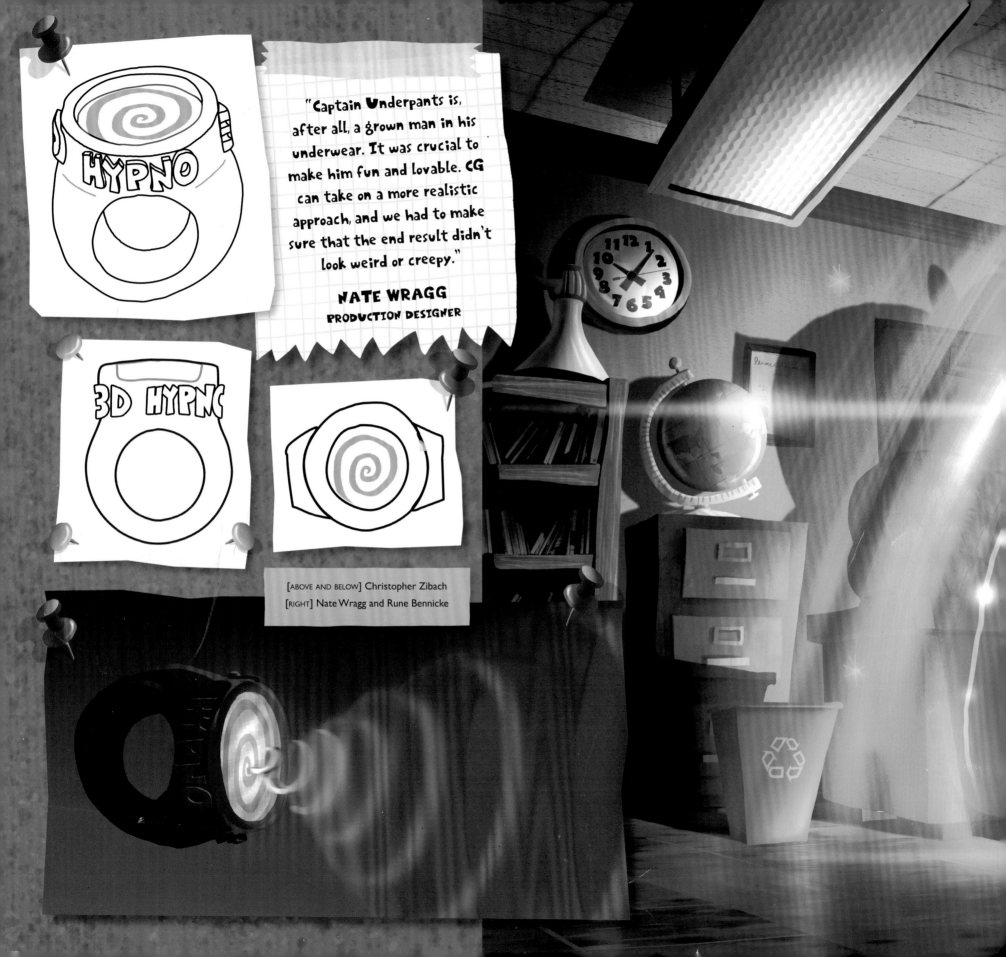

"Captain Underpants is, after all, a grown man in his underwear. It was crucial to make him fun and lovable. CG can take on a more realistic approach, and we had to make sure that the end result didn't look weird or creepy."

NATE WRAGG
PRODUCTION DESIGNER

[ABOVE AND BELOW] Christopher Zibach
[RIGHT] Nate Wragg and Rune Bennicke

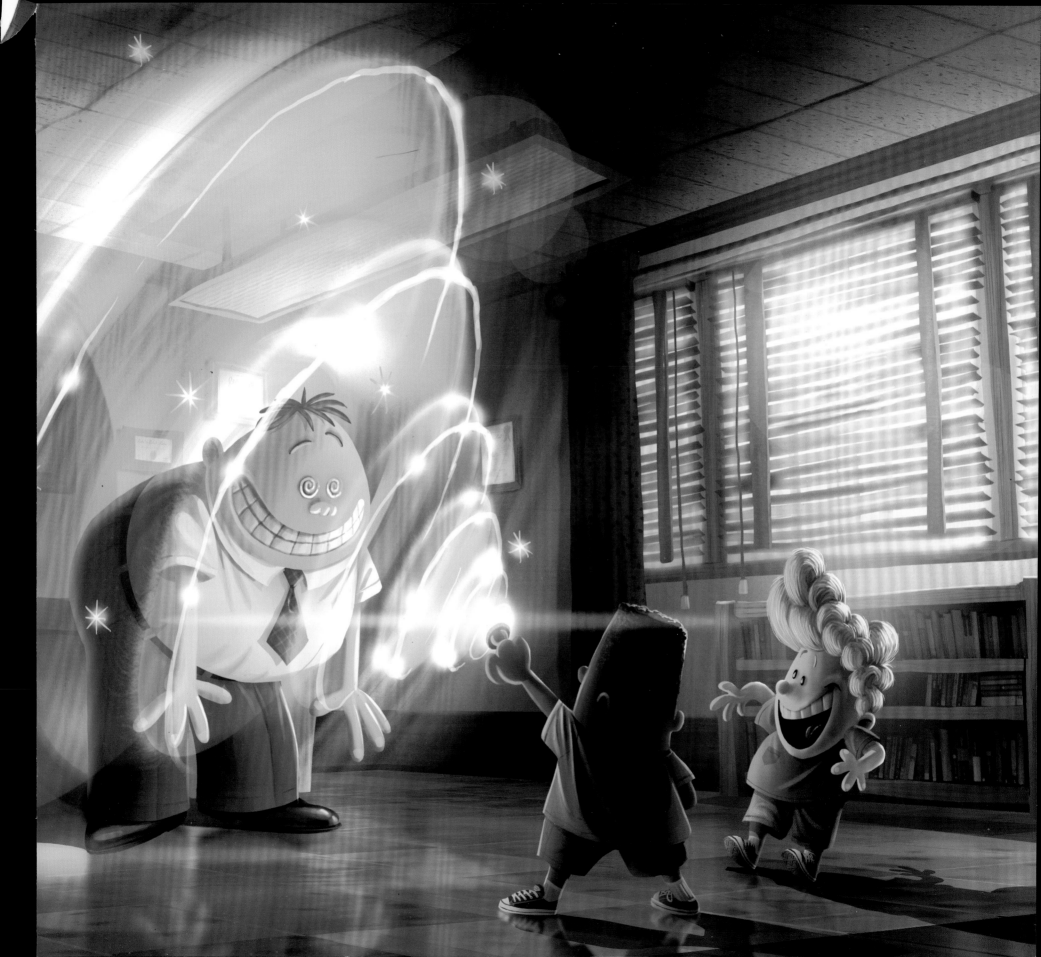

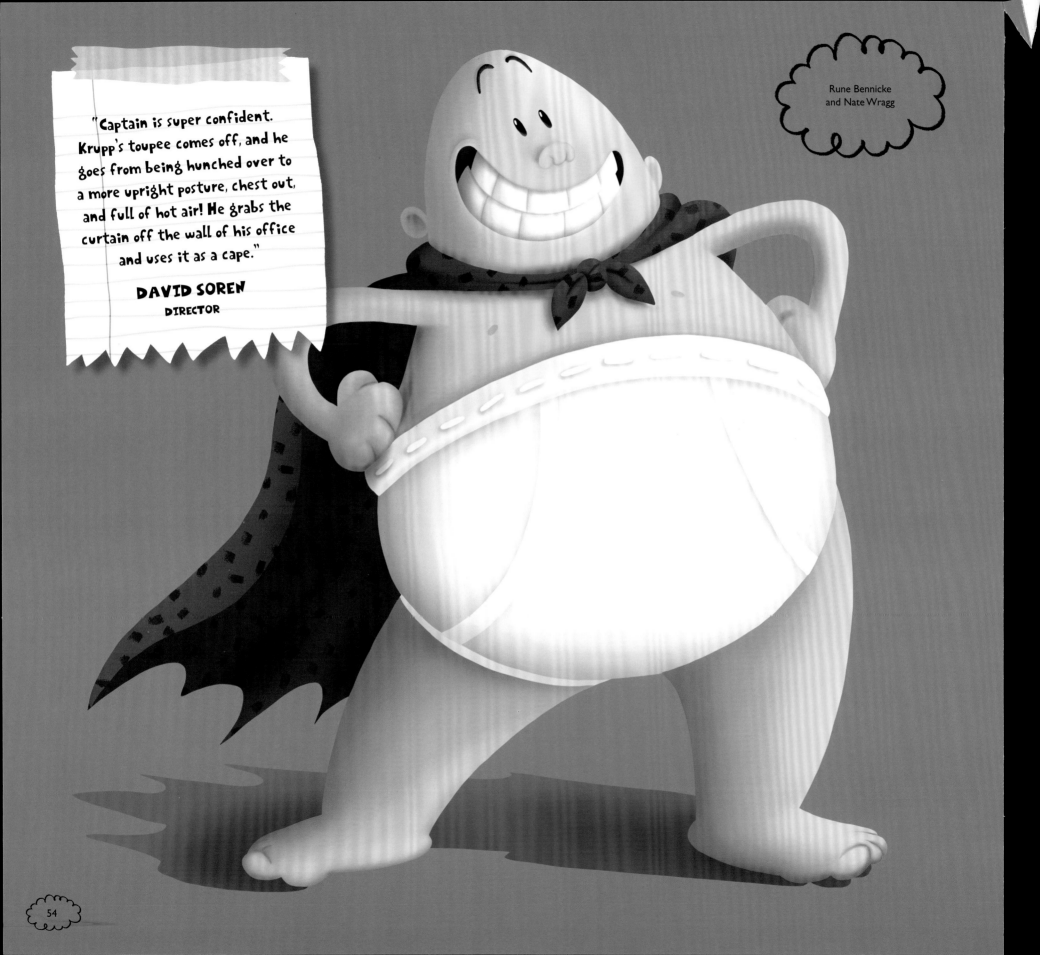

"Captain is super confident. Krupp's toupee comes off, and he goes from being hunched over to a more upright posture, chest out, and full of hot air! He grabs the curtain off the wall of his office and uses it as a cape."

DAVID SOREN
DIRECTOR

Rune Bennicke and Nate Wragg

54

Captain Underpants

George and Harold first created Captain Underpants in their home-made comic book. George came up with the idea first, saying, "'Most superheroes *look* like they're flying around in their underwear.…Well, this guy actually *is* flying around in his underwear!'" (*The Adventures of Captain Underpants* by Dav Pilkey, 1997) How can anyone not love an egg-headed superhero who is faster than a speeding waistband, more powerful than boxer shorts, and able to leap tall buildings without getting a wedgie? Not to mention that his catch phrase is an infectious "Tra-La-Laaaa!"

As director David Soren explains, "Our first reveal of Captain Underpants is through George and Harold's point of view. Their comic book pages are swirling around the principal's office. As the pages settle, we reveal that their creation has come to life. The boys think it's amazing, hilarious…but it's all downhill from there. Captain Underpants turns out to be a well-meaning trainwreck, always doing the wrong things for the right reasons." Completely delusional, he believes the planet is now safe under his watchful eye. Soren notes, "Ed Helms has been such a huge help in defining not just the voice, but the personality and utter stupidity of this character." Of course, the boys are constantly having to do damage control to either prevent Captain from getting hurt or getting themselves into more trouble.

In terms of design, as Krupp and Underpants are the same person, the artists needed to work on posture and attitude changes. "Captain is super confident," says Soren. "Krupp's toupee comes off, and he goes from being hunched over to a more upright posture, chest out, and full of hot air! He grabs the curtain off the wall of his office and uses it as a cape."

There is a third variant to the persona, basically Captain Underpants disguised as Krupp, when the kids have to make him look normal. "He wears the toupee, but it's kind of askew," says the director. "He wears the same shirt, but it's buttoned incorrectly. It seems as if his clothes look a couple of sizes too small for him for no reason; he finds clothes in general to be restrictive and unnecessary. That's where the design challenge was. We had to make sure the audience could easily tell that this wasn't Krupp. It's Captain Underpants playing the role of a principal!"

Production designer Nate Wragg is also thrilled with the results. "This is, after all, a grown man in his underwear," he notes. "It was crucial to make him fun and lovable. CG can take on a more realistic approach, and we had to make sure that the end result didn't look weird or creepy. When you look at the books, you just laugh and don't question the logic. You have a fun character that you simply want to hang out with, and I think we were able to pull that off with our CG version."

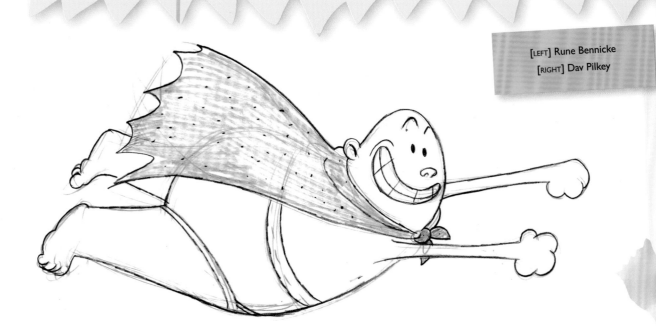

[LEFT] Rune Bennicke
[RIGHT] Dav Pilkey

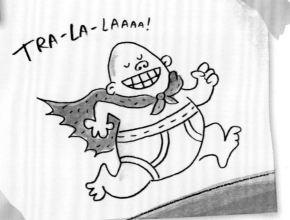

TRA-LA-LAAAA!

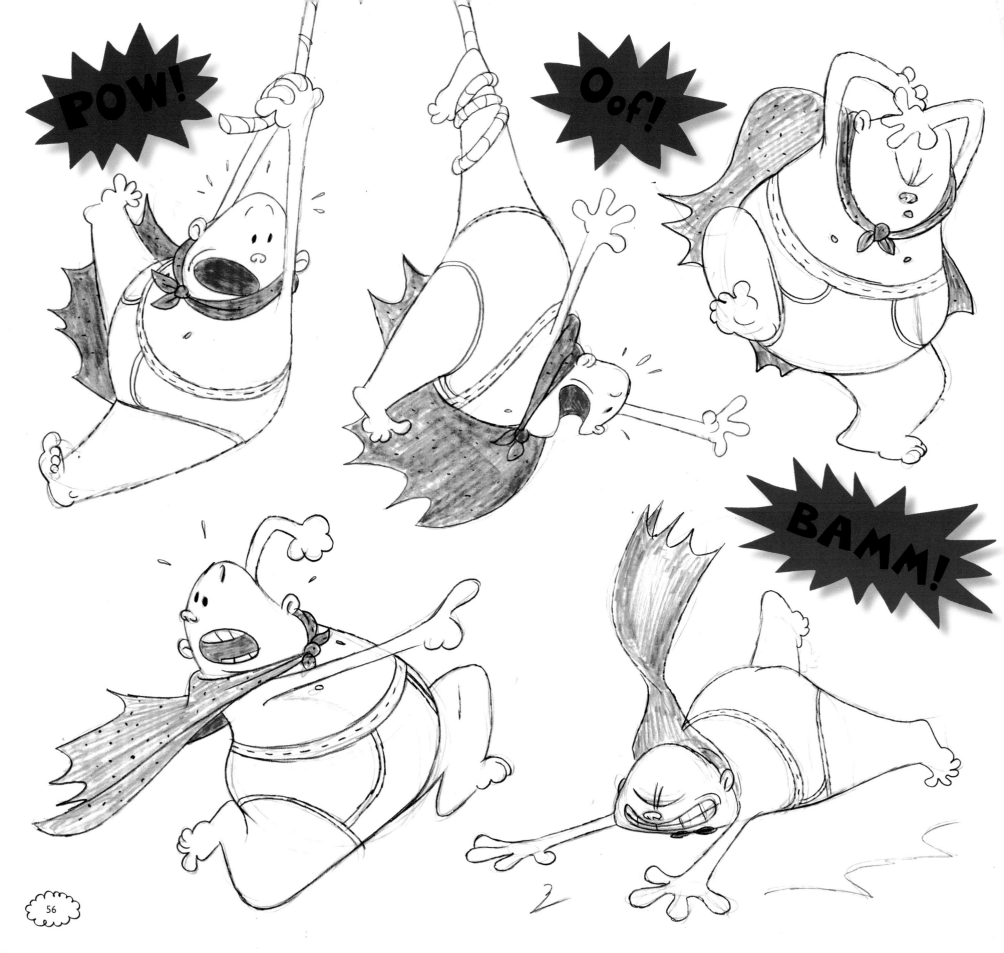

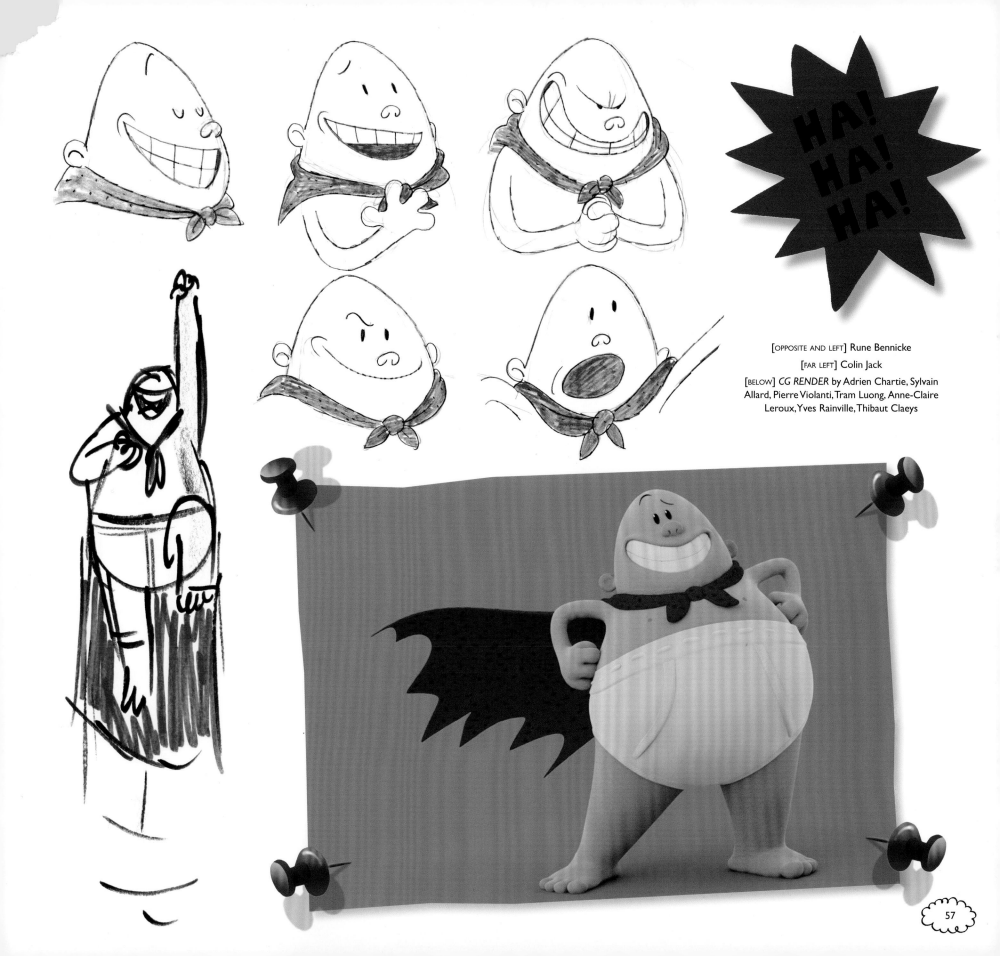

HA! HA! HA!

[OPPOSITE AND LEFT] Rune Bennicke

[FAR LEFT] Colin Jack

[BELOW] *CG RENDER* by Adrien Chartie, Sylvain Allard, Pierre Violanti, Tram Luong, Anne-Claire Leroux, Yves Rainville, Thibaut Claeys

Professor Poopypants

Every superhero needs a mad scientist to cause some havoc in his world, and in the twisted Underpants universe, it's the unfortunately named Professor Pippy Pee-Pee Poopypants from the country of New Swissland. Voiced by comedian Nick Kroll, the Professor despises anything that has to do with laughter because of an unfortunate event in his past: He was about to receive a Nobel Prize, but lost it because the committee changed their mind after they found out about his name and deemed it too ridiculous!

The mad genius inventor of a special shrinking and enlarging machine called the Sizerator provided the design team and the animators with the opportunity to have a lot of fun. "It was a perfect marriage between the unforgettable voice Nick Kroll

created, and Rune Bennicke's drawings and animation style," says director David Soren.

Poopypants is Bennicke's favorite character in the whole movie. "I think he is going to steal the show," he says. "Besides his funny name, he is such a classic cartoon character. You feel like you know this character—he looks a little bit like a mad scientist. He is a complete design dream: No eyes, that crazy hair. Of all the characters in the project, he is the one that you can really push. When he gets angry, smoke comes out of his ears. You can have fun with the wrinkles and the pinch lines when he gets upset. I had so much fun with Professor Poopypants."

[ABOVE] Dav Pilkey
[RIGHT] Rune Bennicke
[OPPOSITE] Rune Bennicke and Nate Wragg
[PAGES 60-61]
Christopher Zibach and Rune Bennicke

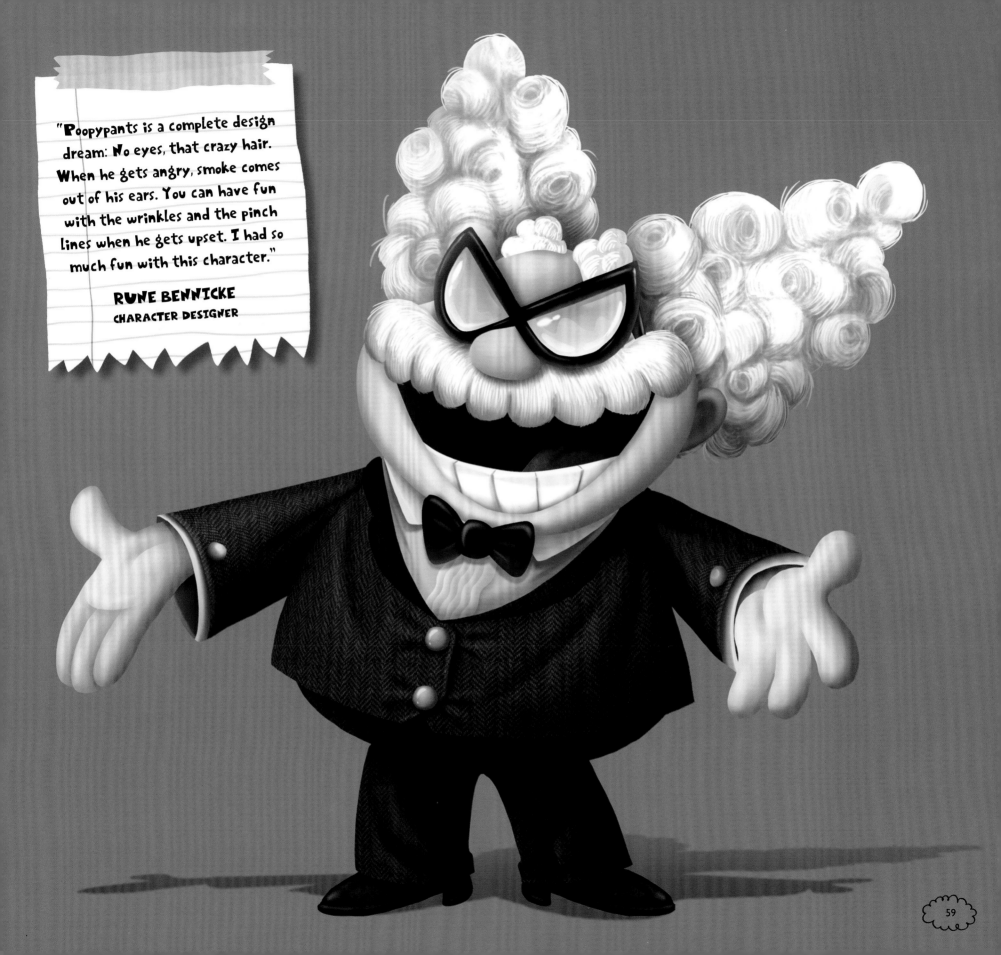

"Poopypants is a complete design dream: No eyes, that crazy hair. When he gets angry, smoke comes out of his ears. You can have fun with the wrinkles and the pinch lines when he gets upset. I had so much fun with this character."

RUNE BENNICKE
CHARACTER DESIGNER

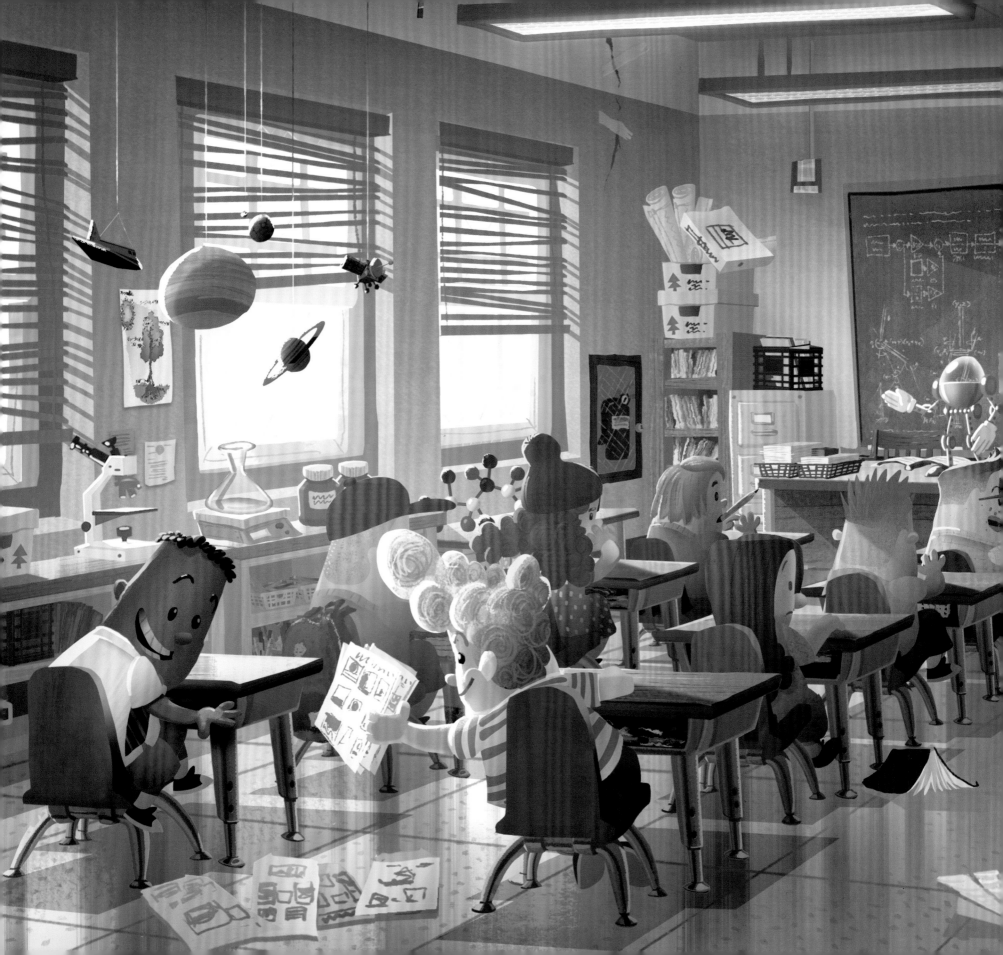

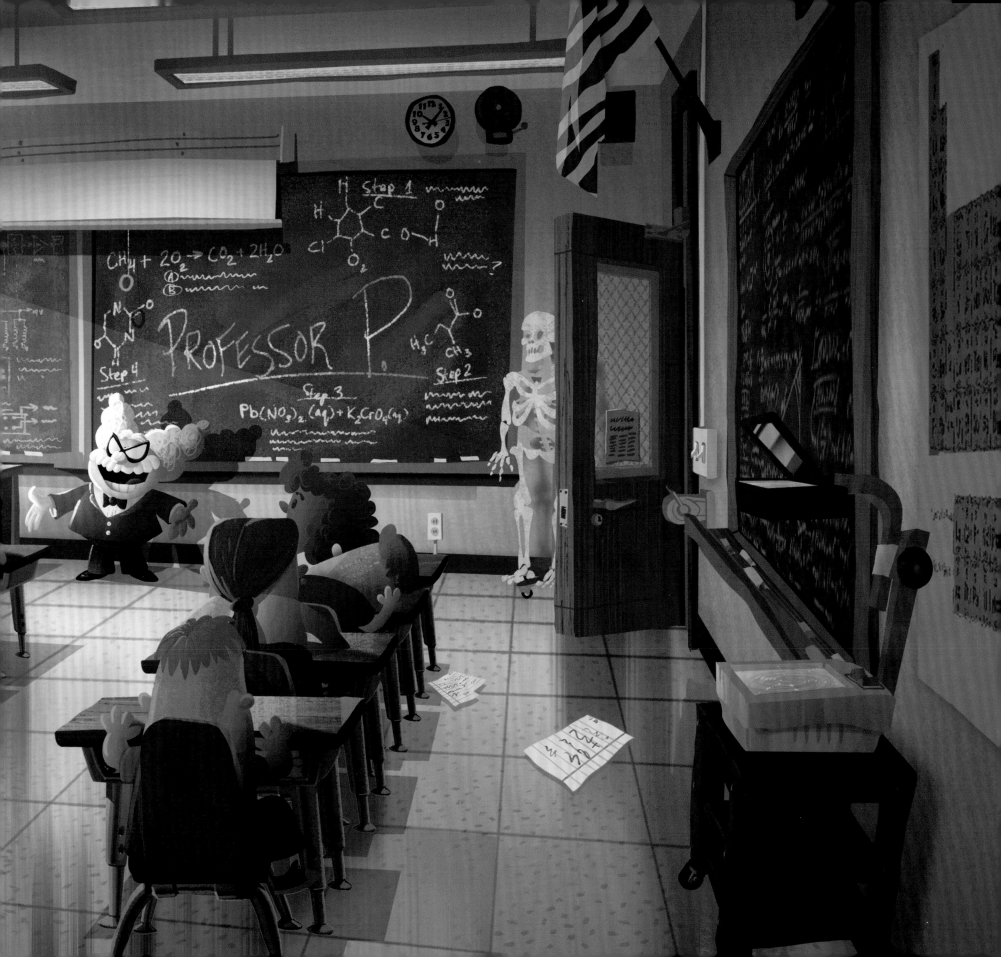

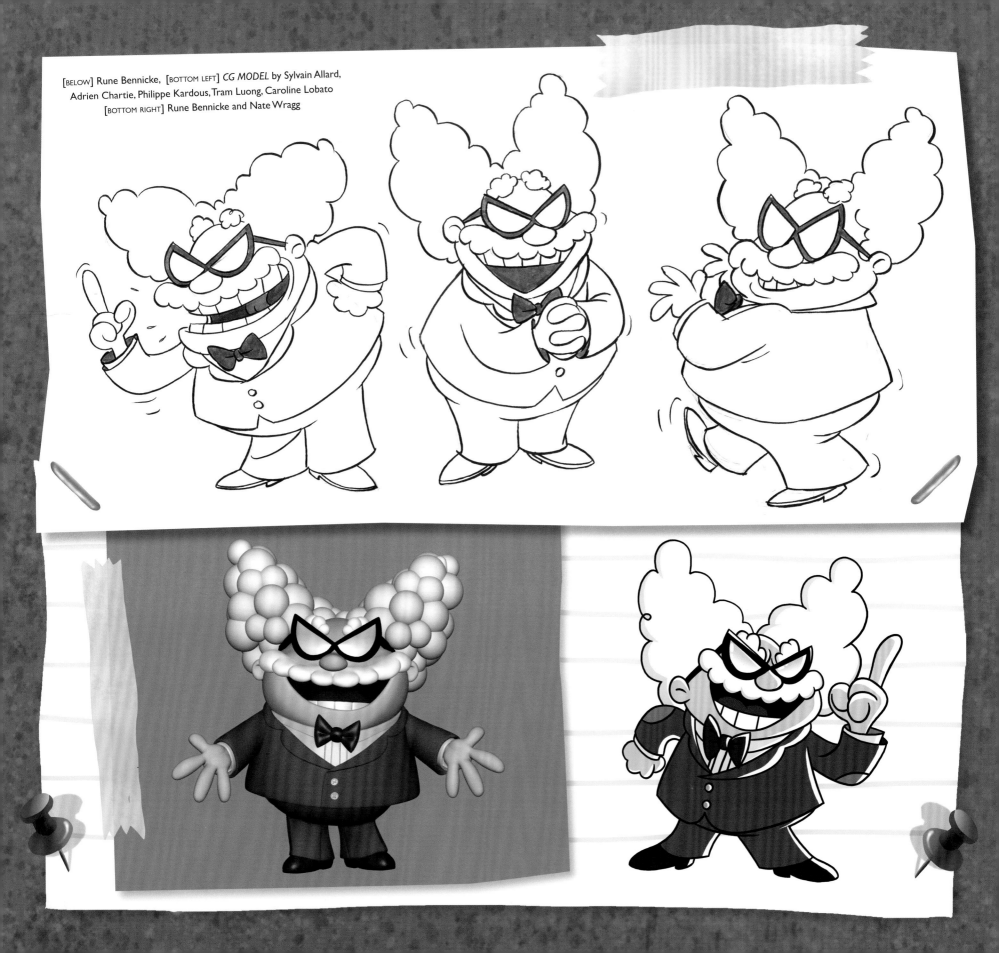

[BELOW] Rune Bennicke, [BOTTOM LEFT] *CG MODEL* by Sylvain Allard,
Adrien Chartie, Philippe Kardous, Tram Luong, Caroline Lobato
[BOTTOM RIGHT] Rune Bennicke and Nate Wragg

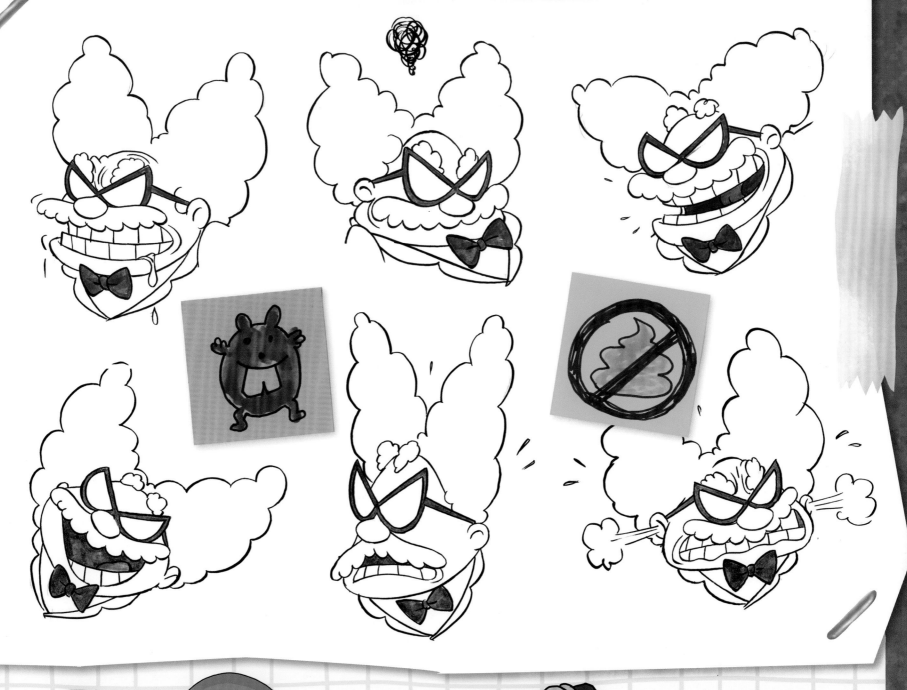

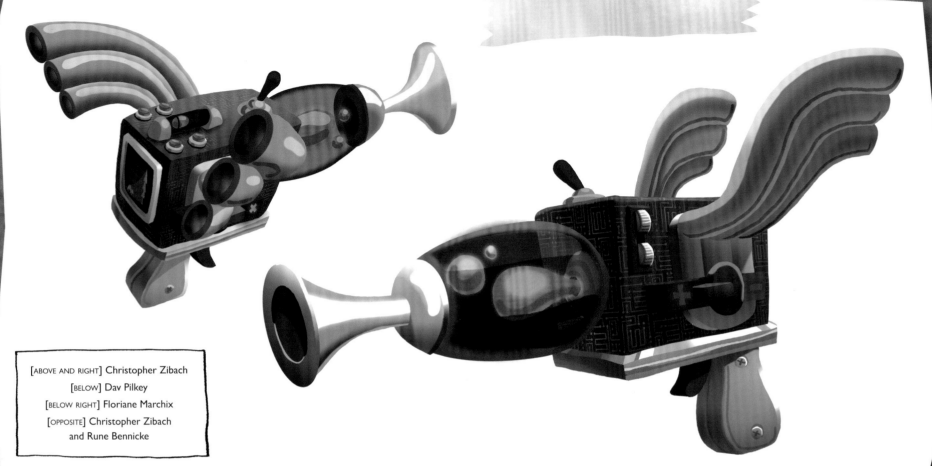

[ABOVE AND RIGHT] Christopher Zibach
[BELOW] Dav Pilkey
[BELOW RIGHT] Floriane Marchix
[OPPOSITE] Christopher Zibach
and Rune Bennicke

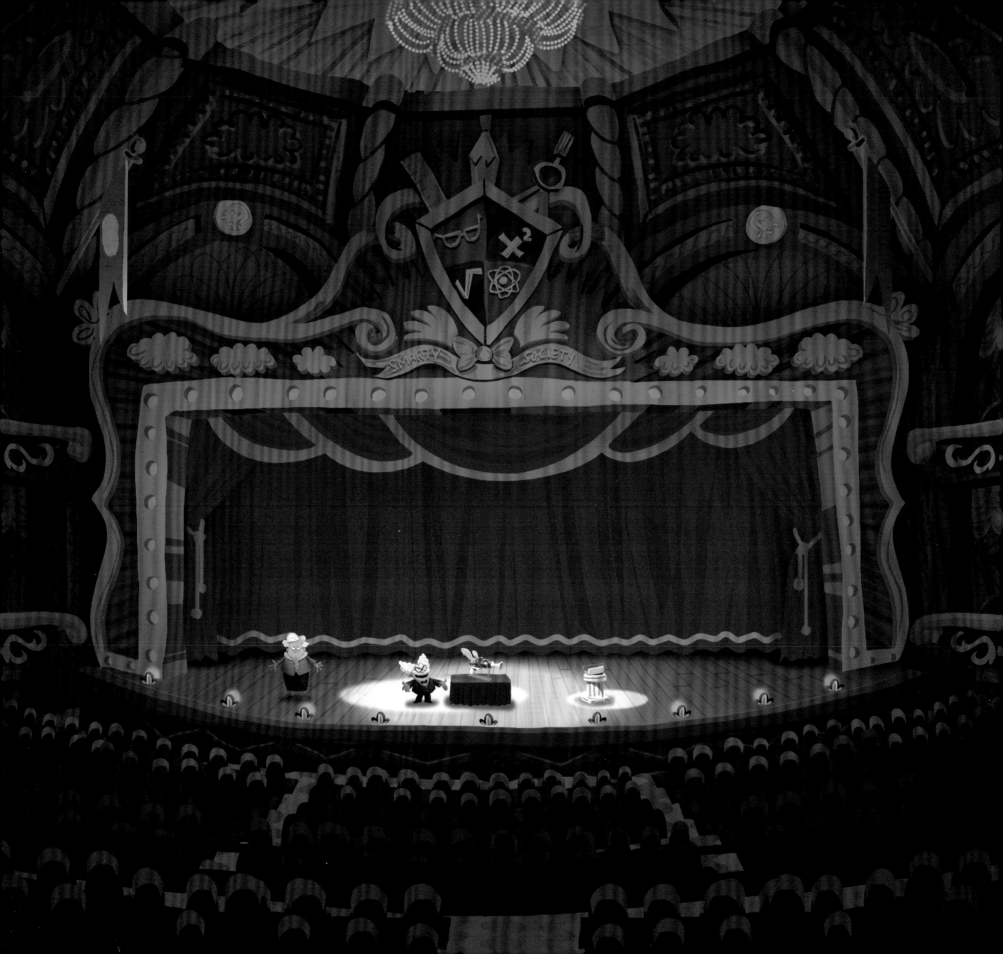

ZEE BLUEPRINT

12

64

18

28.

24

02

15

PATENT # _____ NAME

÷ ZEE OFFICIAL NEW SWISSLAND RESUME ÷

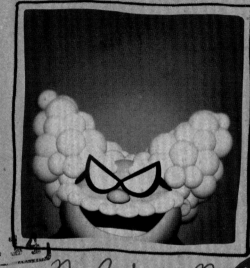

No. 3.14

Professor P

Full Name: Professor P.
DOB: April 1st, 1953
Citizenship: New Swissland
Gender : Male
Address: 3.14 Smarty Pants Blvd, Piqua OH 4535?
Phone : Don't have one
Email : Supergeniusdude220@newswissland.com

NEW SWISSLAND MAD SCIENTIST

Qualifications:

Genius, Super Smart, Intelligent, Über Smart
Wears Glasses, not great with children, Holds Grudges

Education :

• Head of Class at Chuncky Q. Boogernose University 1978

• Smartest Person in New Swissland 1953 - Present.

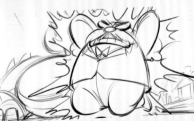
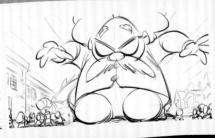

[BOTH OPPOSITE LEFT] Christopher Zibach, [OPPPOSITE BOTTOM RIGHT] STORYBOARDS by Gary Graham, [LEFT AND BELOW] Nate Wragg, [RIGHT AND MIDDLE] Christopher Zibach, [BOTTOM RIGHT] Rune Bennicke

÷ ZEE OFFICIAL NEW SWISSLAND RESUME ÷

Professional Experience:

- Master Inventor of super cool inventions like The Shrinky Pig 2000

- Über smart creator of the Goosy-Grow 4000

- Entrepreneur of the Gerbil Jogger 2000

- Maitré D at New Swisslands famed House of Stinky Salads

References :

- President of New Swissland Chuckles Jingleberry McMonkeyburger Jr.

- Super Smart Ivana Goda de' Bafroom

- Mastermind Jiggles T. Chunkyskunks

- Brainiac Tipper Q. Zipperdripper

Awards Recieved:

- New Swissland Baby Genius Convention 1954

- New Swissland Prize for Inventing Stuff 1955 - Presen

No. 3.14 *Professor P*

Our teachers don't use Deodorant

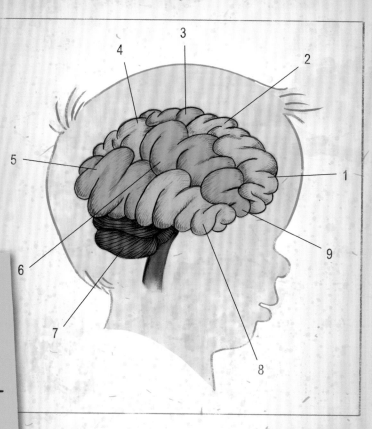

BRAIN OF ZEE AVERAGE CHILD

7

MAJOR PARTS OF ZEE BRAIN

1.) Thinkingaboutcandyopalus
2.) Fearofwhatsunderthebed Lobe
3.) Iwanttohitthings Anterior Lobe
4.) Rollonthefloortantrum Lobe
5.) Spituitary Gland
6.) Paininzeebutt Cortex
7.) Hahaguffawchuckleleamalus
8.) Theonlythingilleatispizzachicken-nuggetsorbottlednoodles Lobe
9.) Youhavethattoynowiwantthattoy cortex

ADDITIONAL NOTES

One may observe the brain safely through the nasal access port. It is said we only use 10% of our brains. Zee average child uses 12% and it baffles science to this day.

Product of New Swissland

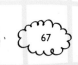

Melvin Sneedly

You can't have a school without an annoying nerd, and Melvin Sneedly (voiced by Jordan Peele) is the thorn in George and Harold's side. A brainiac, super snitch and lover of Principal Krupp's mandatory Saturday science fair, Melvin becomes Professor Poopypants' sidekick thanks in part to his complete lack of a sense of humor. "Poopypants discovers that Melvin has no *Huffaguffawchuckleamulus*, the part of the brain that understands jokes and humor!" notes Soren. "Melvin goes from being an annoying tattletale, to the missing link in Poopypants' evil plan to rid the world of humor once and for all."

[RIGHT] Nate Wragg, [FAR RIGHT] Perry Dixon Maple, [BELOW] Dav Pilkey
[BELOW RIGHT] Rune Bennicke

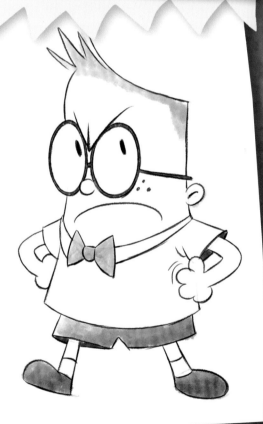

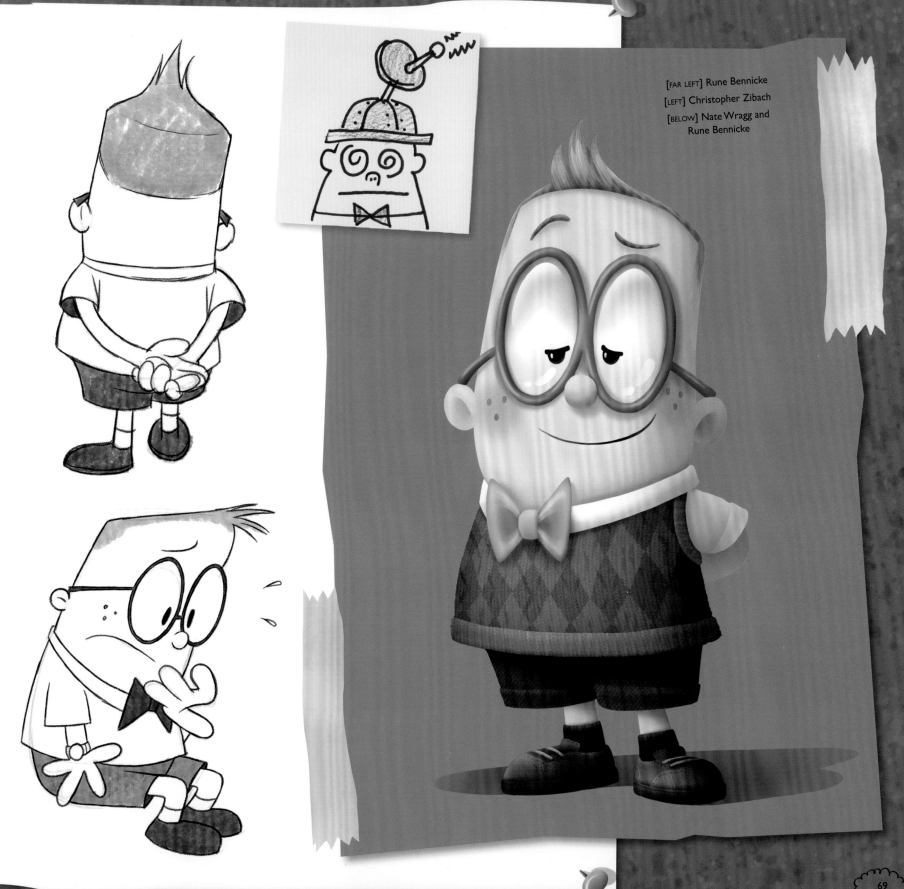

[FAR LEFT] Rune Bennicke
[LEFT] Christopher Zibach
[BELOW] Nate Wragg and Rune Bennicke

69

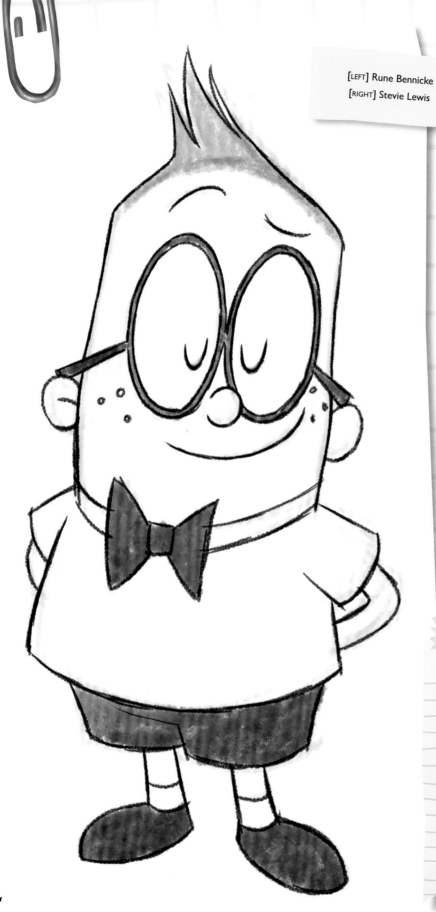

"Melvin goes from being an annoying tattletale to the missing link in Poopypants' evil plan to rid the world of humor once and for all."

DAVID SOREN
DIRECTOR

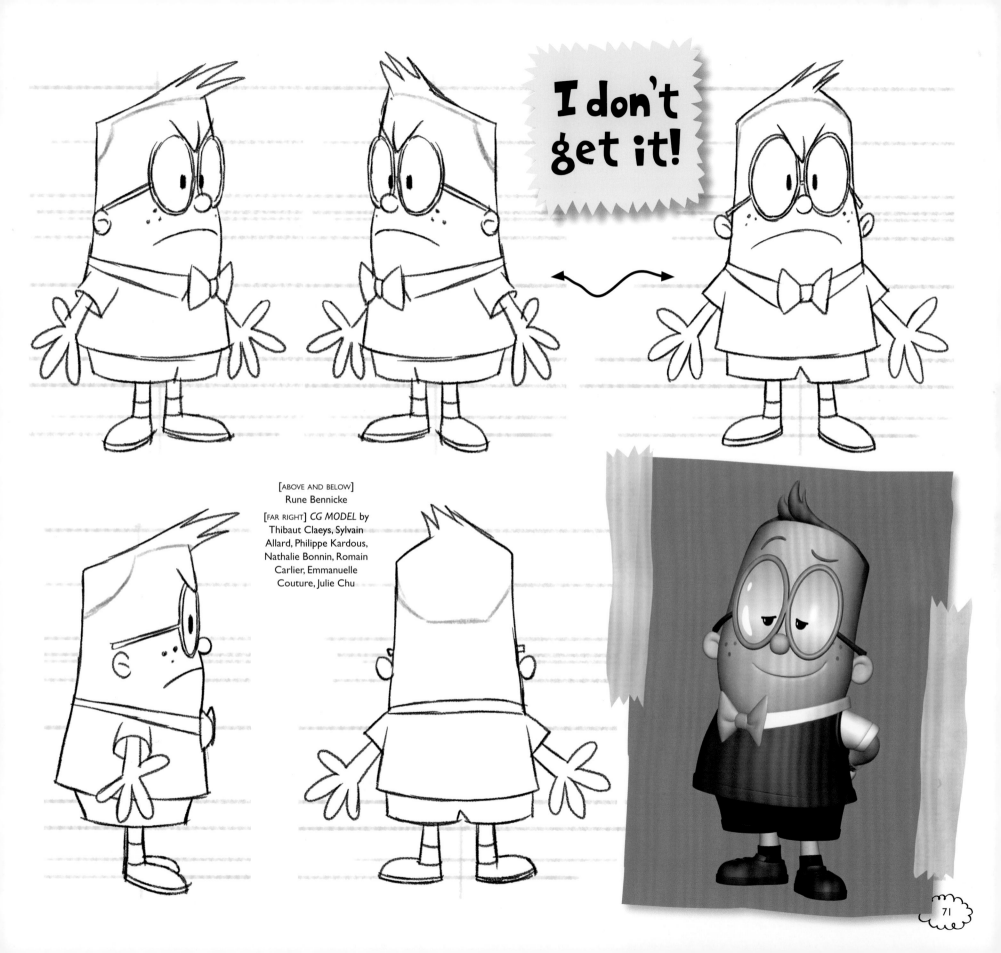

I don't get it!

[ABOVE AND BELOW]
Rune Bennicke

[FAR RIGHT] *CG MODEL* by
Thibaut Claeys, Sylvain
Allard, Philippe Kardous,
Nathalie Bonnin, Romain
Carlier, Emmanuelle
Couture, Julie Chu

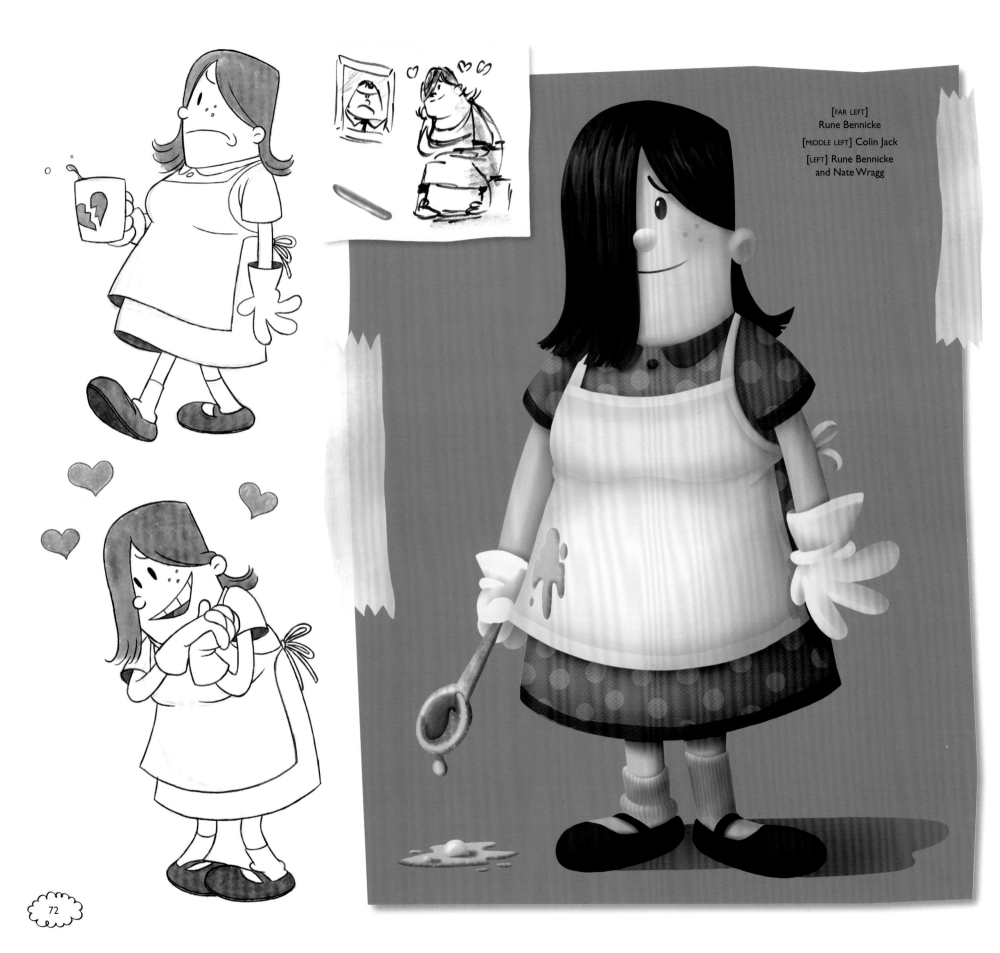

[FAR LEFT]
Rune Bennicke

[MIDDLE LEFT] Colin Jack

[LEFT] Rune Bennicke
and Nate Wragg

Edith, the school's lunch lady

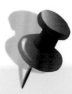

Edith, the school's lunch lady, is the only new character created especially for the *Captain Underpants* movie. She's a wallflower. Her messy hair covering one of her blue eyes. Voiced brilliantly by Kristen Schaal, Edith is Principal Krupp's hidden love interest. "They are painfully awkward," says director David Soren. "They clearly like each other, but their wires have been crossing for a long time. They try to get together, but neither has the social skills to make it work."

In the earlier versions of the movie, she was more of an annoyance to Krupp, but it soon became clear that it would be more fun to have Edith and Krupp share a weird, unresolved affection for each other. "They are the perfect match for each other," explains Soren. "As socially inept as they are, we can't help but root for them to get together."

Once George and Harold see how lonely Mr. Krupp's life is, they decide to pull their first ever "prank for good" and help bring the two very strange lovebirds together.

As the film's producer Mireille Soria points out, due to Edith's social awkwardness her charms are somewhat hidden. This presented a challenge since the film's artists needed to create a new character design that fit perfectly in Pilkey's quirky universe, while at the same time highlighting her likability underneath her misfit exterior.

"If you are not familiar with the books, you'll have no idea that Rune, our character designer, invented this character from scratch. She really reflects the author's sensibilities and is the perfect love interest for Krupp. I think the audience will be rooting for these characters to end up together—despite the fact that Krupp is the boys' nemesis, and Edith—well, she is so painfully shy!"

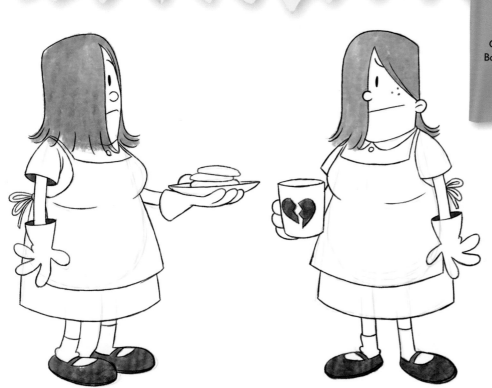

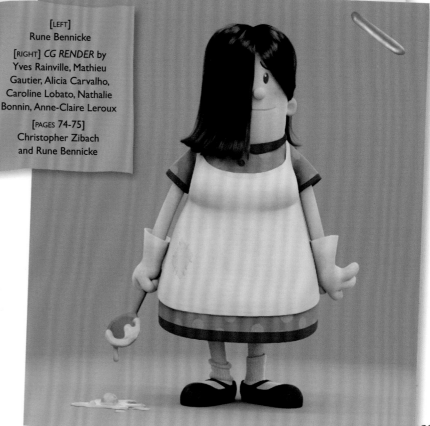

[LEFT]
Rune Bennicke

[RIGHT] *CG RENDER* by Yves Rainville, Mathieu Gautier, Alicia Carvalho, Caroline Lobato, Nathalie Bonnin, Anne-Claire Leroux

[PAGES 74-75]
Christopher Zibach and Rune Bennicke

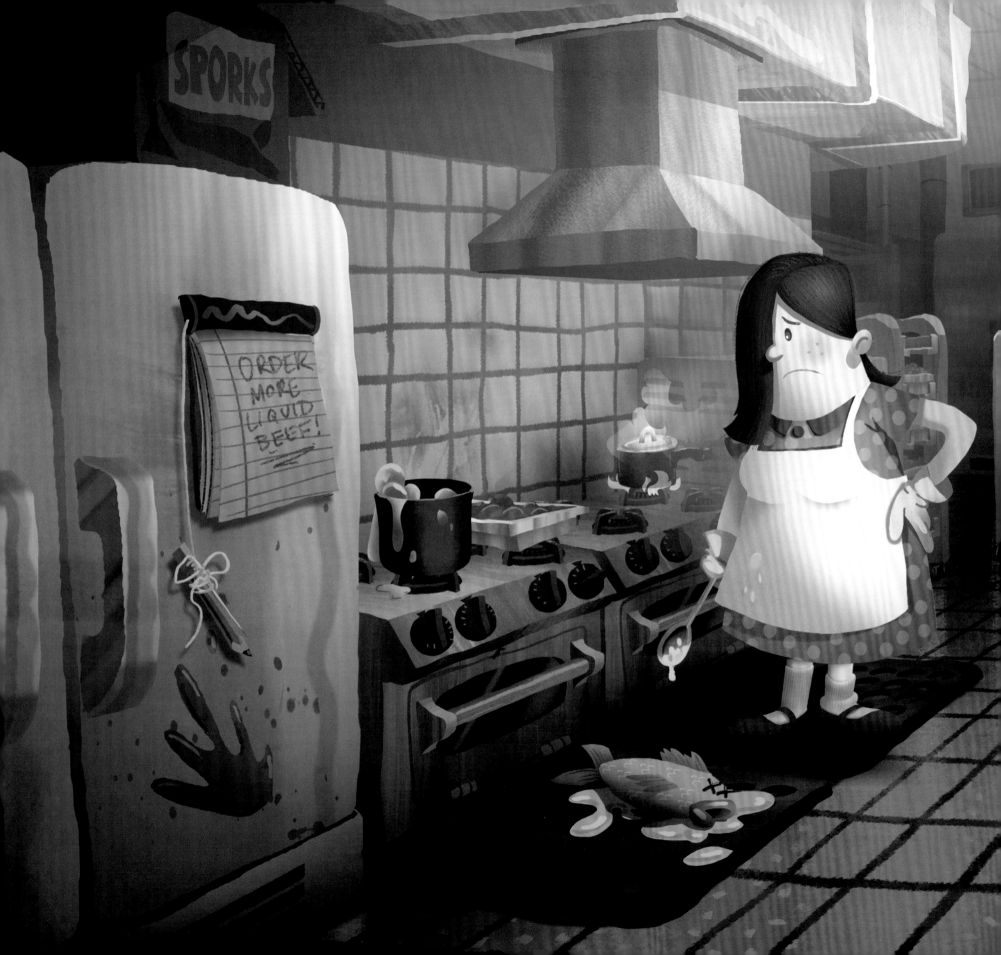

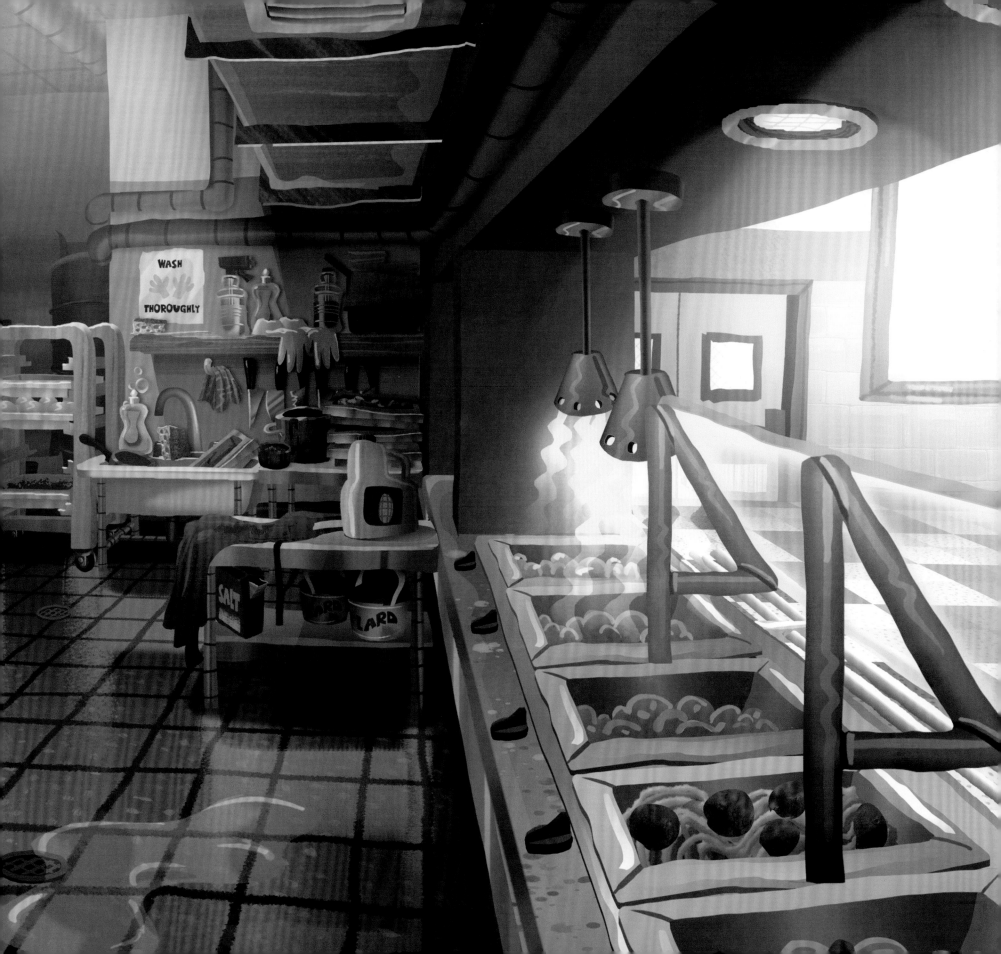

The Teachers

There are lots of wacky brow-beaten teachers at Jerome Horwitz Elementary School, who may not get a lot of screen time in the movie, but they do make memorable cameos. In Pilkey's world, they all have hilarious names. How can you not laugh out loud when you hear names such as Ms. Tara Ribble, Mr. Meaner, Miss Edith Anthrope, Mr. Morty Fyde, Mr. Rected, Miss Fitt, Ms. Guided?

"Even though Principal Krupp is the worst of the worst," director David Soren says, "the rest of the teachers aren't far behind in terms of their general uninspired approach to teaching. None would win teacher of the year. And they all deserve a good old pranking!"

The drawings of the teachers in the books also provided the design team with a wealth of inspiration for the movie. "We used the teachers as the model for a lot of our background characters and townspeople," notes production designer Nate Wragg. "Our generic characters are based on those designs. That's how we managed to include them in the movie without having them as bigger characters. So when we needed a random guy walking down the street, we used Pilkey's illustrations. We were able to mix and match all of these familiar shapes that are constant in the books. There's also a sequence that is a montage of all of George and Harold's many pranks…and we made sure the school librarian Ms. Singerbrains was included. She is on screen for no more than two seconds, but it was important for us to include her in the movie even if it was for a brief moment or two!"

[ABOVE] Dav Pilkey, [RIGHT] Christopher Zibach

[FAR RIGHT AND OPPOSITE] Rune Bennicke

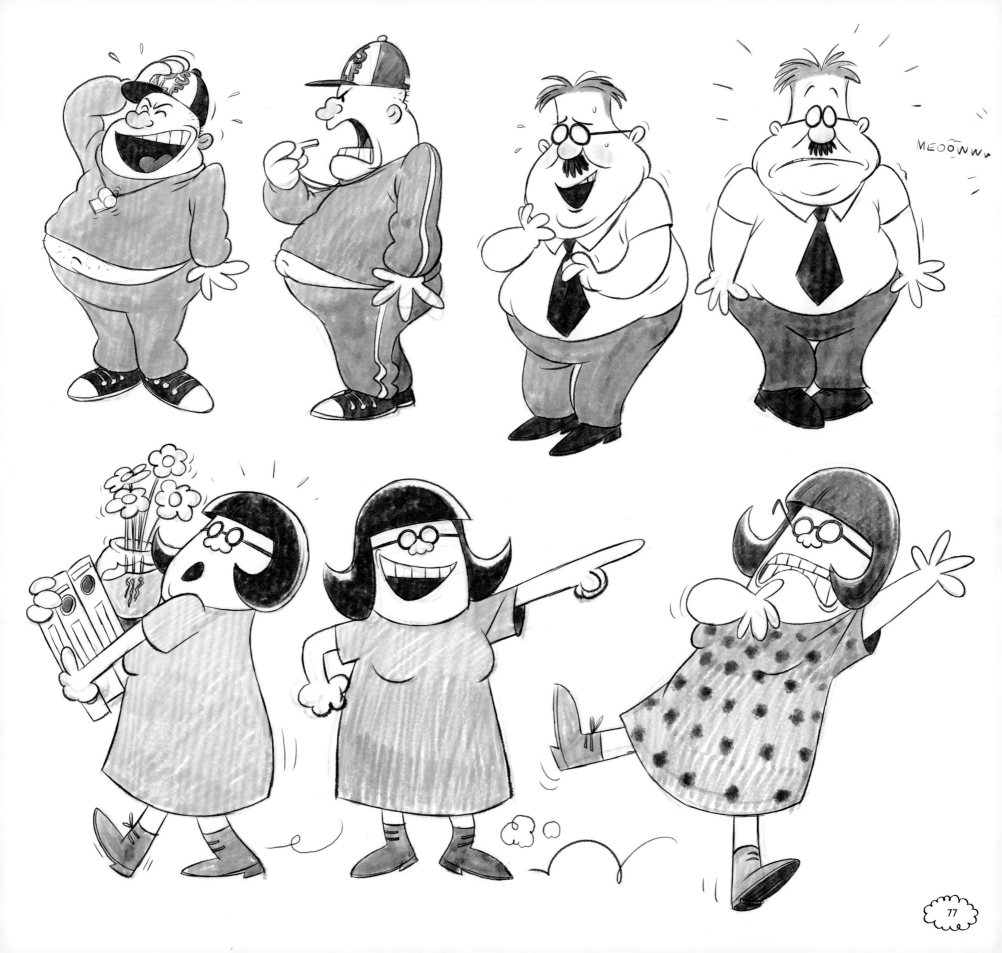

MEOÓWWr

77

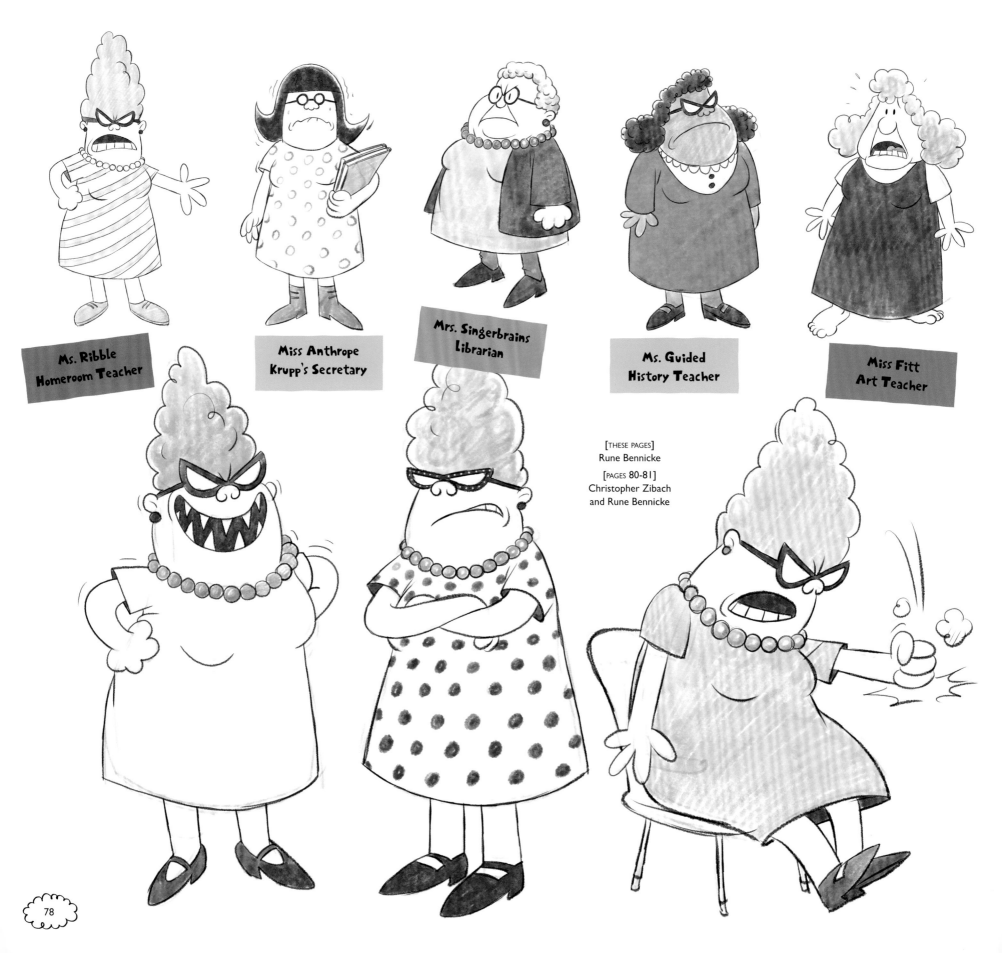

Ms. Ribble
Homeroom Teacher

Miss Anthrope
Krupp's Secretary

Mrs. Singerbrains
Librarian

Ms. Guided
History Teacher

Miss Fitt
Art Teacher

[THESE PAGES]
Rune Bennicke

[PAGES 80-81]
Christopher Zibach
and Rune Bennicke

78

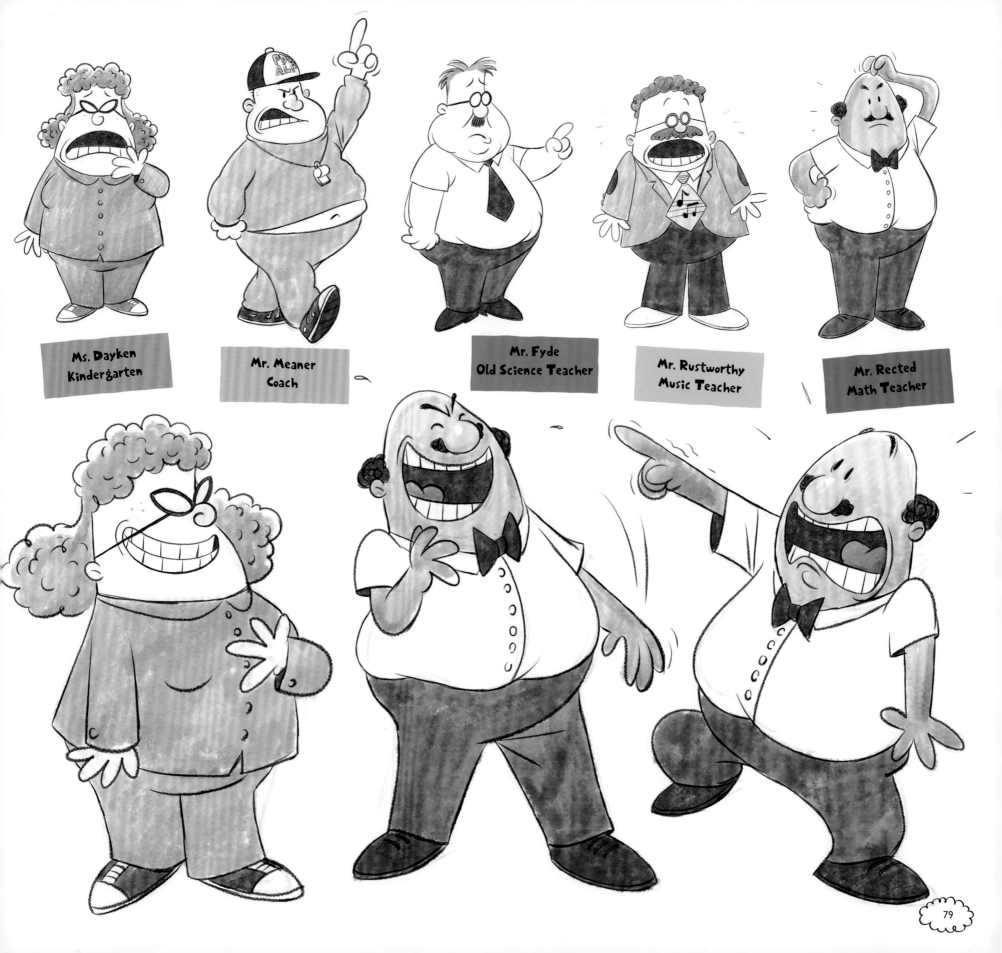

Ms. Dayken
Kindergarten

Mr. Meaner
Coach

Mr. Fyde
Old Science Teacher

Mr. Rustworthy
Music Teacher

Mr. Rected
Math Teacher

79

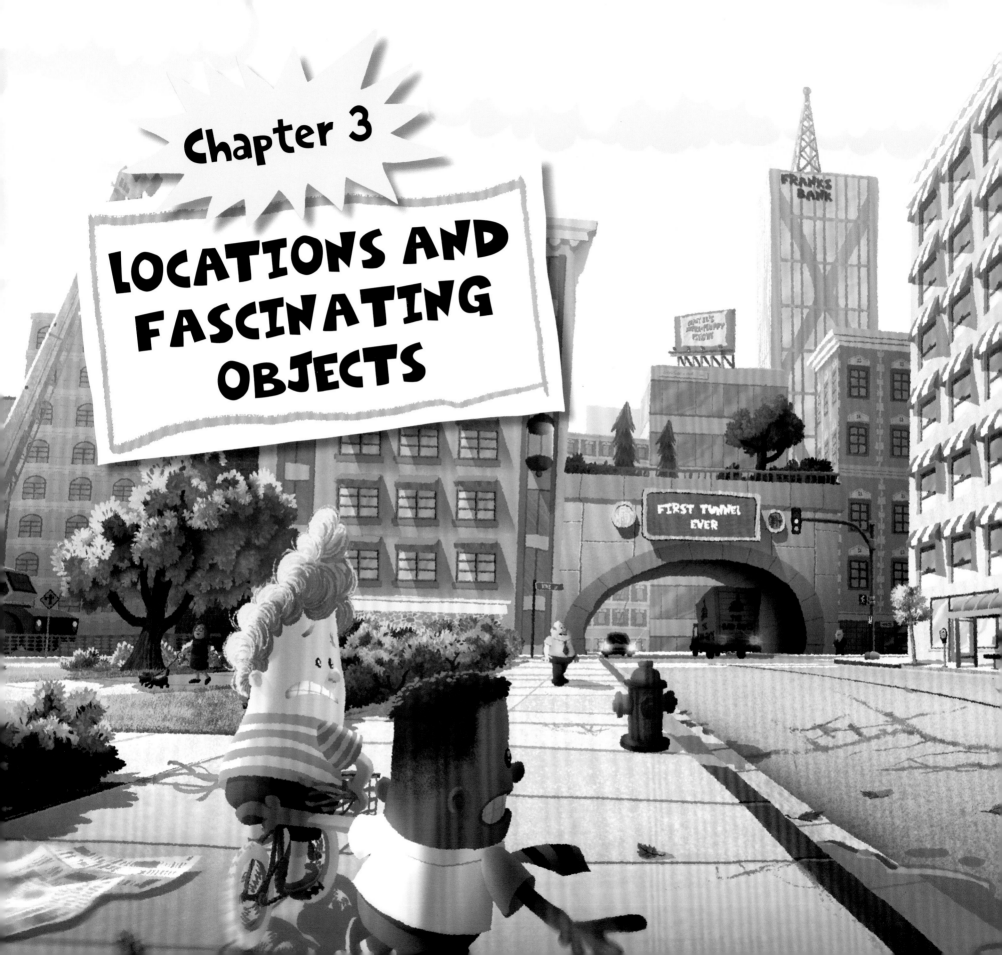

Chapter 3

LOCATIONS AND FASCINATING OBJECTS

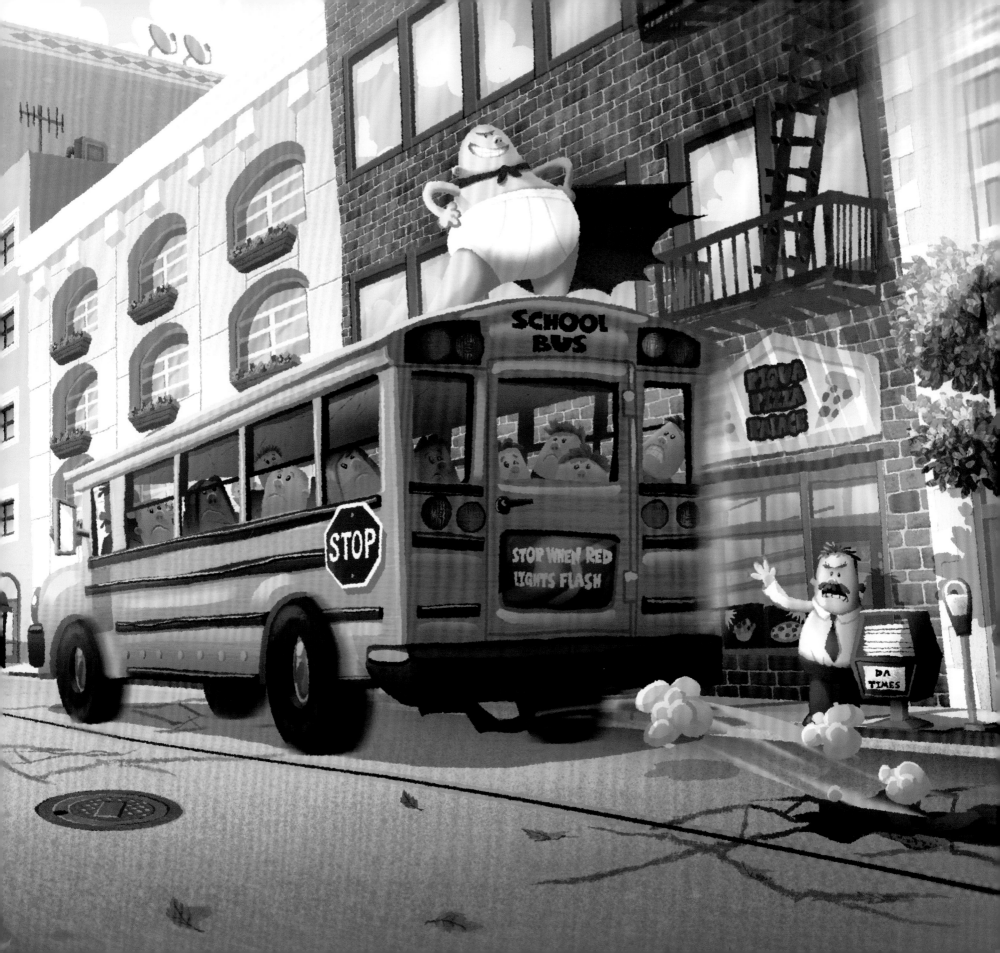

Jerome Horwitz Elementary

Just like the books, most of the movie takes place in the dreadfully bland Jerome Horwitz Elementary School.

The big challenge was to create an uninspired, boring school that wasn't uninspired and boring to watch as well. It had to be entertaining. As production designer Nate Wragg explains, "In the books, the school is drawn as a giant shoebox. When we started to think about the architecture of the school, it quickly became too detailed and complicated in our early design passes. It lost the simple charm and silliness of the books and became more realistic. So we thought, this is basically a prison for children, so we should just make it look like a Russian prison!"

Wragg and his team designed a giant brick shoebox with dead grass, cracked sidewalks, metal fence, no trees, and heavy metal frames in the windows to feel like bars. "That was it," he says. "Find the simple idea that supports the story, don't overcomplicate things and just go with it."

As visual development artist Christopher Zibach points out, "The school had to provide the complete opposite space of the boys' tree house, which is warm and creative. So the school is very utilitarian, almost like a penitentiary. It's all very solid and Midwestern—because kids are going to make a mess out of it, and it has to survive decades!"

[RIGHT] Dav Pilkey
[BELOW] Nate Wragg
[OPPOSITE]
Perry Dixon Maple
and Rune Bennicke
[PAGES 84-85]
Christopher Zibach
and Rune Bennicke

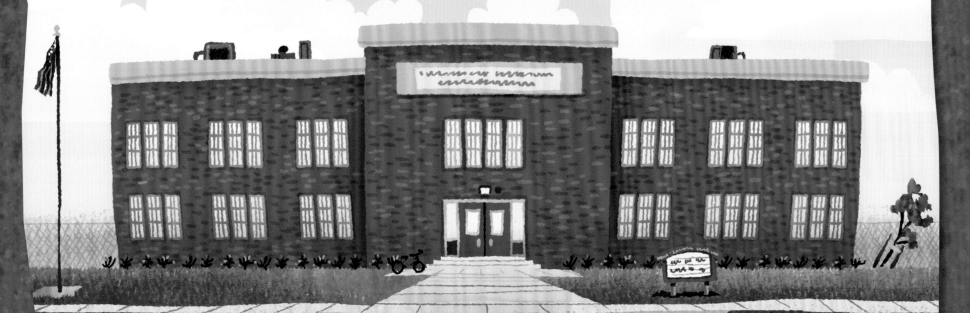

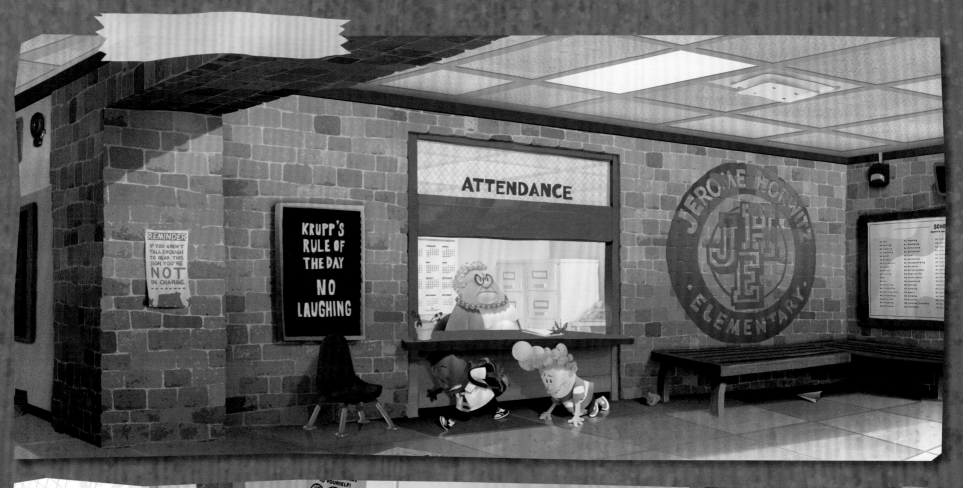

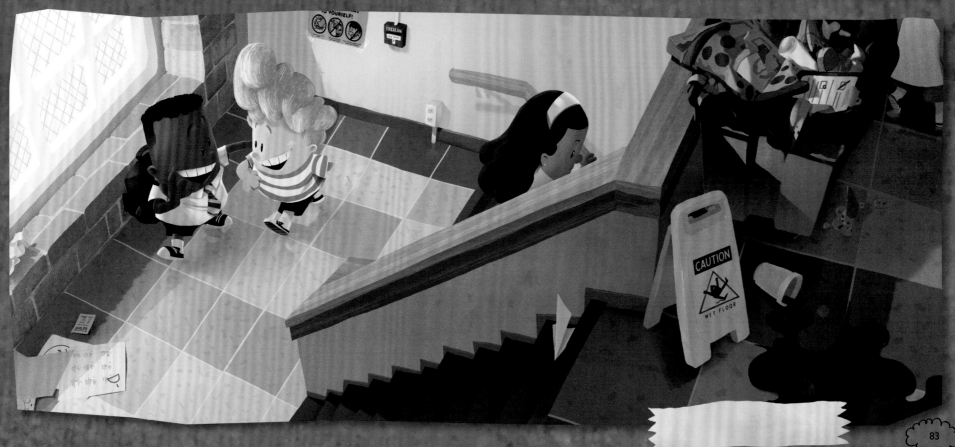

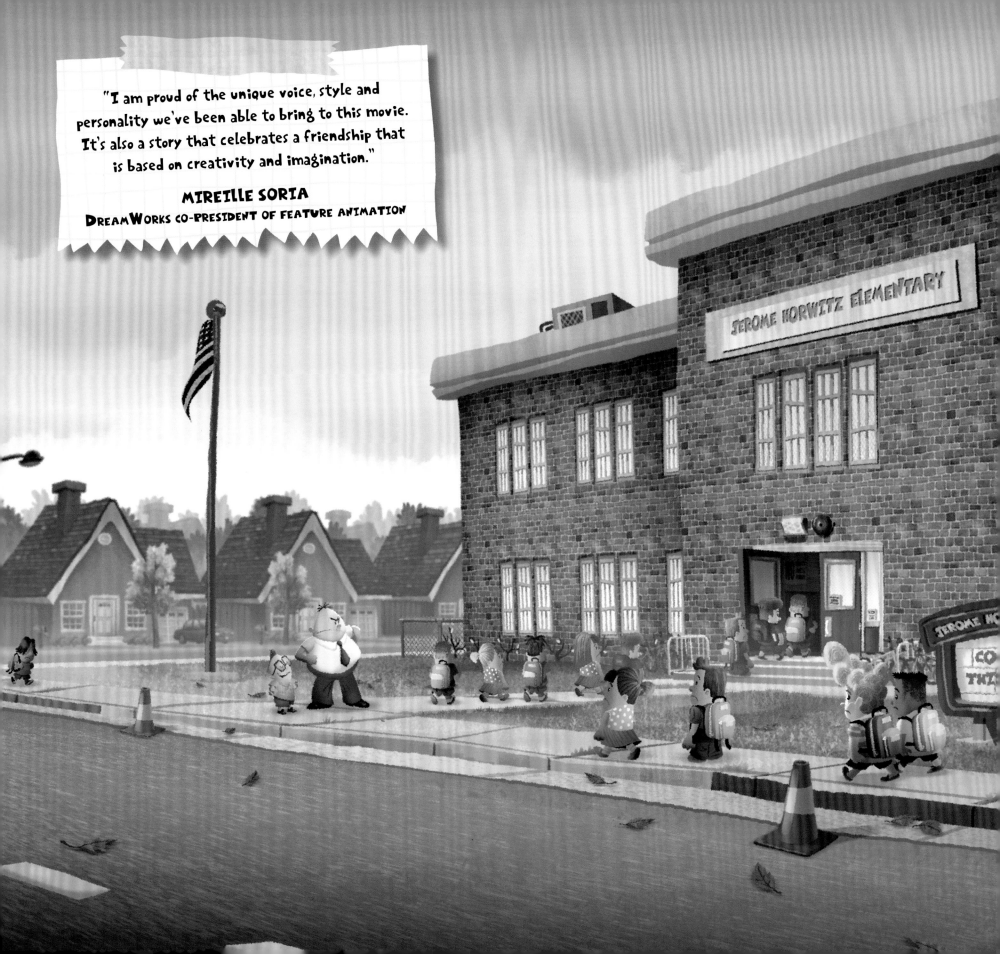

"I am proud of the unique voice, style and personality we've been able to bring to this movie. It's also a story that celebrates a friendship that is based on creativity and imagination."

MIREILLE SORIA
DREAMWORKS CO-PRESIDENT OF FEATURE ANIMATION

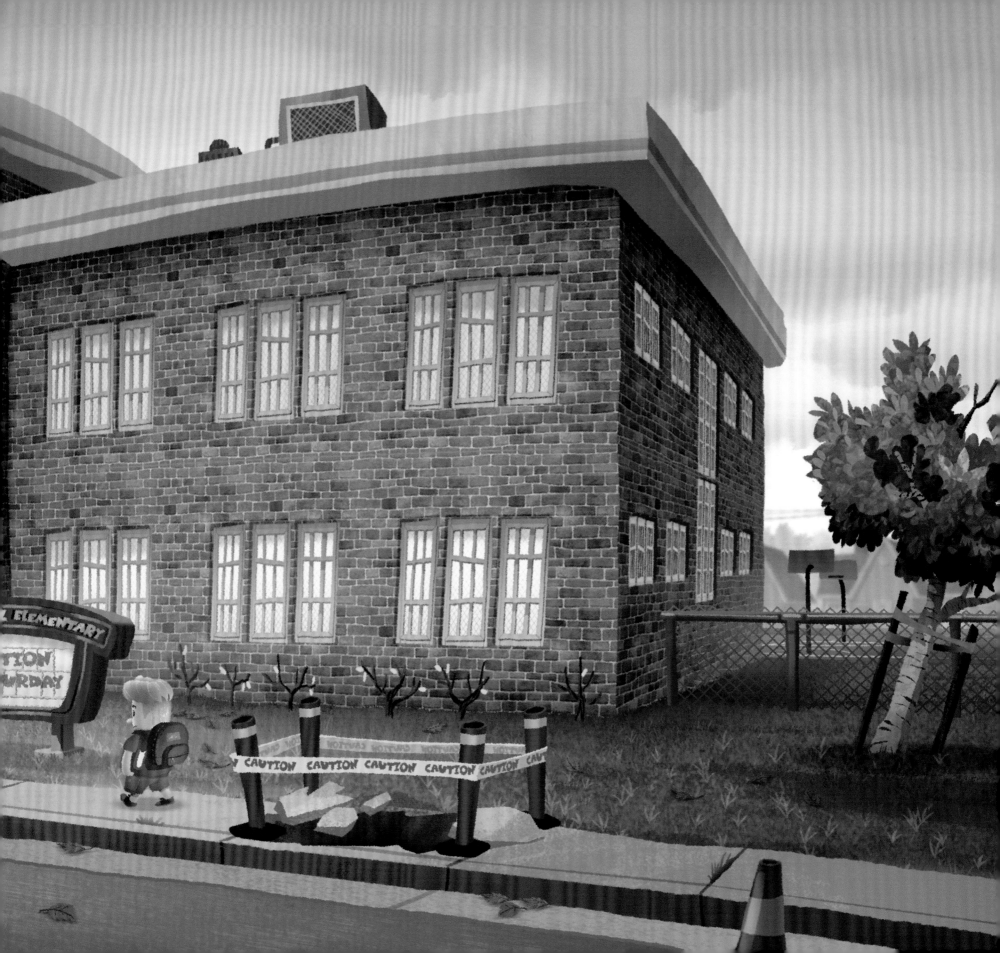

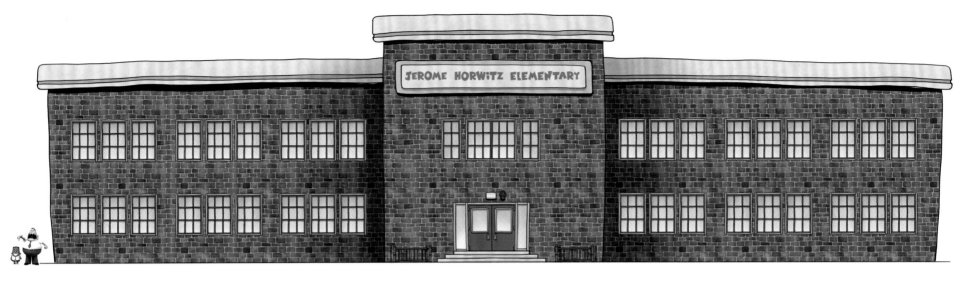

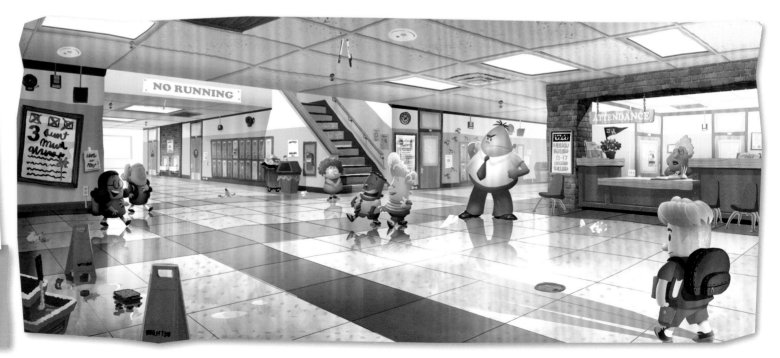

[TOP] Nate Wragg

[ABOVE AND ABOVE MIDDLE]
Perry Dixon Maple

[RIGHT] Christopher Zibach
and Rune Bennicke

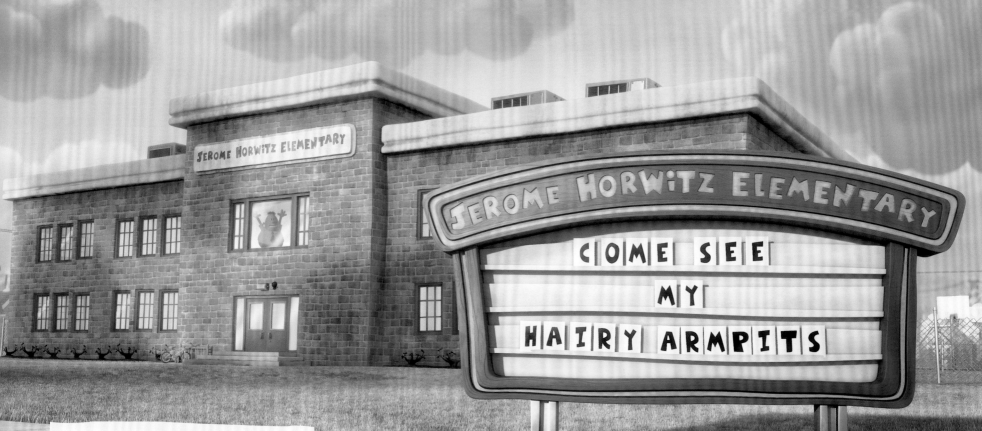

[TOP] *LIGHTING* by Matthieu Rouxel

[ABOVE MIDDLE] Dav Pilkey

[ABOVE] *CG RENDER* by Sébastien Monnier and Sarah Mesmacre

[RIGHT] Nate Wragg

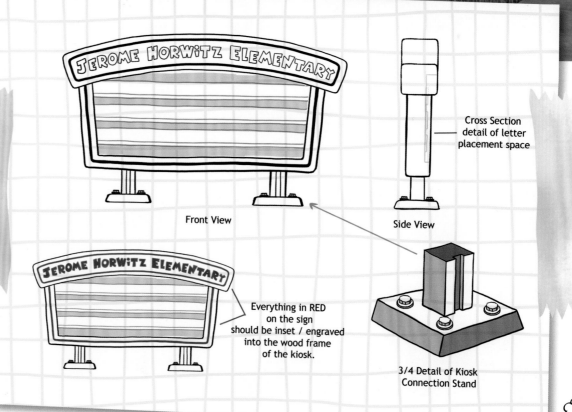

Cross Section detail of letter placement space

Front View

Side View

Everything in RED on the sign should be inset / engraved into the wood frame of the kiosk.

3/4 Detail of Kiosk Connection Stand

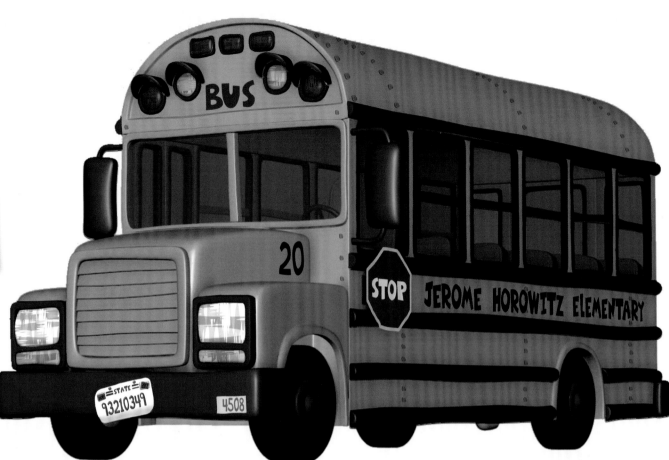

[ABOVE] Dav Pilkey
[RIGHT AND BELOW] Maxime Dauphinais
[FAR RIGHT] Christopher Zibach
[OPPOSITE] *STORYBOARDS* by Gary Graham

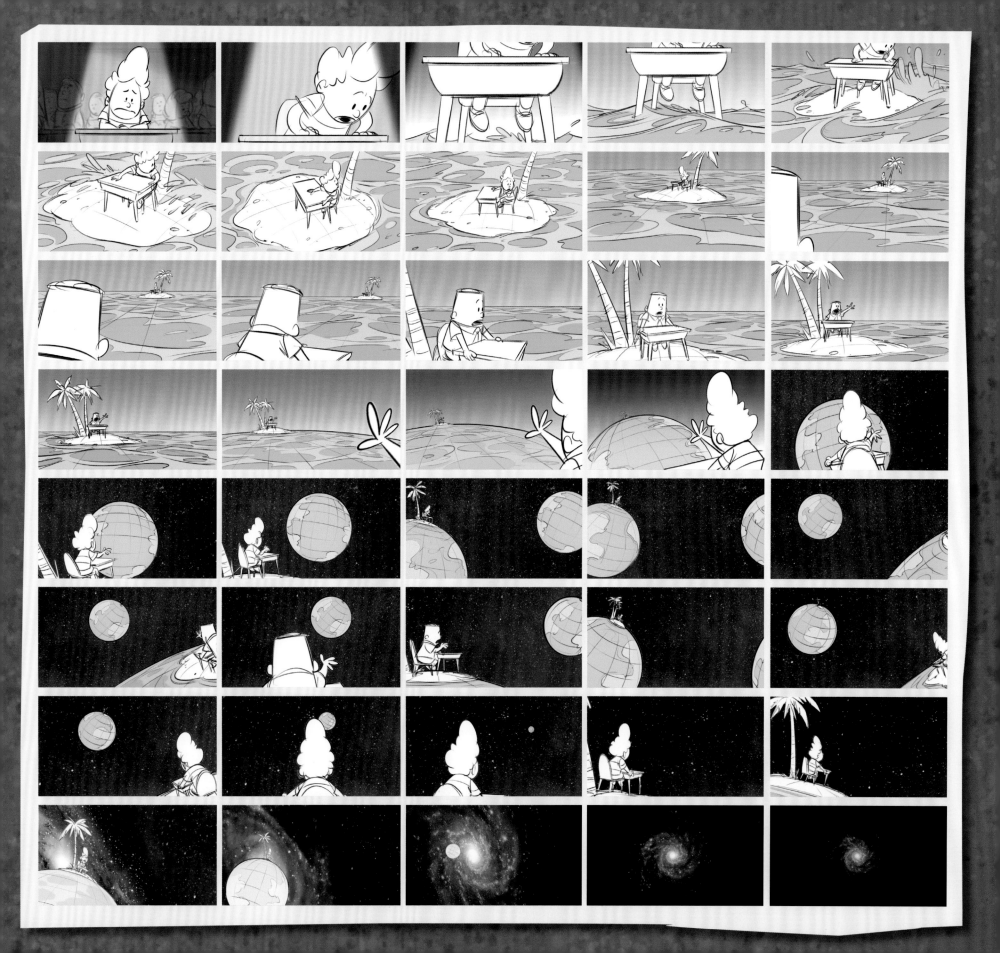

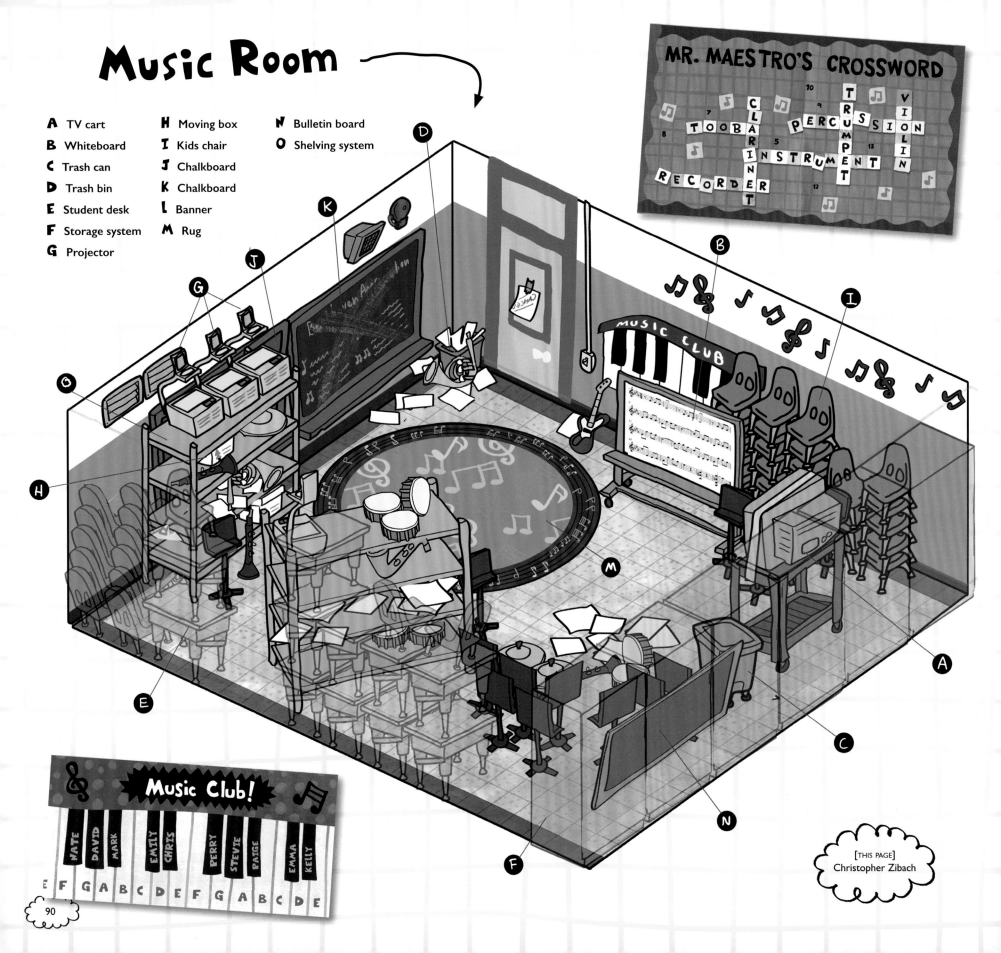

Music Room

A TV cart
B Whiteboard
C Trash can
D Trash bin
E Student desk
F Storage system
G Projector

H Moving box
I Kids chair
J Chalkboard
K Chalkboard
L Banner
M Rug

N Bulletin board
O Shelving system

MR. MAESTRO'S CROSSWORD

Music Club!

NATE DAVID MARK EMILY CHRIS PERRY STEVIE PAIGE EMMA KELLY

E F G A B C D E F G A B C D E

90

[THIS PAGE]
Christopher Zibach

Kindergarten Room

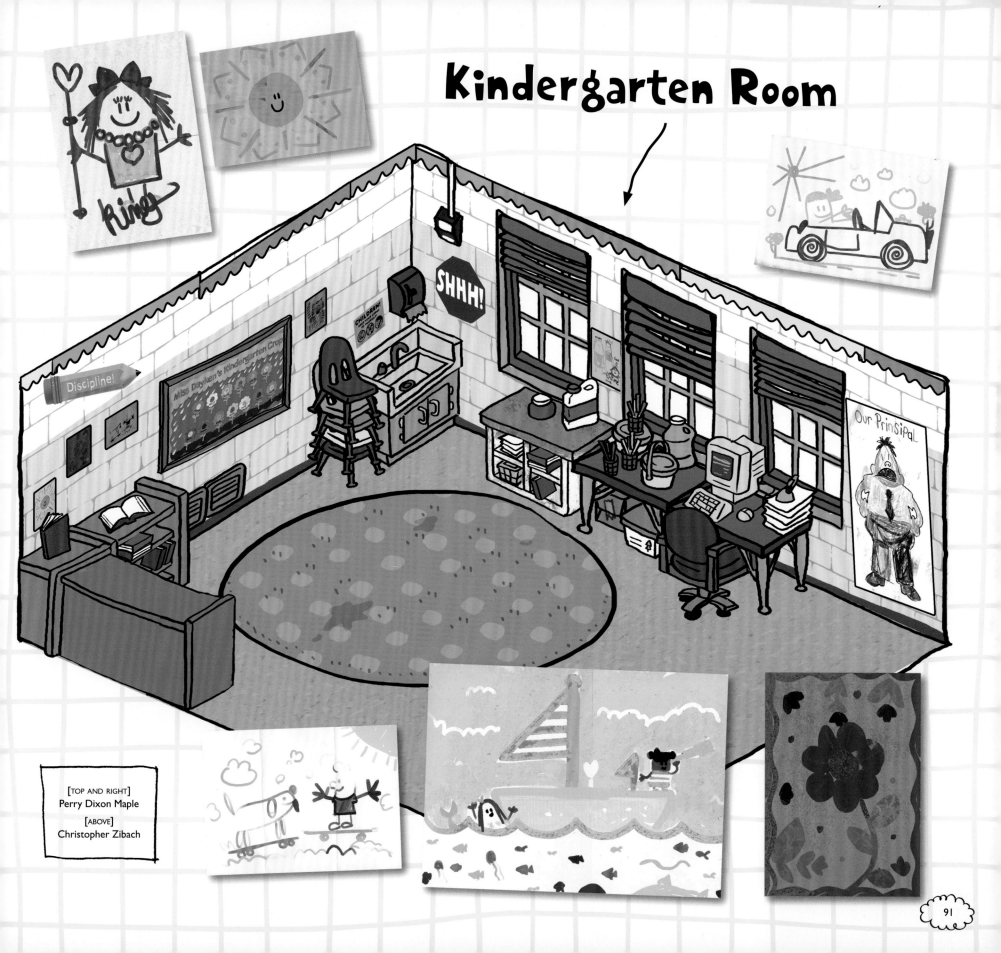

[TOP AND RIGHT]
Perry Dixon Maple
[ABOVE]
Christopher Zibach

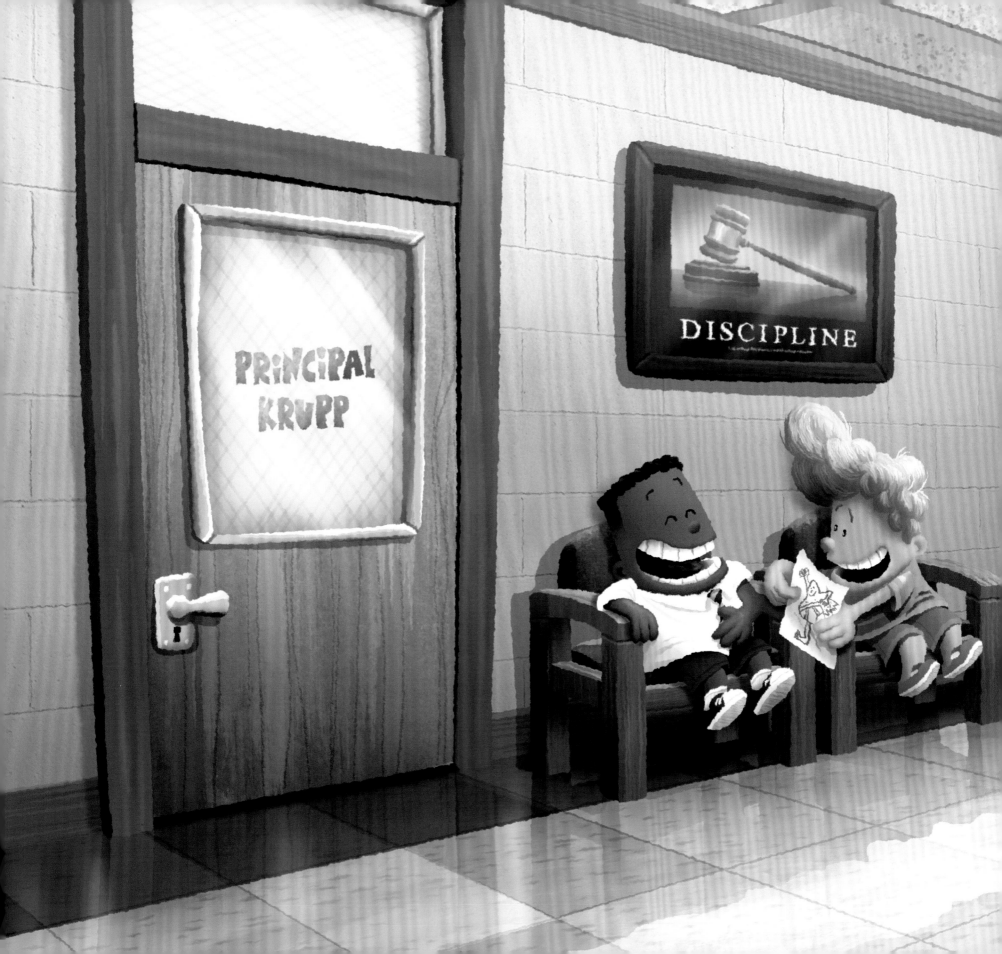

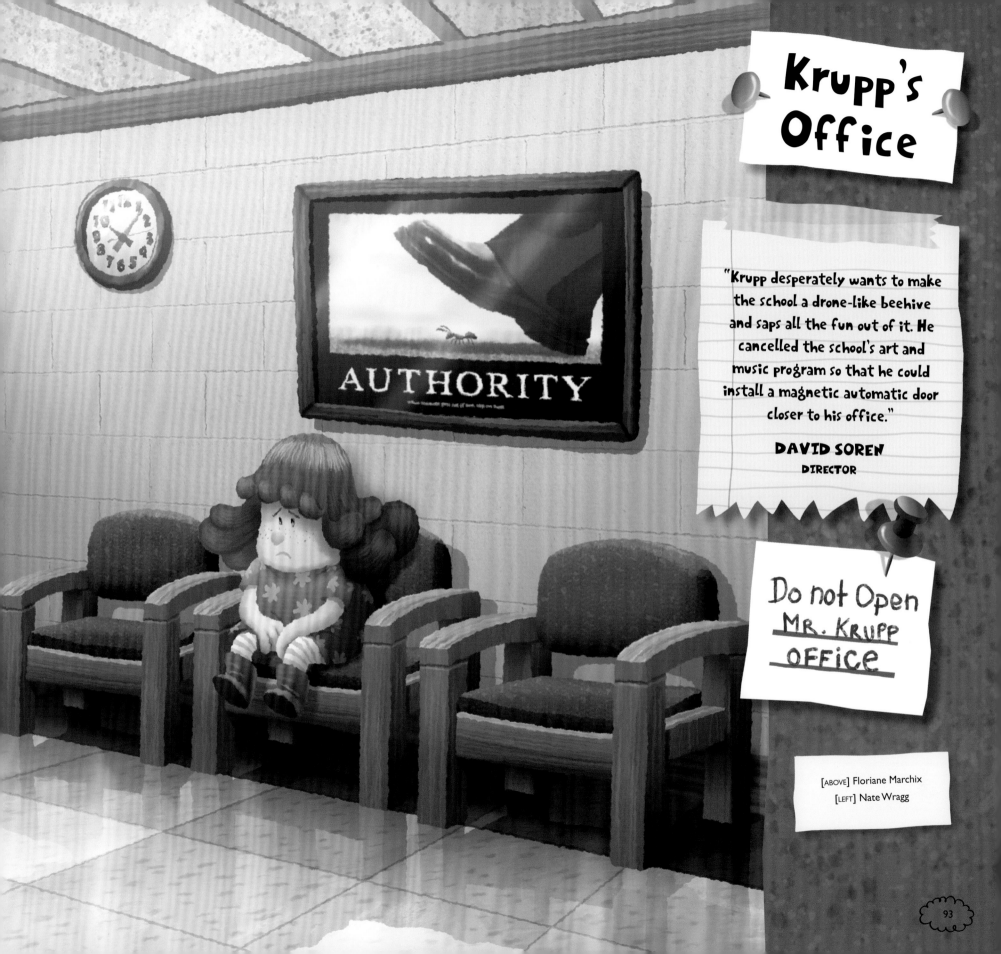

AUTHORITY

Krupp's Office

"Krupp desperately wants to make the school a drone-like beehive and saps all the fun out of it. He cancelled the school's art and music program so that he could install a magnetic automatic door closer to his office."

DAVID SOREN
DIRECTOR

Do not Open MR. KRUPP OFFICE

[ABOVE] Floriane Marchix
[LEFT] Nate Wragg

93

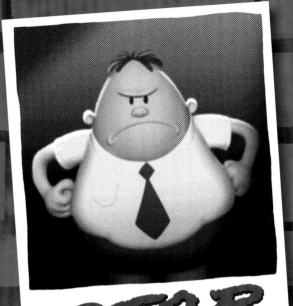

S.T.O.P.

Stop Talking Or Pay

UPAK United Principals Against Kids

THE
CERTIFICATE OF
MEDIOCRITY
FOR BEING
MOST BORING SCHOOL

[LEFT] Christopher Zibach, [ABOVE] Perry Dixon Maple,
[BELOW] *LIGHTING* by Matthieu Rouxel

"Krupp's desk is basically his disciplinary captain's chair, so as we designed his office around this prop, we treated the space as more of an interrogation room, something that would build on the illustration as we designed the set, all while staying true to the tone of the illustration and the story it was telling."

**NATE WRAGG
PRODUCTION DESIGNER**

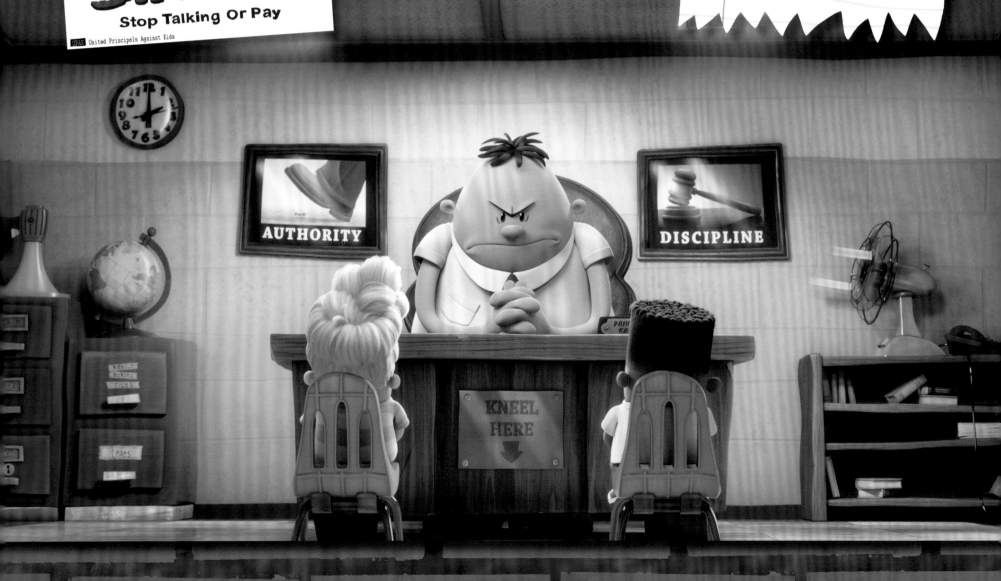

A

ENGRAVED GOLD SIGN

C

SIMPLER MAP FOR OVERVIEWS
(DO NOT USE THIS ONE FOR
CLOSE-UP)

D

(*) SEE COLOR
VARIATION FOR
BOOKS & BINDERS
ON PREVIOUS PAGE.

E

B

①

F

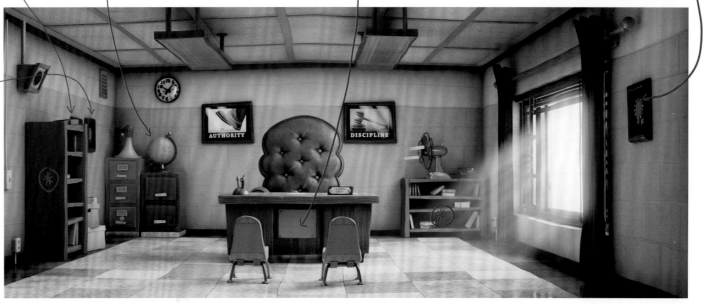

95

The Secretary

to do
- ☑ shop online
- ☐ work

file this under do later

COPYMATIC 2000

SHUT OFF

[ABOVE LEFT AND ABOVE] Perry Dixon Maple

[BELOW] Christopher Zibach

[OPPOSITE TOP] Christopher Zibach and Rune Bennicke

[OPPOSITE BOTTOM] Nate Wragg

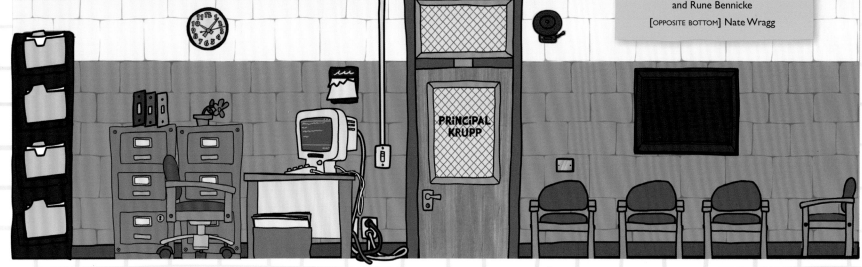

PRINCIPAL KRUPP

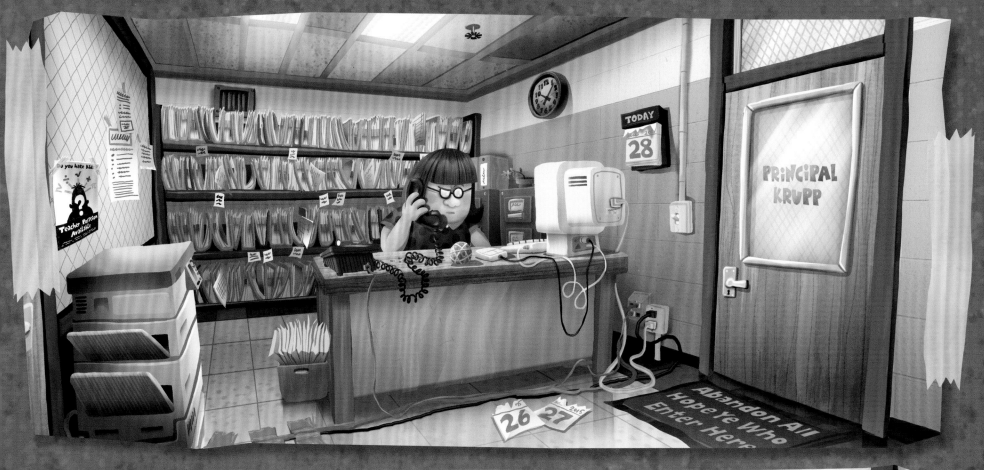

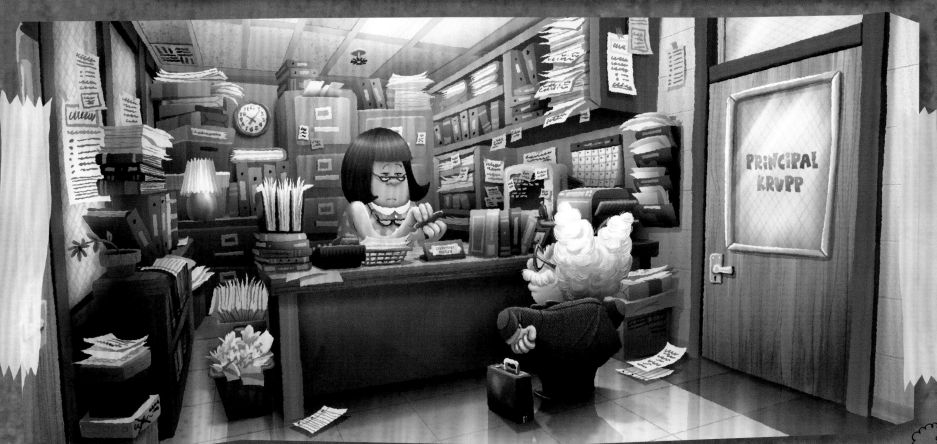

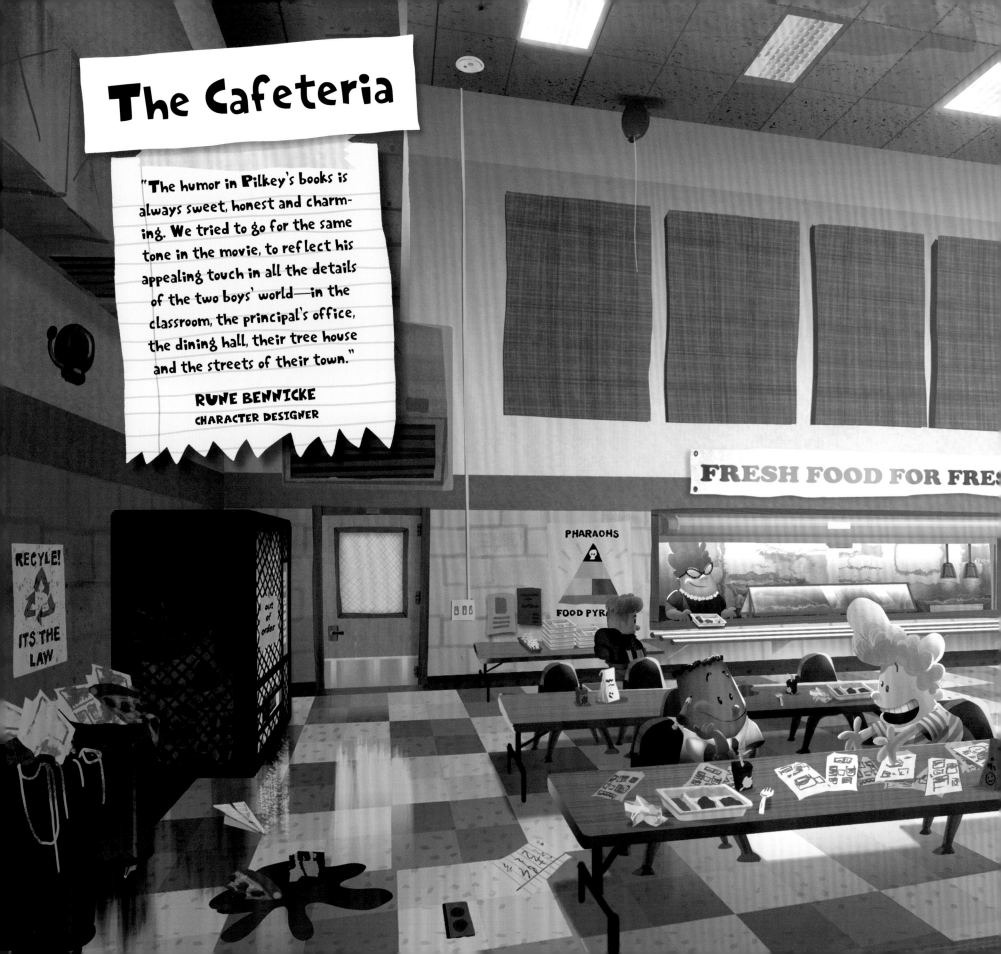

The Cafeteria

"The humor in Pilkey's books is always sweet, honest and charming. We tried to go for the same tone in the movie, to reflect his appealing touch in all the details of the two boys' world—in the classroom, the principal's office, the dining hall, their tree house and the streets of their town."

RUNE BENNICKE
CHARACTER DESIGNER

RECYLE! ITS THE LAW

out of order

PHARAOHS

FOOD PYRA

FRESH FOOD FOR FRES

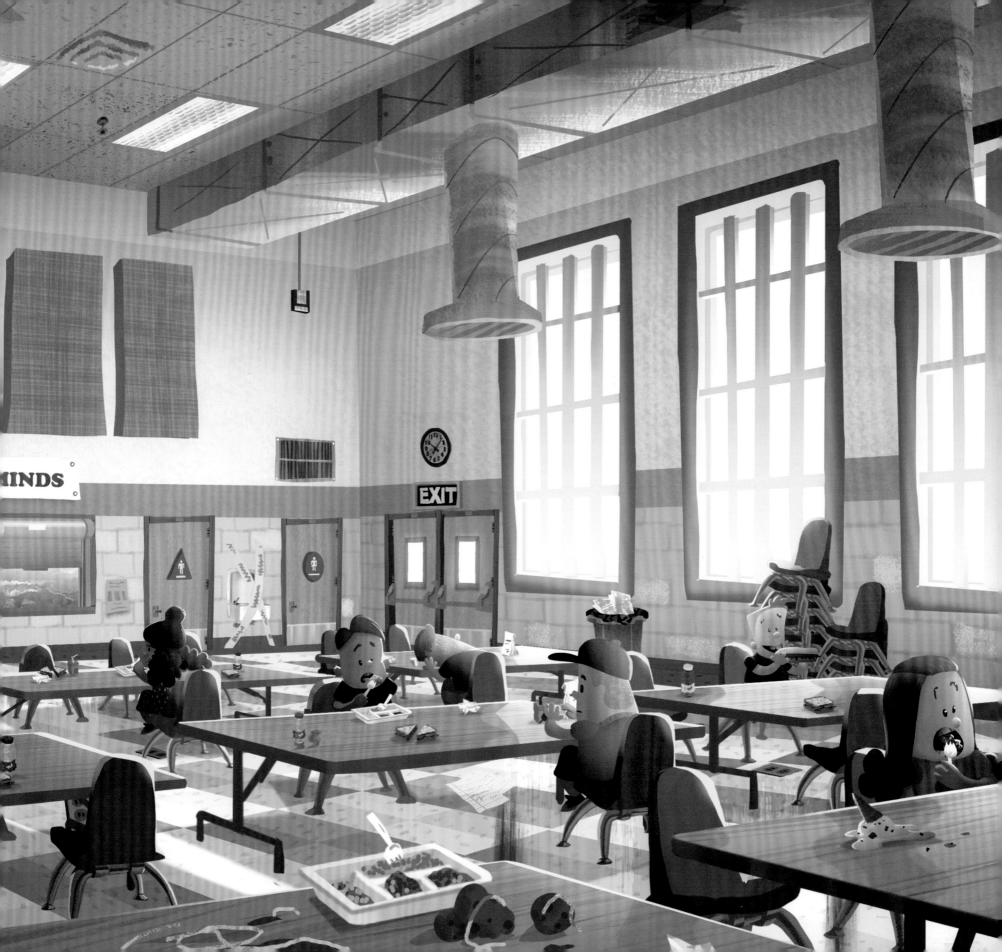

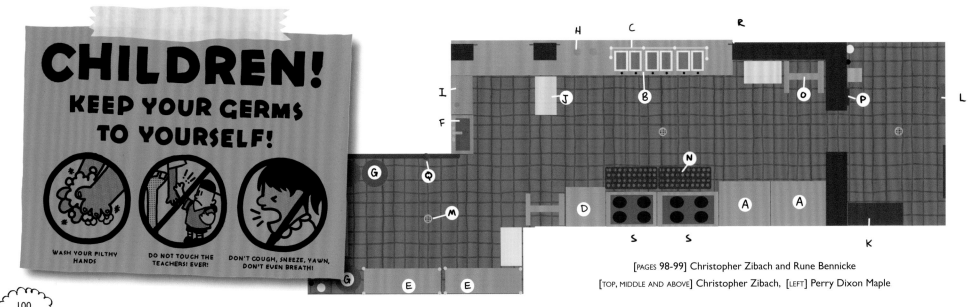

PLease see stage_wall_001-4a for elevations inside stage.

PLease see stage_wall_001-4a for elevations inside stage.

CHILDREN!
KEEP YOUR GERMS TO YOURSELF!

WASH YOUR FILTHY HANDS

DO NOT TOUCH THE TEACHERS! EVER!

DON'T COUGH, SNEEZE, YAWN, DON'T EVEN BREATH!

[PAGES 98-99] Christopher Zibach and Rune Bennicke
[TOP, MIDDLE AND ABOVE] Christopher Zibach, [LEFT] Perry Dixon Maple

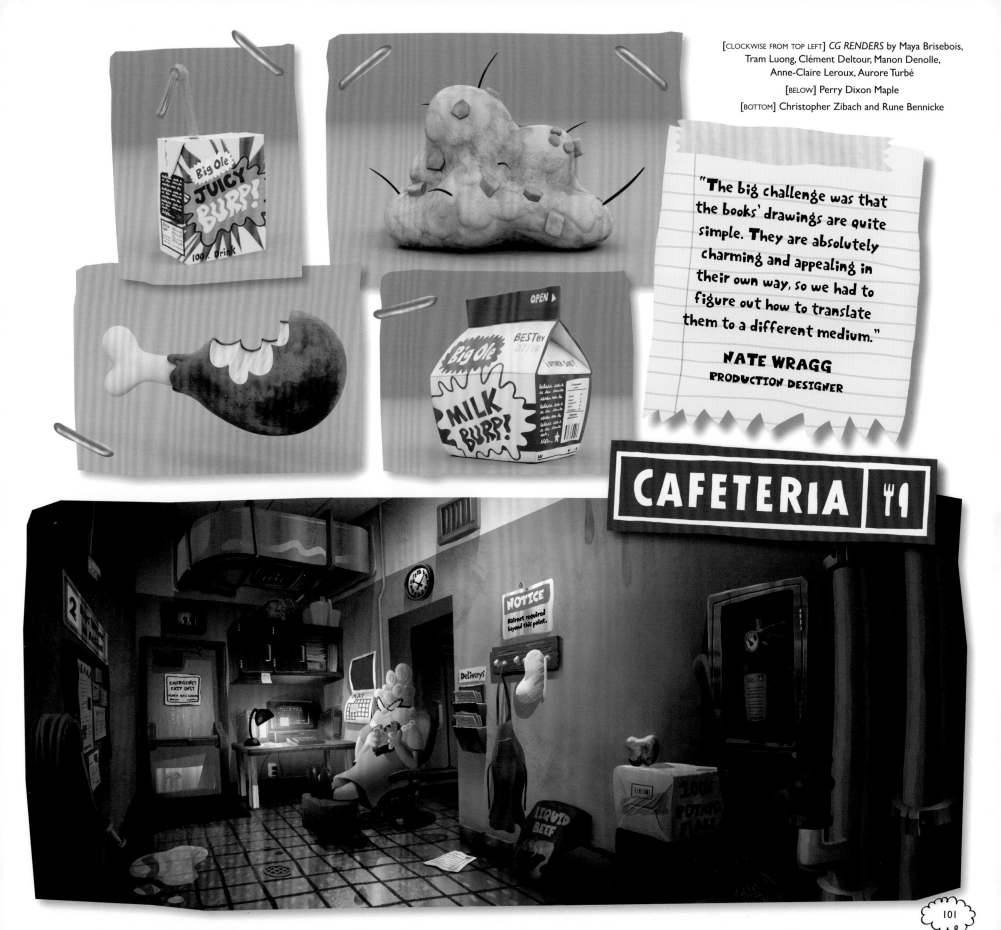

[CLOCKWISE FROM TOP LEFT] *CG RENDERS* by Maya Brisebois, Tram Luong, Clément Deltour, Manon Denolle, Anne-Claire Leroux, Aurore Turbé
[BELOW] Perry Dixon Maple
[BOTTOM] Christopher Zibach and Rune Bennicke

"The big challenge was that the books' drawings are quite simple. They are absolutely charming and appealing in their own way, so we had to figure out how to translate them to a different medium."

NATE WRAGG
PRODUCTION DESIGNER

CAFETERIA

The Tree House

The tree house, which is built on a tree situated between the boys' houses, is their creative haven and the world headquarters of Tree House Comix, Inc. It's where George and Harold spend most of their free time, writing and drawing their comic books away from the tyranny of Principal Krupp.

"I wanted to make sure that Krupp's office and the tree house were complete opposites," says director David Soren. "If you put them next to each other, you could tell that one represented prison and the other freedom. We had to do a lot of work to make sure the tree house looked magical and special enough. Most of the tree house sequences take place around golden hour, which adds a warmth and light to the environment. However, it couldn't be so whimsical that it no longer felt like something two kids could have created in their backyard."

To make this setting specific to George and Harold's interests, the team filled it with art supplies, posters, comic books, and the odd plunger or two. They wove tree branches into the space to give it a more indoor/outdoor feel. "Of course, it also had to be a shrine to Captain Underpants, their greatest creation," says Soren.

[TOP AND ABOVE] Dav Pilkey

[RIGHT] Christopher Zibach and Rune Bennicke

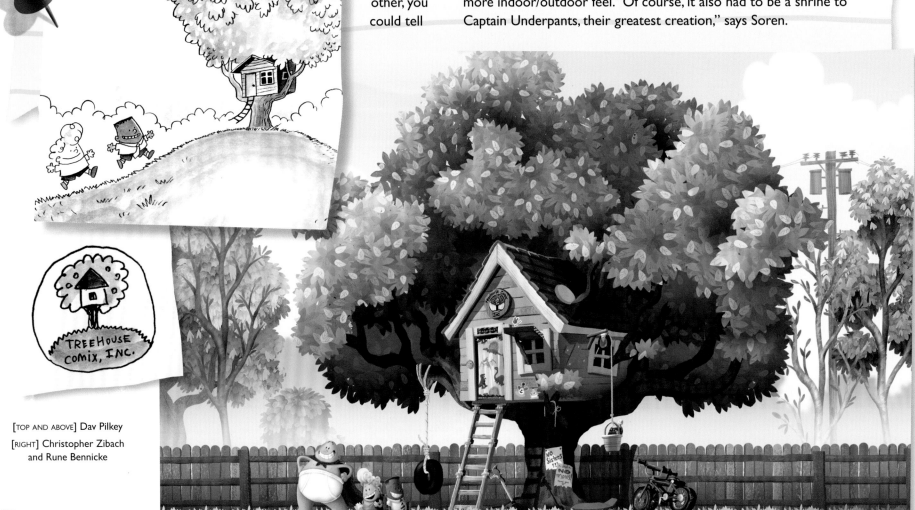

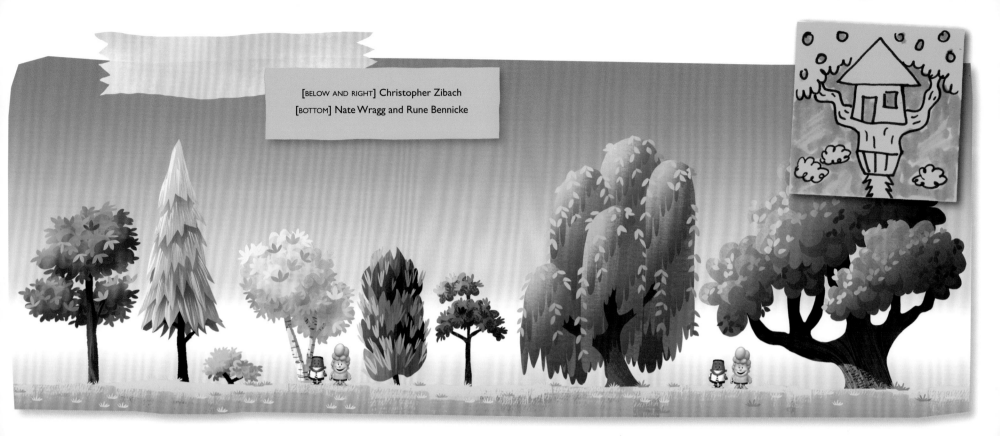

[BELOW AND RIGHT] Christopher Zibach

[BOTTOM] Nate Wragg and Rune Bennicke

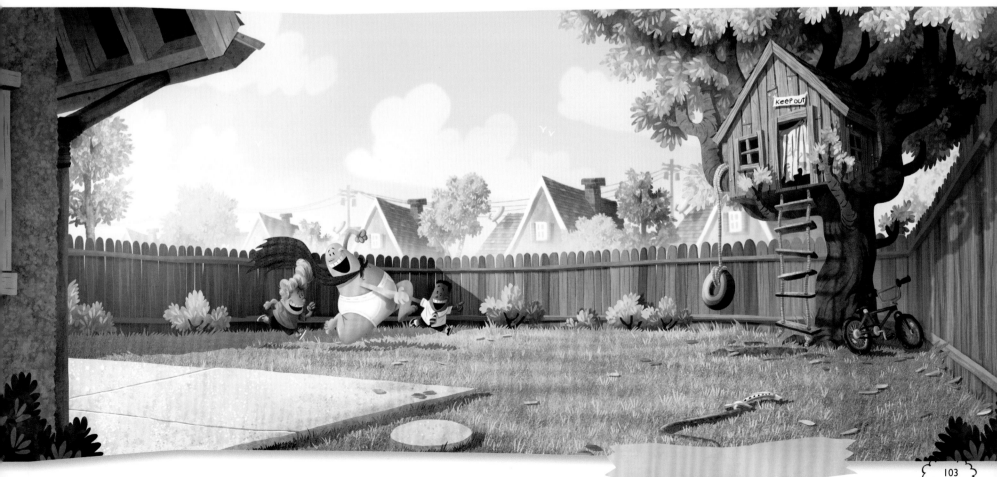

Production designer Nate Wragg points out, "You can really believe that the boys and their parents built this tree house. And we specifically didn't put in any clean lines, no sharp edges…Everything has that natural Dav Pilkey wobbliness. If you looked at just one of the props or one of the elements alone, you would think it's too wobbly, but when put together, it all works very well."

For visual development artist Christopher Zibach, the tree house represented everything he would have wanted as a boy. "They have their own TV set and videogames. For most kids, that would be enough to make it a wonderful place, but we built it as the ideal children's cave," says Zibach. "Every corner is chock-full of fun things—comics, toys, pranks, games, slingshots, water guns, magic tricks, everything. It's all that you dreamed about as a kid growing up. But, most of all, the tree house offers them a place to be free and creative."

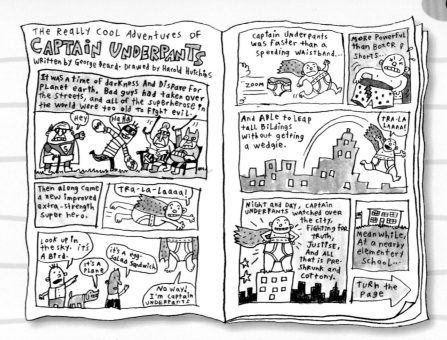

[ABOVE] Dav Pilkey, [BELOW LEFT] Christopher Zibach and Nate Wragg

[BELOW] *STORYBOARDS* by Louie del Carmen, Colin Jack

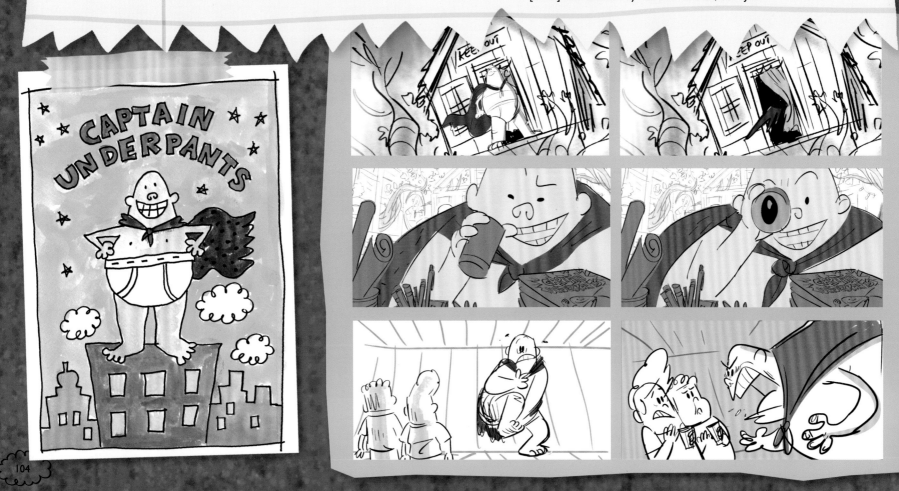

104

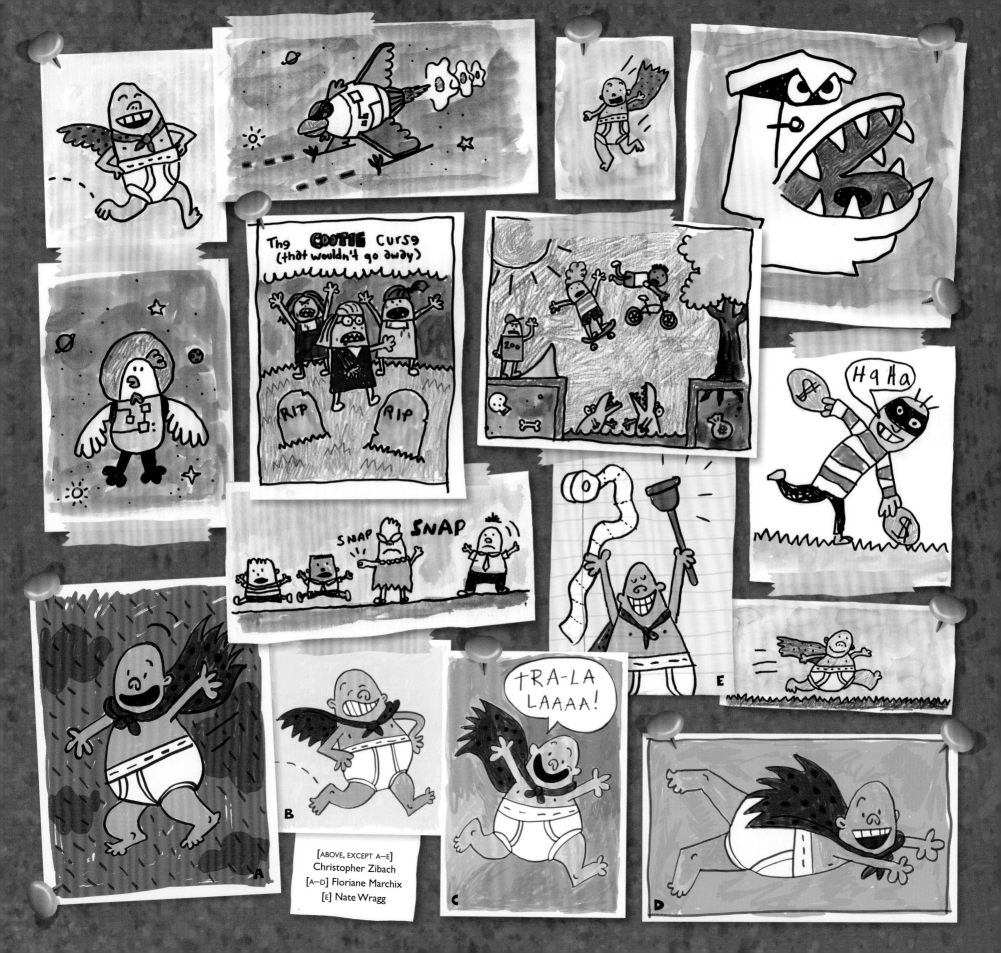

[ABOVE, EXCEPT A–E]
Christopher Zibach
[A–D] Floriane Marchix
[E] Nate Wragg

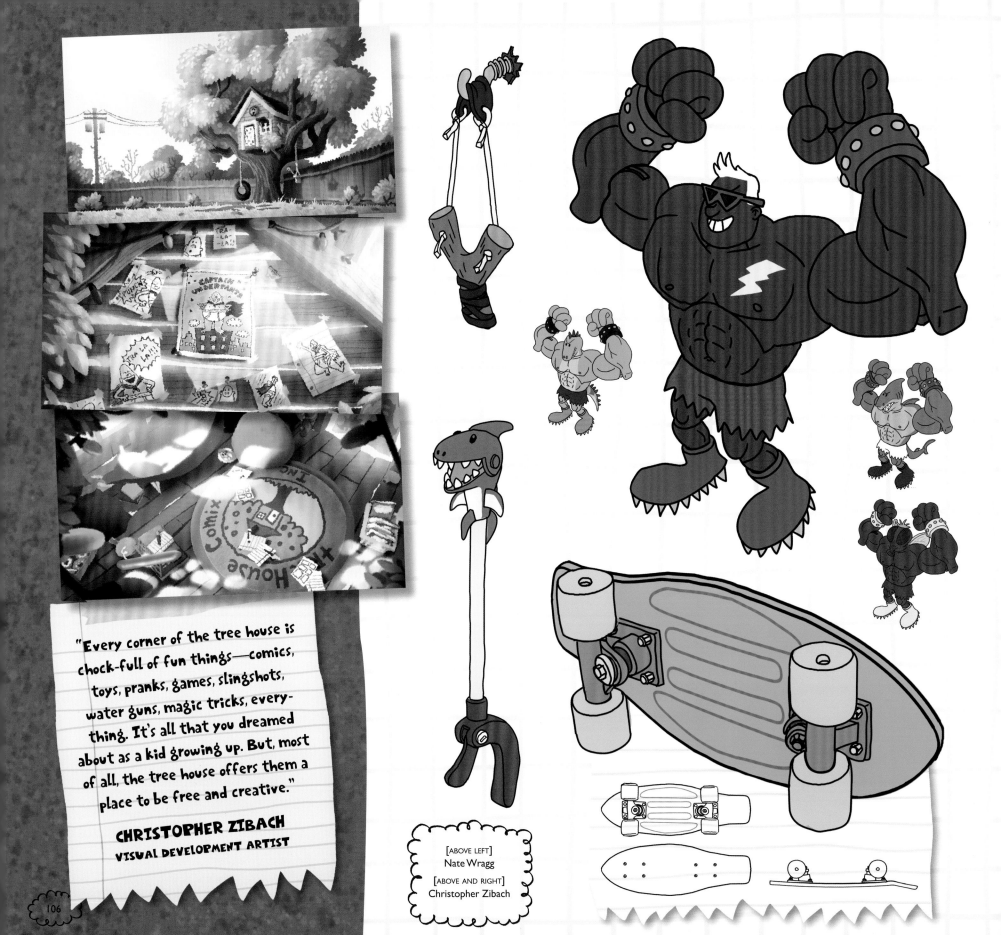

"Every corner of the tree house is chock-full of fun things—comics, toys, pranks, games, slingshots, water guns, magic tricks, everything. It's all that you dreamed about as a kid growing up. But, most of all, the tree house offers them a place to be free and creative."

CHRISTOPHER ZIBACH
VISUAL DEVELOPMENT ARTIST

[ABOVE LEFT]
Nate Wragg

[ABOVE AND RIGHT]
Christopher Zibach

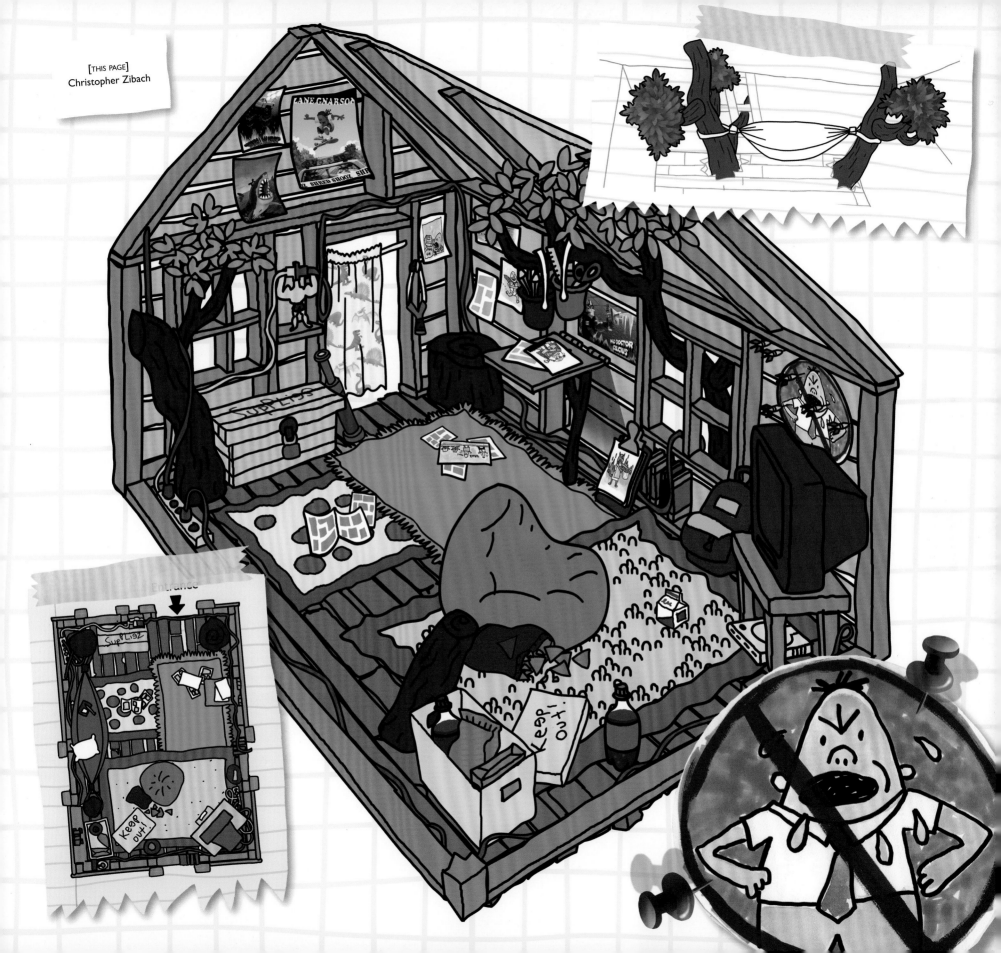

[THIS PAGE]
Christopher Zibach

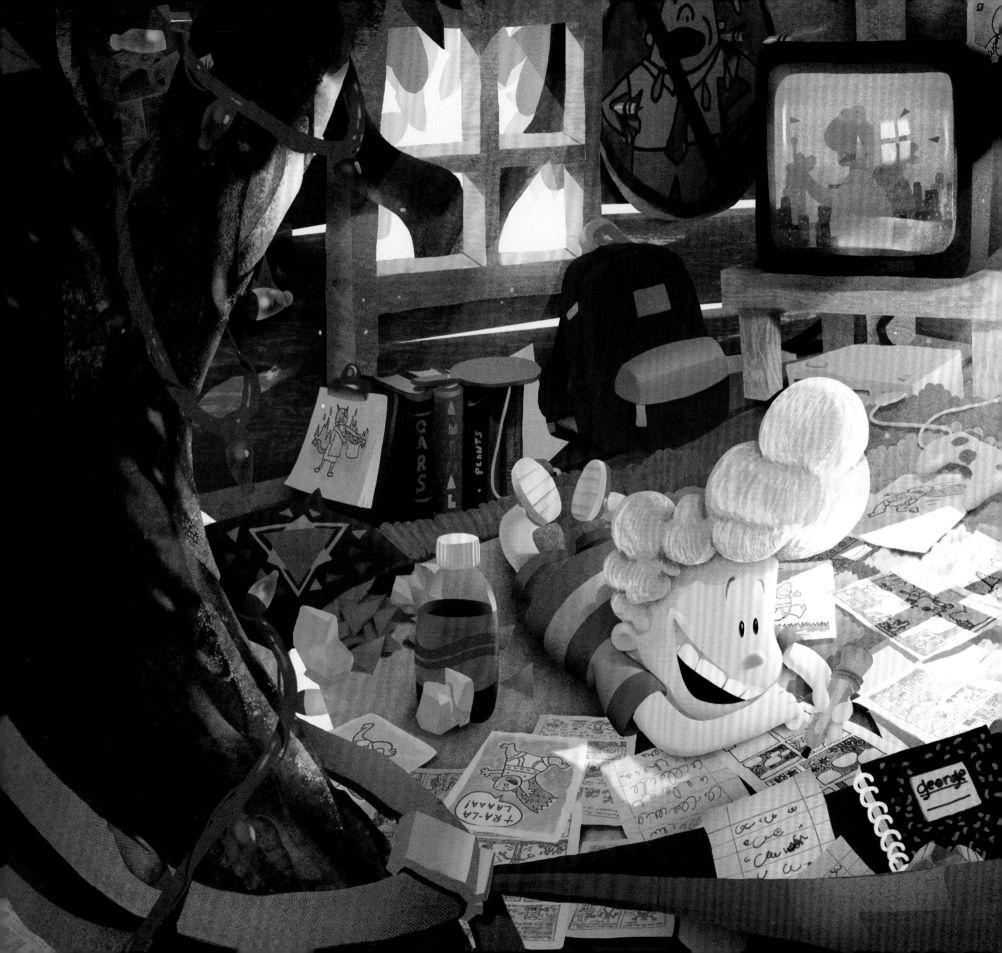

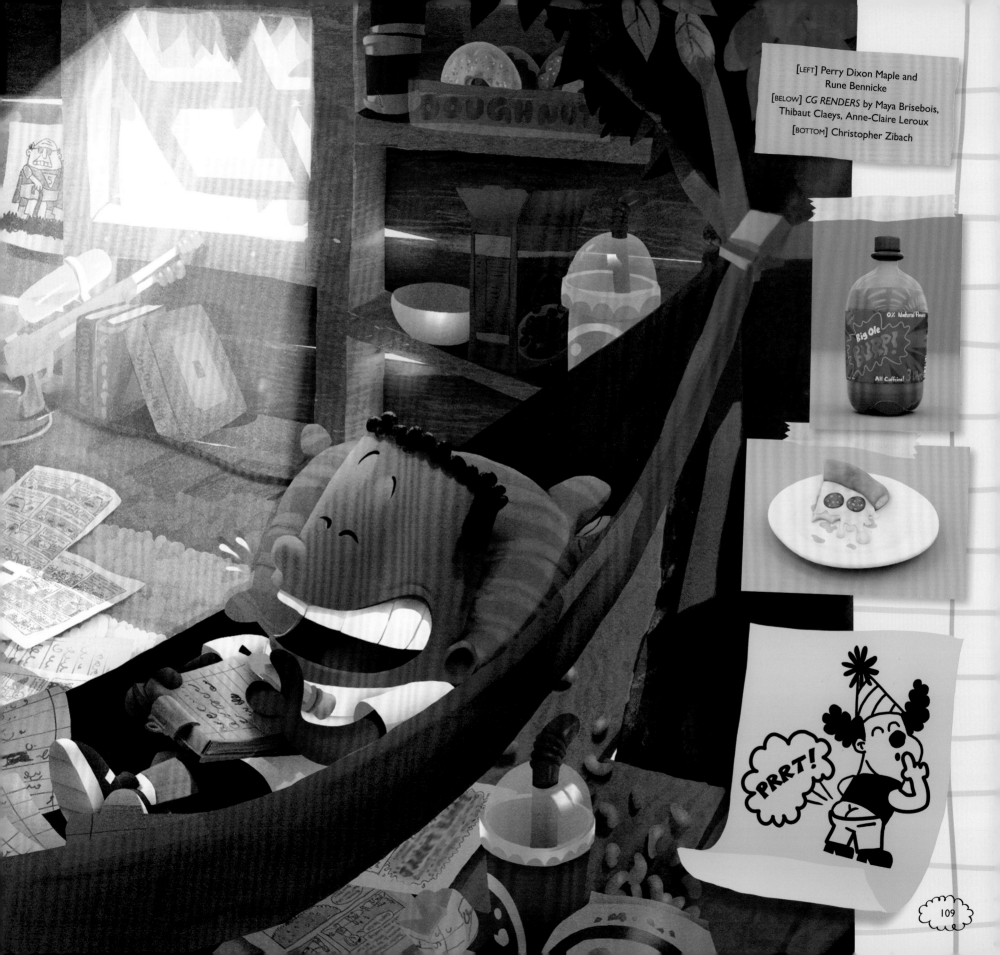

[LEFT] Perry Dixon Maple and Rune Bennicke

[BELOW] *CG RENDERS* by Maya Brisebois, Thibaut Claeys, Anne-Claire Leroux

[BOTTOM] Christopher Zibach

109

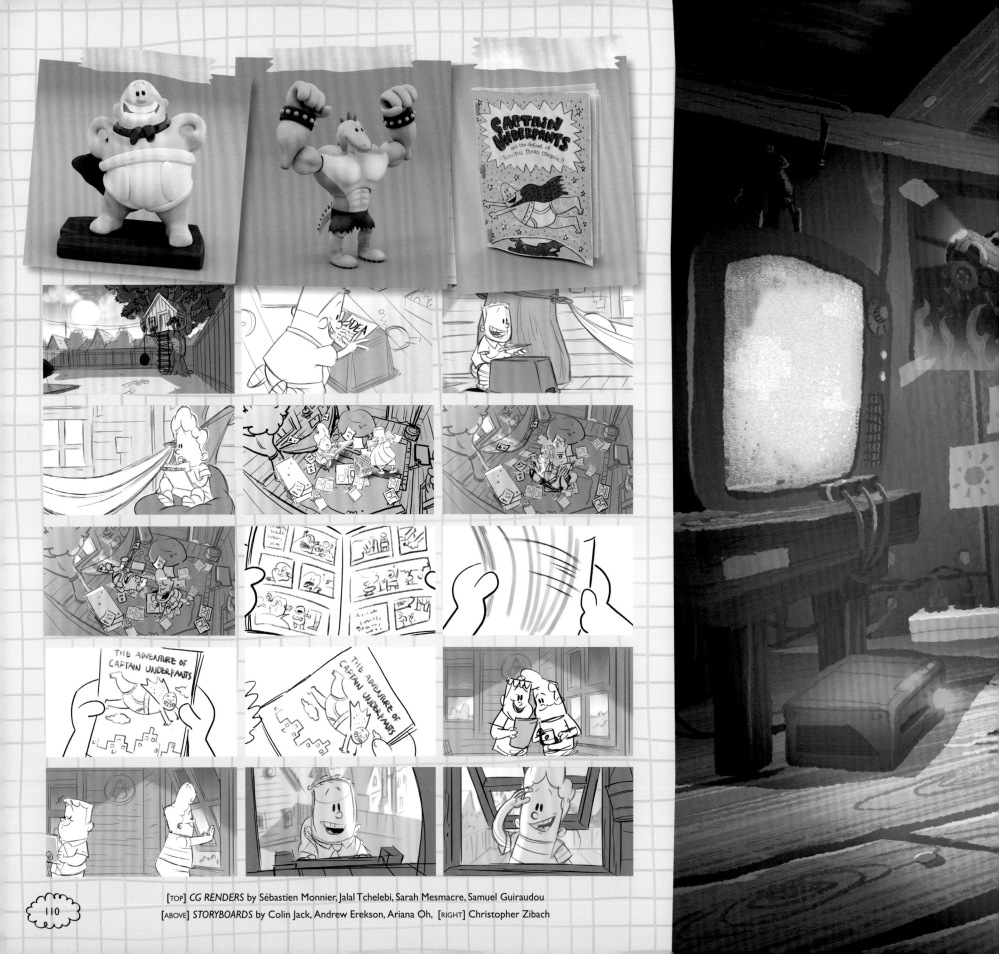

[TOP] *CG RENDERS* by Sébastien Monnier, Jalal Tchelebi, Sarah Mesmacre, Samuel Guiraudou

[ABOVE] *STORYBOARDS* by Colin Jack, Andrew Erekson, Ariana Oh, [RIGHT] Christopher Zibach

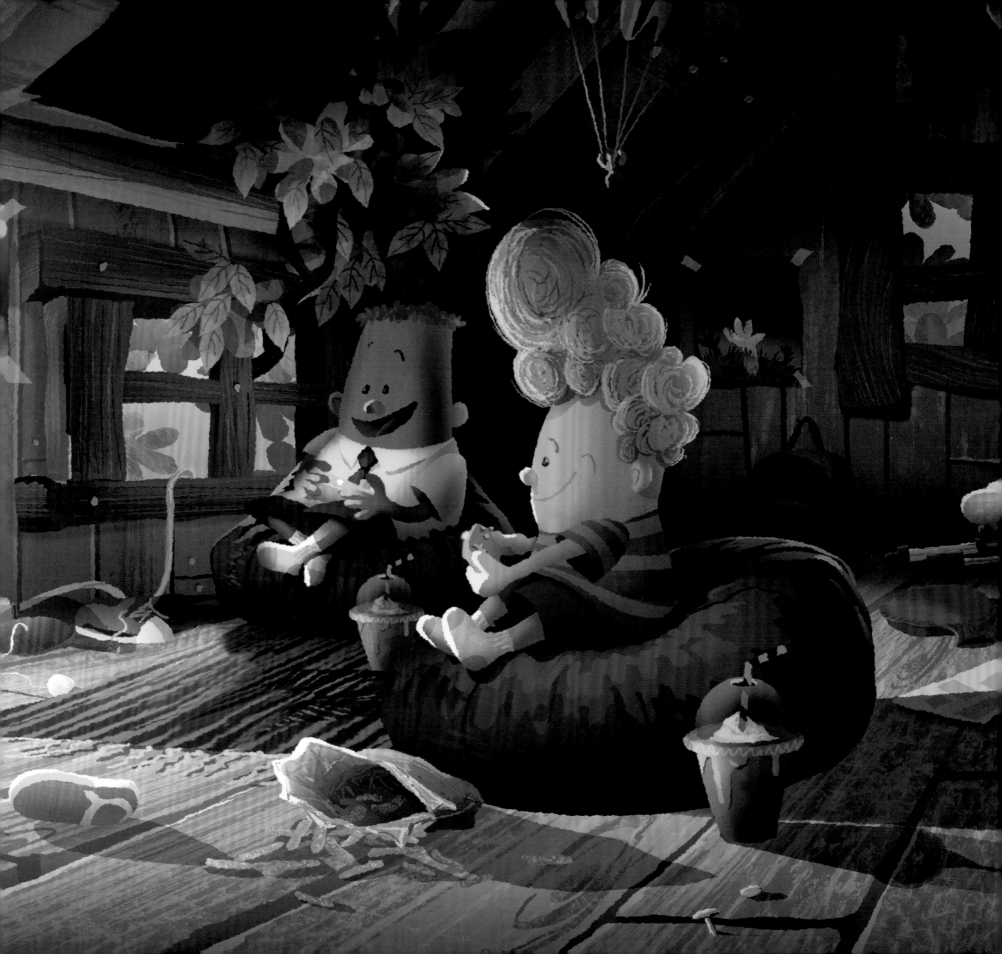

Piqua City Center

Dav **Pilkey** set his books in Piqua, Ohio, because the town was once known as the "underwear capital of the world!" That fact alone granted the filmmakers permission to embrace their silly sides while creating the town center, which connects all the different lives of its residents. "Piqua is a working-class community, not the usual metropolis we are used to seeing in superhero movies," says director David Soren. "In Pilkey's world, all the stores have silly names. Our approach was, we have a delusional superhero running around in his underpants and a cape, what would be the most entertaining environments he can be in?" The team decided that more grown-up institutions—like banks and construction sites—would provide the most fun juxtaposed against our waistband warrior.

"Pilkey's drawing of cityscapes informed our skyline. They look more like the way a kid would imagine a skyline than an architect," says Soren. "Like a single line connecting a series of rectangles rather than individual buildings."

The various stores in town, many of which make appearances in the book series, served as another opportunity for the filmmakers to generate laughs. With places like Snotco, Nothing But Prune Smoothyz, or the Spatula Showroom, no street corner should pass by without a chuckle.

Production designer Nate Wragg says there are at least 50 different Easter Eggs hidden in those scenes. "Hopefully people who love the books will notice them and know that we've taken good care of the characters and locations as we adapted them into the film. We've taken note of the different store, street and company names rather than just creating generic locations. I mean how can you not use a store named John's House of Toilets?"

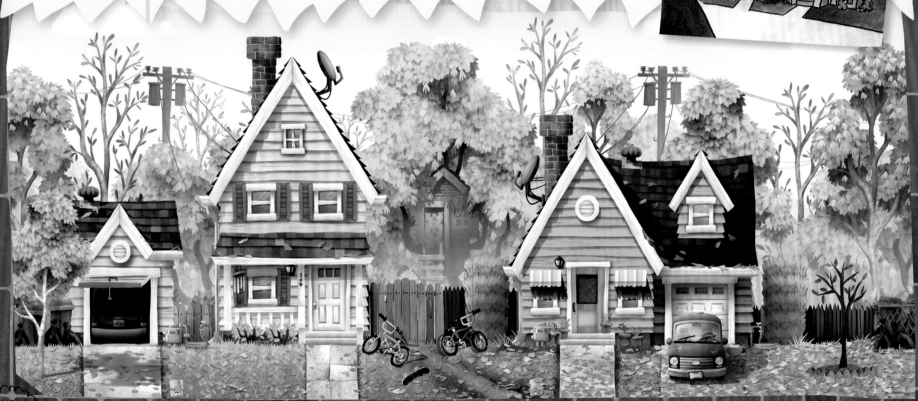

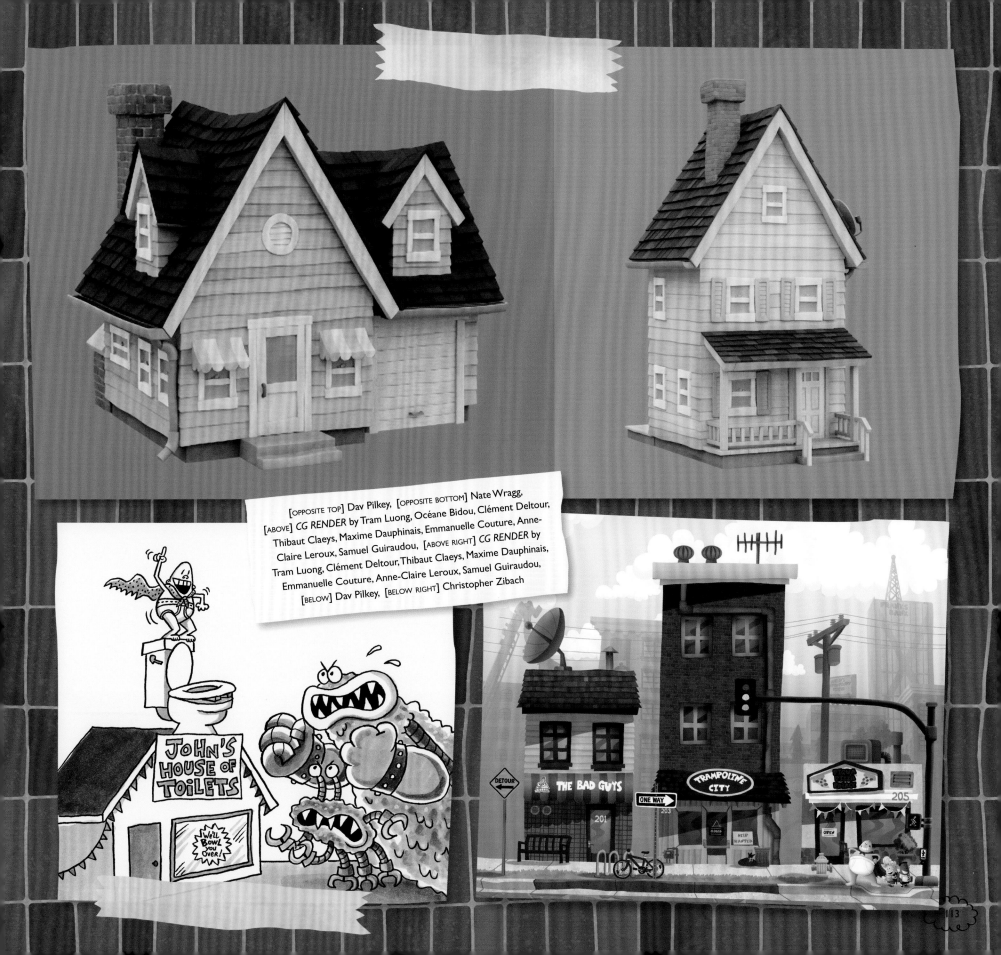

[OPPOSITE TOP] Dav Pilkey, [OPPOSITE BOTTOM] Nate Wragg,
[ABOVE] CG RENDER by Tram Luong, Océane Bidou, Clément Deltour,
Thibaut Claeys, Maxime Dauphinais, Emmanuelle Couture, Anne-
Claire Leroux, Samuel Guiraudou, [ABOVE RIGHT] CG RENDER by
Tram Luong, Clément Deltour, Thibaut Claeys, Maxime Dauphinais,
Emmanuelle Couture, Anne-Claire Leroux, Samuel Guiraudou,
[BELOW] Dav Pilkey, [BELOW RIGHT] Christopher Zibach

"If Pilkey fans look closely, they will notice that we have included many details from the books as backgrounds or visual jokes around the town: Piqua Pizza Palace, John's House of Toilets, SNOTCO, and even Frank's Bank make appearances."

NATE WRAGG
PRODUCTION DESIGNER

THE LAVISH WORLD OF LETTUCE

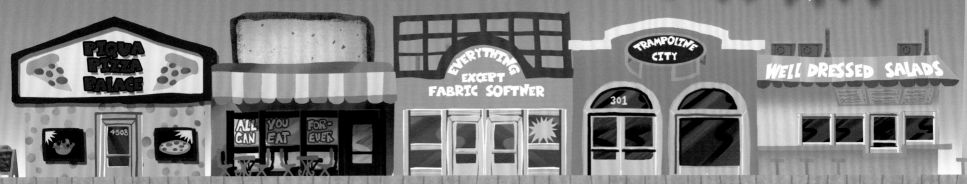

PIQUA PIZZA PALACE

4508

ALL YOU FOR-
CAN EAT EVER

EVERYTHING
EXCEPT
FABRIC SOFTNER

TRAMPOLINE CITY

301

WELL DRESSED SALADS

[TOP LEFT] Nate Wragg
[ABOVE, LEFT AND BELOW] Christopher Zibach

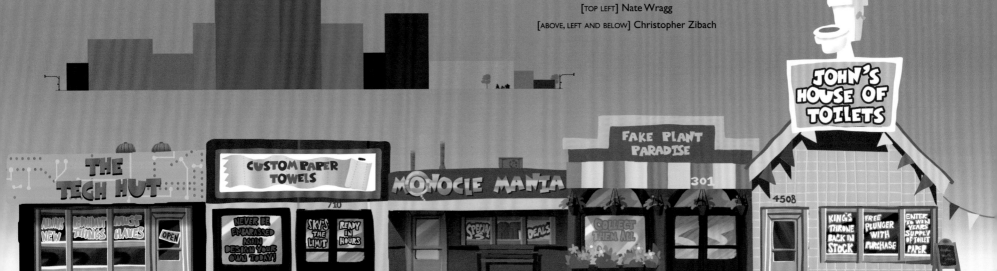

THE TECH HUT

ALWAYS REMOVING MUST
NEW THINGS HAVES OPEN

CUSTOM PAPER TOWELS

710

NEVER BE
EMBARRASSED
AGAIN
DESIGN YOUR
OWN TODAY!

SKY'S READY
THE IN
LIMIT HOURS

MONOCLE MANIA

SPECIAL HOT DEALS

FAKE PLANT PARADISE

COLLECT THEM ALL

301

JOHN'S HOUSE OF TOILETS

4508

KING'S
THRONE
BACK IN
STOCK

FREE
PLUNGER
WITH
PURCHASE

ENTER
TO WIN
YEARS
SUPPLY
OF TOILET
PAPER

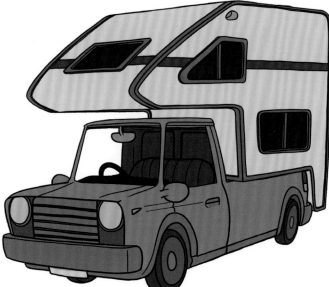

[FAR LEFT] Perry Dixon Maple

[ABOVE MIDDLE] *CG MODEL* by Maxime Dauphinais

[ABOVE] *CG RENDER* by Maxime Dauphinais and Tram Luong

[LEFT] *CG RENDER* by Maxime Dauphinais and Sarah Mesmacre

[BELOW] *CG MODEL AND DRAWOVER* by Maxime Dauphinais and Christopher Zibach

[A AND B] Christopher Zibach

B

POLICE

A

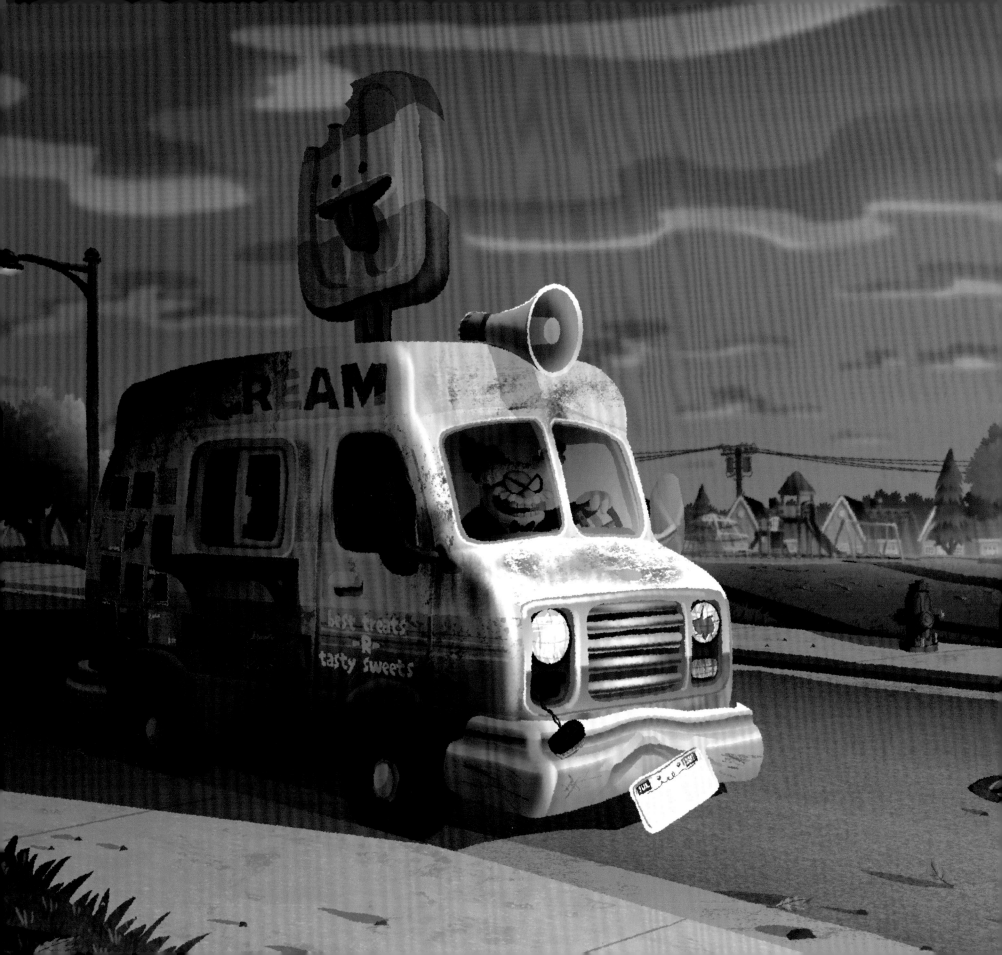

Professor Poopypants' Ice Cream Truck

If you're an evil scientist bent on banishing laughter from the face of the world, you definitely need a crazy lab for all your experiments. Poopypants' ice cream truck serves as the ideal mad scientist's lair in the movie.

"There are all kinds of ridiculous gadgets, computers and experimental equipment intermingled with ice cream supplies," notes director David Soren. "This is where Poopypants and Melvin team up to do their nefarious experiments on the human brain."

Visual development artist Christopher Zibach says he had a lot of fun designing the exterior of the truck. "I wanted to capture the ice cream trucks that I remembered from my childhood, growing up in Valencia, California," he says. "Back in the 50s, the ice cream trucks had this iconic shape, and the men selling the ice creams wore these cool uniforms. Today, they look like any old rusty van. We figured Poopypants probably bought the van for very little money to use it as a lab. There's even a silly ice cream cone on top we call Mr. Licky!"

Zibach loves the fact that the interior of the truck is full of nondescript gadgets and items that serve as zany visual cues. He explains, "We have all these weird objects in there, many of which don't really serve a purpose, but look funny or cool, like lava lamps or computers that don't really do anything. But they make the truck memorable and funny to look at."

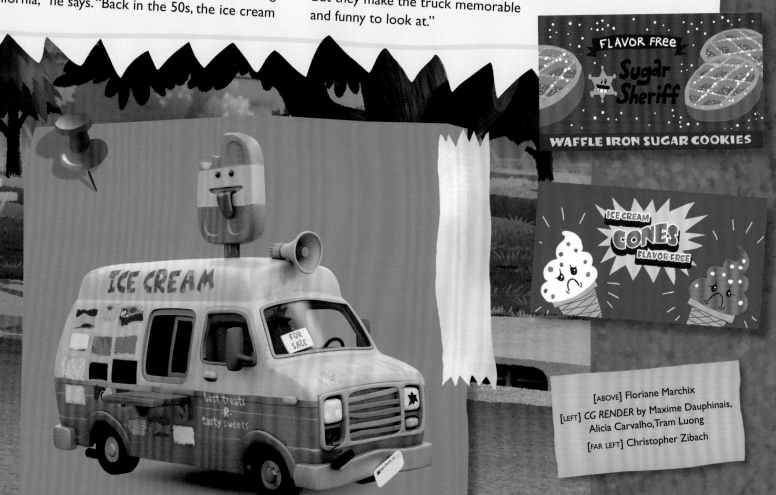

FLAVOR FREE
Sugar Sheriff
WAFFLE IRON SUGAR COOKIES

ICE CREAM **CONES** FLAVOR-FREE

ICE CREAM

best treats
-R-
tasty sweets

FOR SALE

[ABOVE] Floriane Marchix

[LEFT] CG RENDER by Maxime Dauphinais, Alicia Carvalho, Tram Luong

[FAR LEFT] Christopher Zibach

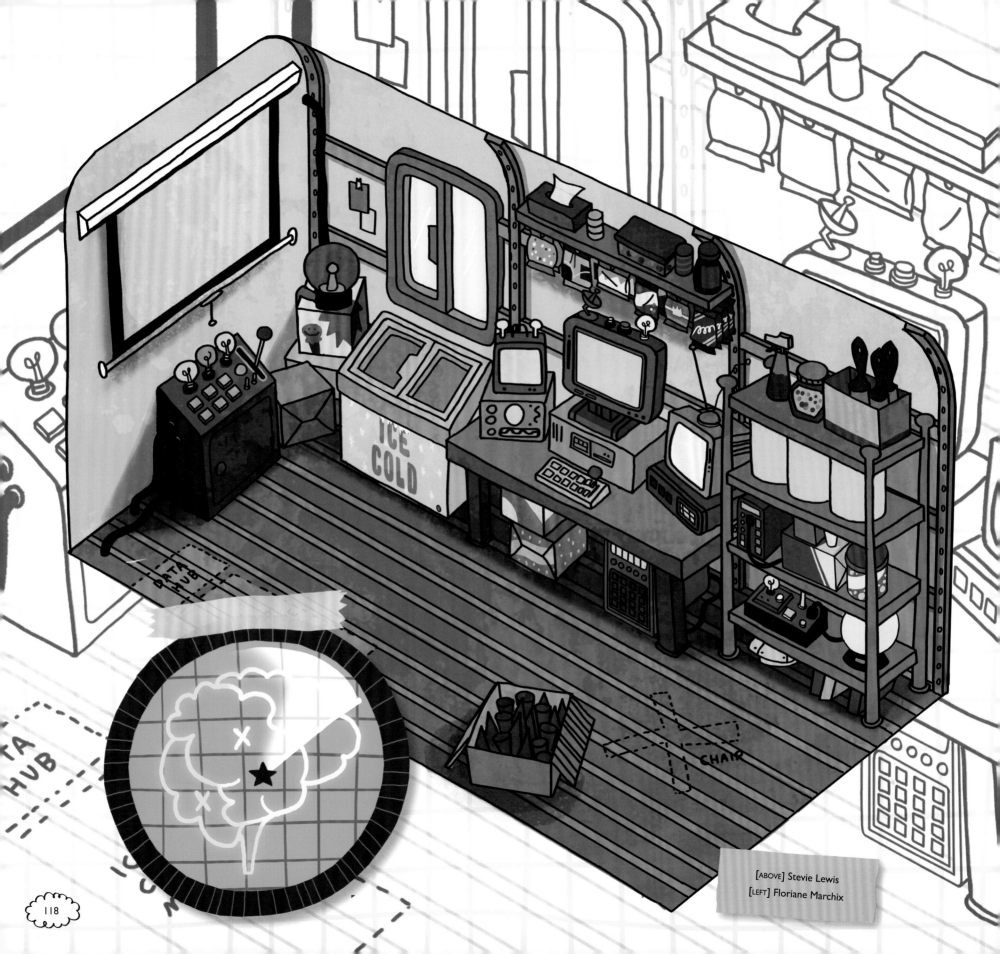

ICE COLD

CHAIR

[ABOVE] Stevie Lewis
[LEFT] Floriane Marchix

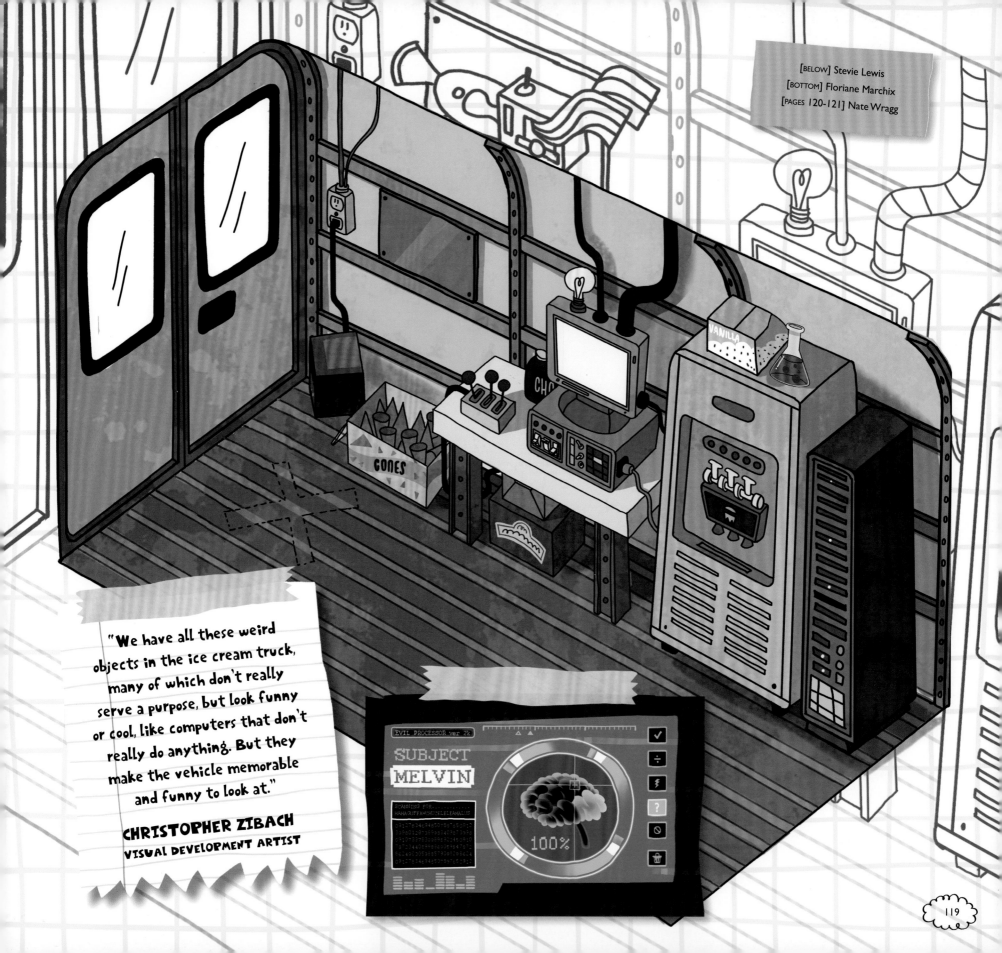

[BELOW] Stevie Lewis
[BOTTOM] Floriane Marchix
[PAGES 120-121] Nate Wragg

CONES

VANILLA

CHO

EVIL PROCESSOR ver 2k

SUBJECT
MELVIN

SCANNING FOR...
HAHARUFFAWCHUCKLEEEAHAUS

100%

"We have all these weird objects in the ice cream truck, many of which don't really serve a purpose, but look funny or cool, like computers that don't really do anything. But they make the vehicle memorable and funny to look at."

CHRISTOPHER ZIBACH
VISUAL DEVELOPMENT ARTIST

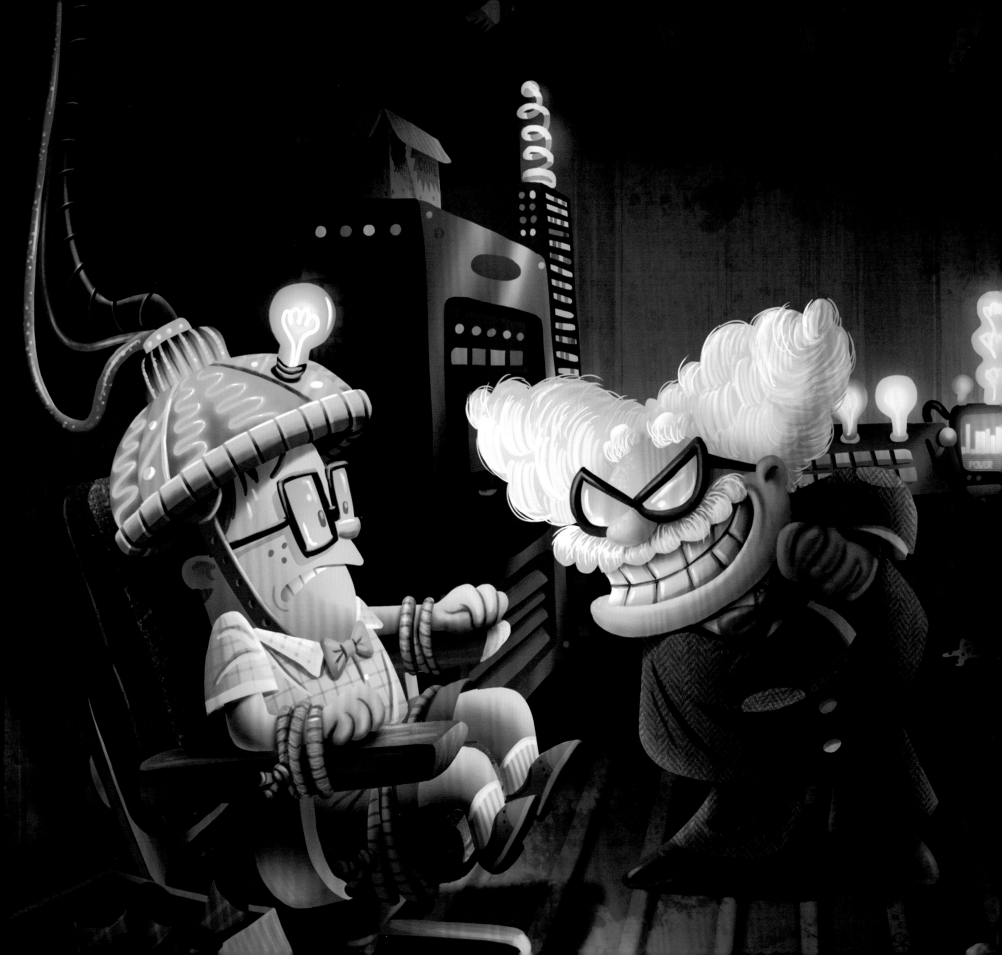

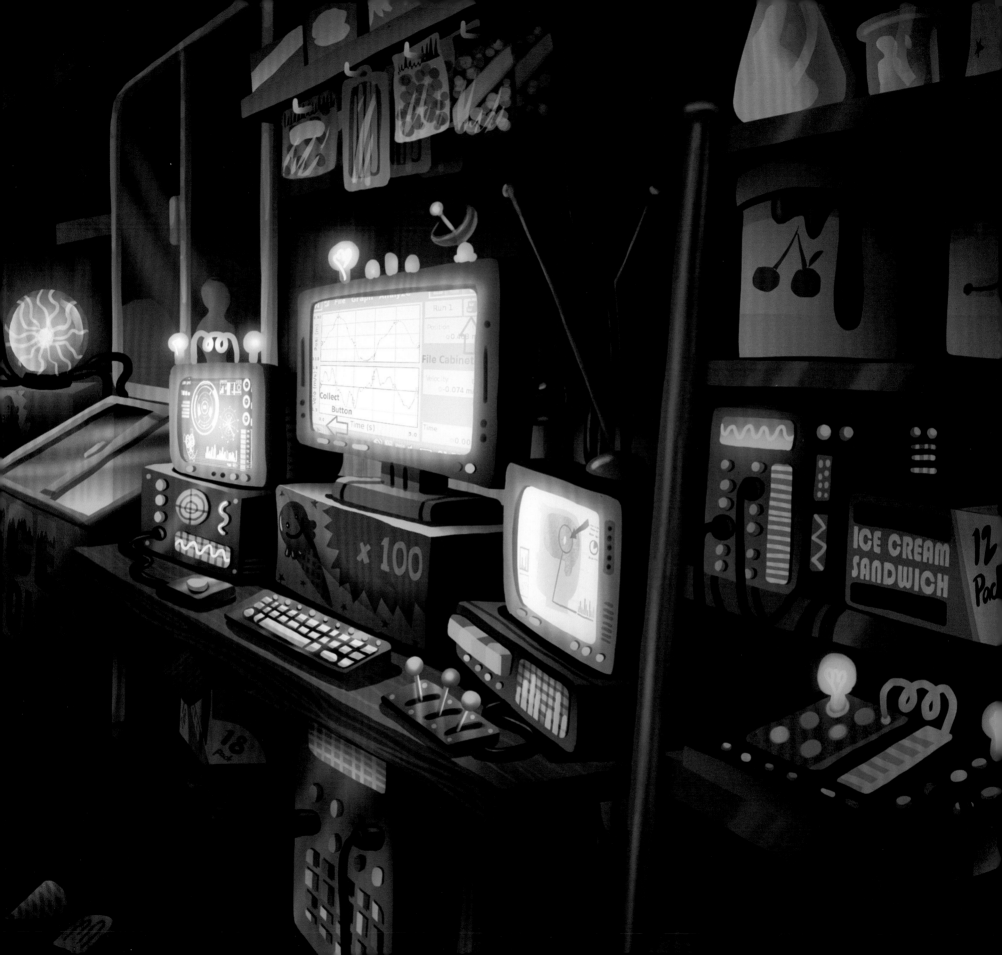

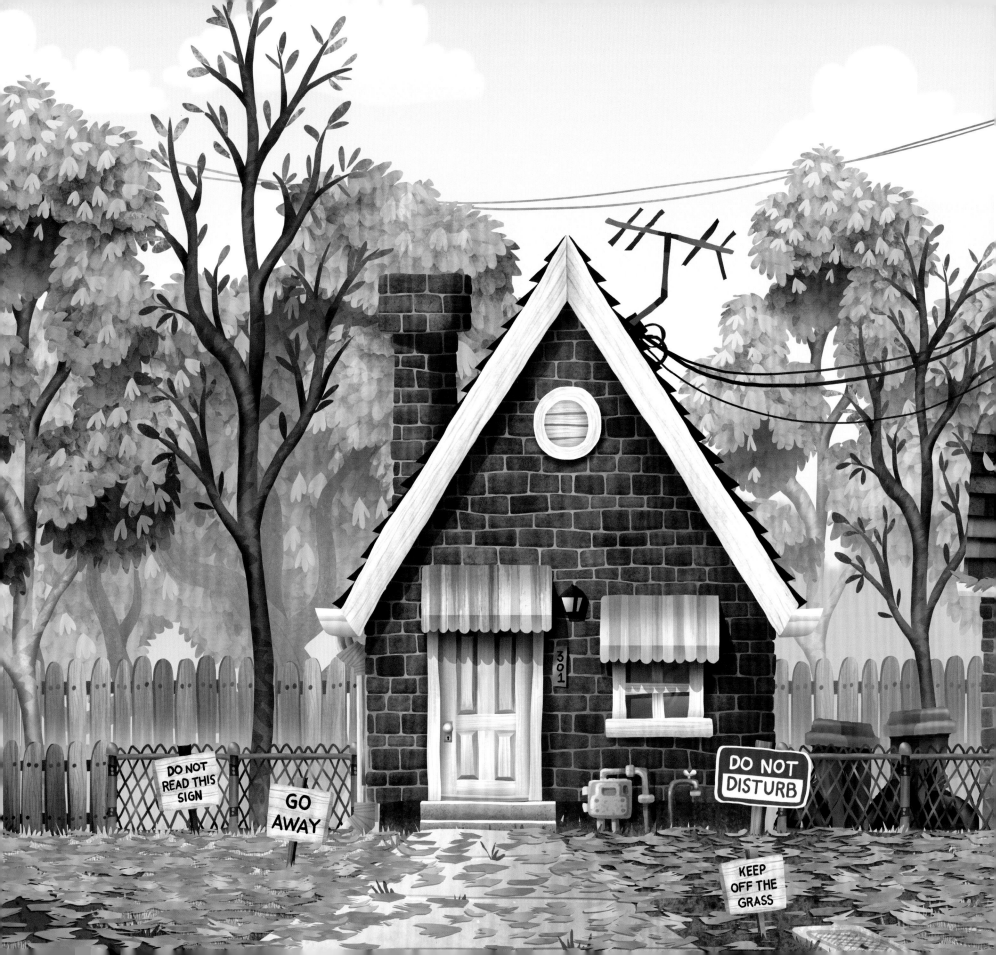

Principal Krupp's House

The boys have certain preconceived notions about what Principal Krupp's house actually looks like. They assume it must be a horrible, scary place. However, they discover that it's actually a sad, lonely place when they wheel him back home after he's been hypnotized.

"From the outside, it looks ominous and exactly like the house of horrors they had expected," says director David Soren. "But, inside, it's almost like an old lady's home. It seems deeply lonely and melancholy to them. Their discovery is actually one of my favorite scenes in the movie. Until then, Krupp has been a monstrous presence in their minds, but he is actually humanized to them. They leave very conflicted and hope that they never end up as lonely as Krupp. They promise they'll never let that happen to each other."

[LEFT AND BELOW] Dav Pilkey
[FAR LEFT] Nate Wragg

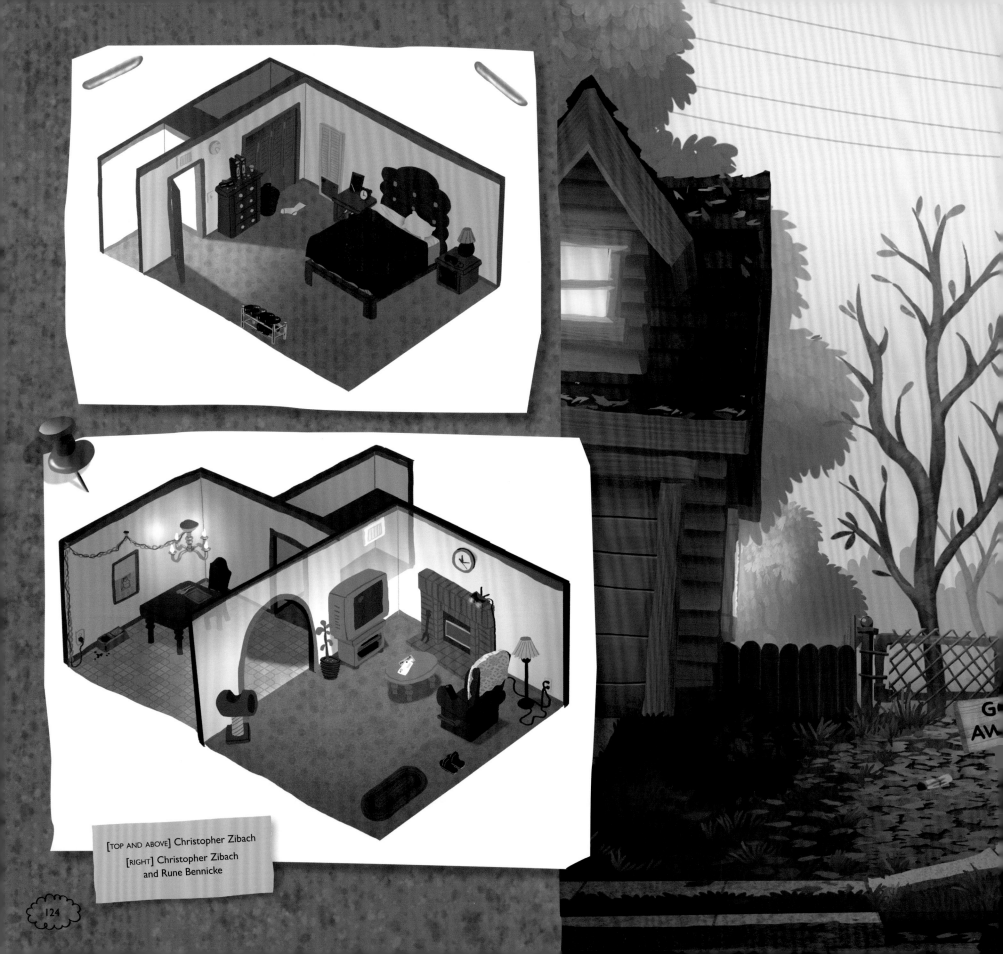

[TOP AND ABOVE] Christopher Zibach

[RIGHT] Christopher Zibach
and Rune Bennicke

124

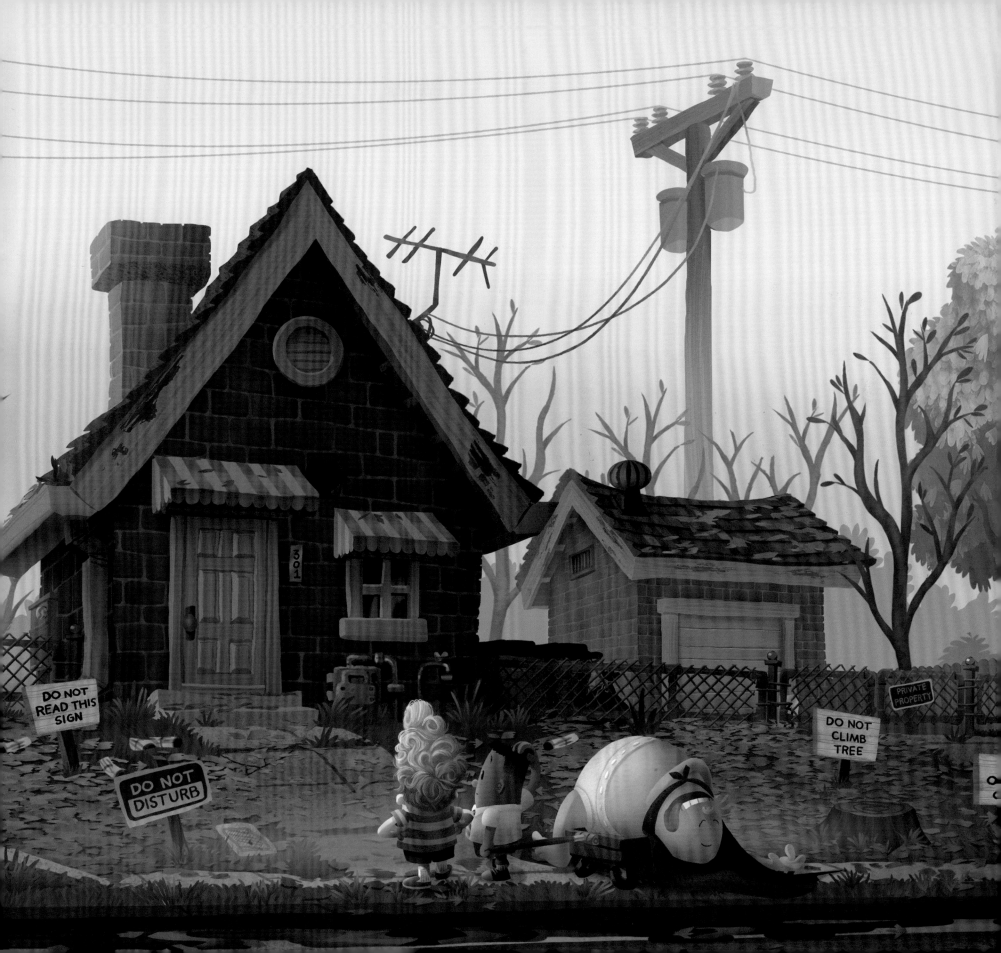

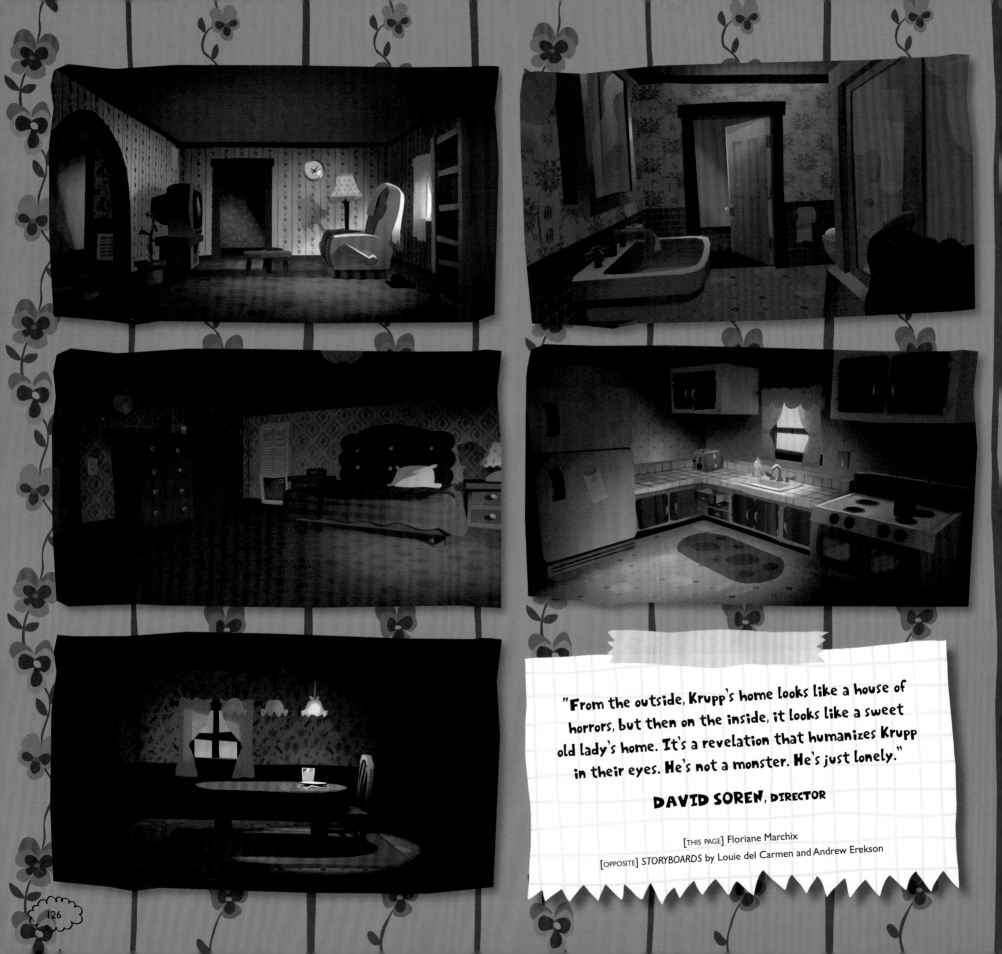

"From the outside, Krupp's home looks like a house of horrors, but then on the inside, it looks like a sweet old lady's home. It's a revelation that humanizes Krupp in their eyes. He's not a monster. He's just lonely."

DAVID SOREN, DIRECTOR

[THIS PAGE] Floriane Marchix

[OPPOSITE] *STORYBOARDS* by Louie del Carmen and Andrew Erekson

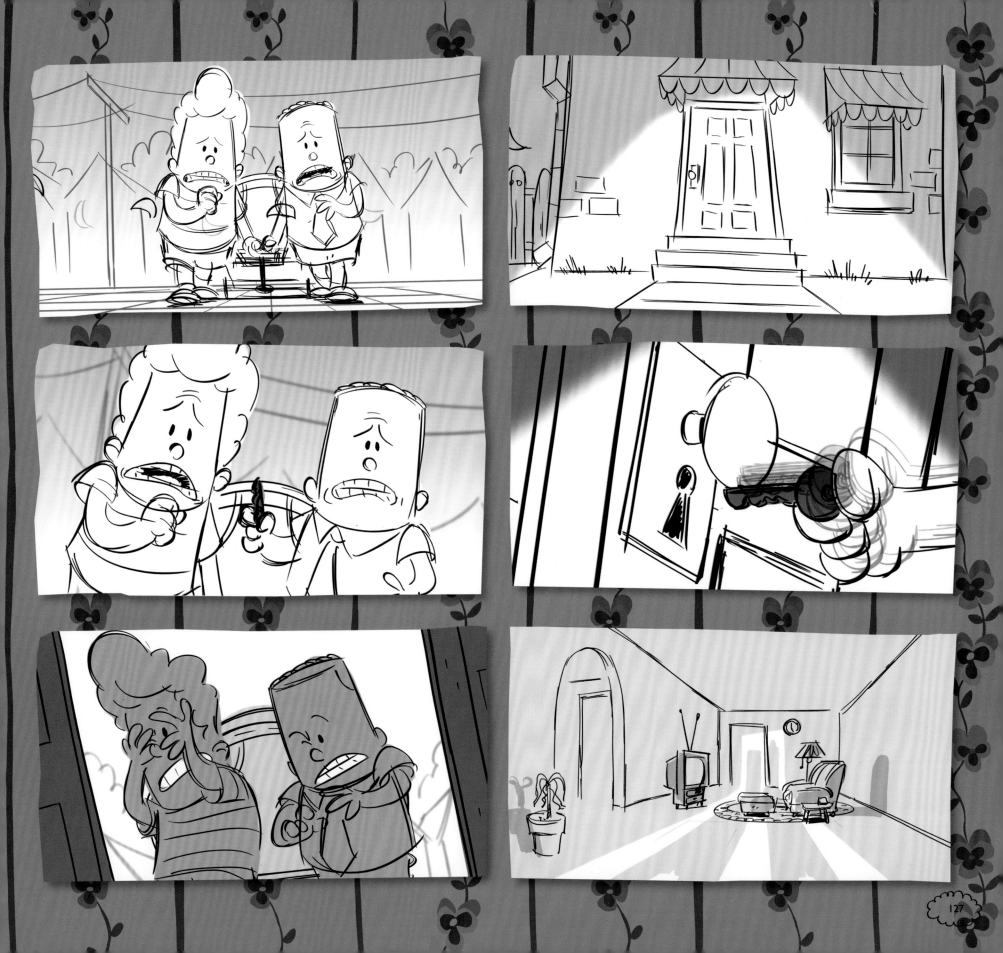

The Turbo Toilet 2000

The Turbo Toilet 2000 may go down in history as Melvin Sneedly's most astonishing and troublesome invention. Among other features, this fantastic robotic toilet comes with a personal potty playlist, a special screen with music, and robotic arms that change the toilet paper. In turn, Professor Poopypants enlarges the Turbo Toilet 2000 with his Sizerator device so that it becomes a massive T-rex-size battle vehicle.

"The Turbo Toilet 2000 becomes this battle vehicle that the professor drives through the third act of the movie. Melvin is perched on top with an electrode ray on his head," says director David Soren. "Poopypants can just gesture and point his finger and this giant robotic toilet mimics his actions. It's not just a vehicle, it's a character of its own!"

For visual development artist Christopher Zibach, the Turbo Toilet 2000 provided its share of satisfying moments and challenges.

"It's like an absurdist version of your favorite science-fiction giant robot movie," he notes. "We used the same kind of silliness and gadgetry that Pilkey sprinkles in his books—with chunky visuals and glove hands and light bulbs. To see it evolve from what we had in the beginning of the process to how it appears in the movie has been very rewarding."

The toughest aspect of the assignment was figuring out how the Turbo Toilet 2000 was actually going to battle Captain Underpants. "We had to think about the absurdity of the situation—a 100-foot-tall toilet fighting this superhero in his underwear in front of the school," says Zibach. "We were constantly asking ourselves, how do we make the lighting better and how can we make this scene funnier? We ended up adding God rays and colored light. So we took this silly idea and added CG cinematic elements to the mix and made all the various elements work together."

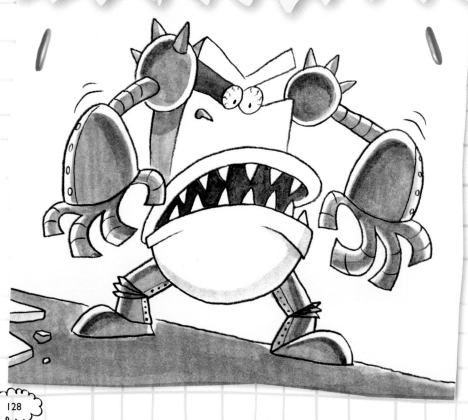

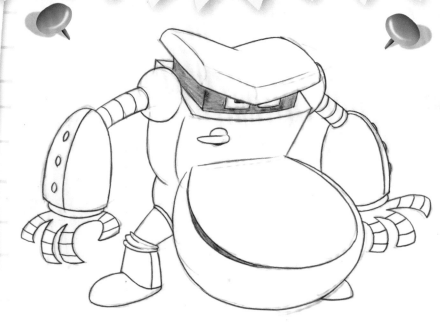

[LEFT] Dav Pilkey, [ABOVE] Rune Bennicke
[OPPOSITE LEFT] Nate Wragg, [OPPOSITE RIGHT] Floriane Marchix

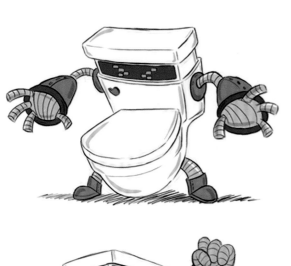

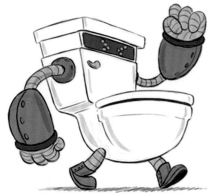

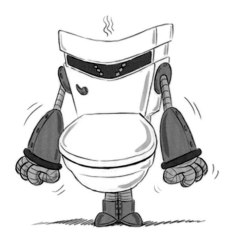

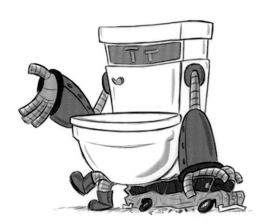

CAPTAIN UNDERPANTS

and the PERILOUS PLOT of

PROFESSOR POOPYPANTS

Written by George Beard

Drawed by Harold Hutchins

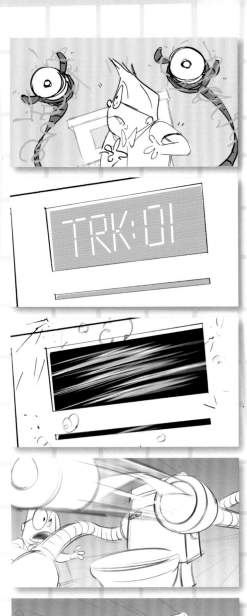

"One of the things that stood out to me when you read the books is just how silly the world is. The cars, buildings, store names are always silly in the way they are drawn and portrayed in the books. Even a boring and oppressive school like Jerome Horwitz Elementary is funny in its own way."

NATE WRAGG
PRODUCTION DESIGNER

[LEFT] *STORYBOARDS* by Gary Graham and Sharon Bridgeman
[RIGHT] Christopher Zibach and Rune Bennicke

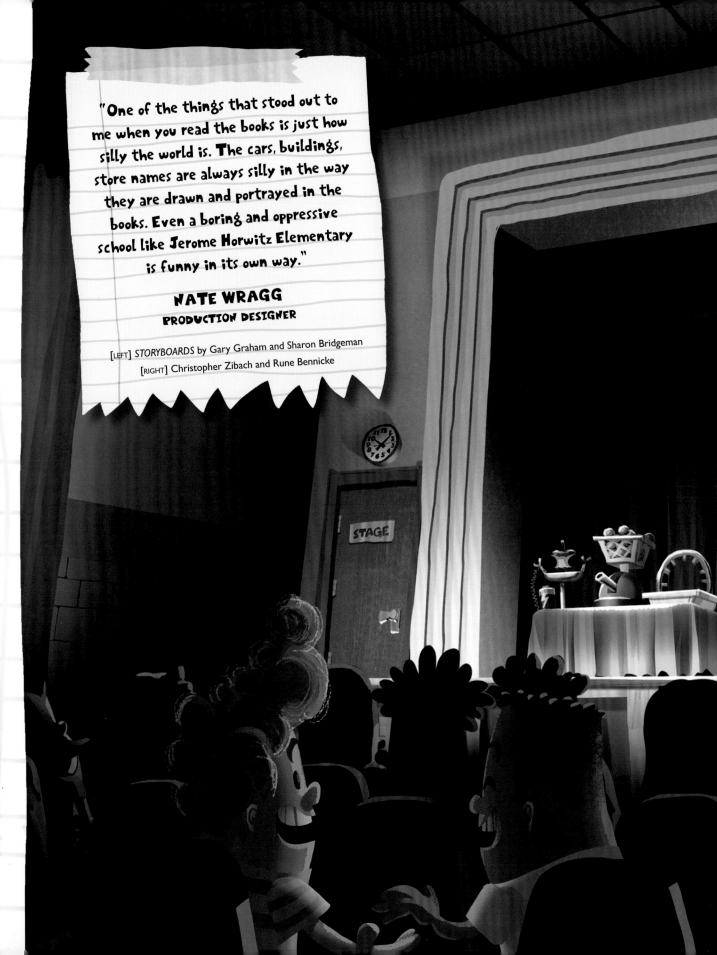

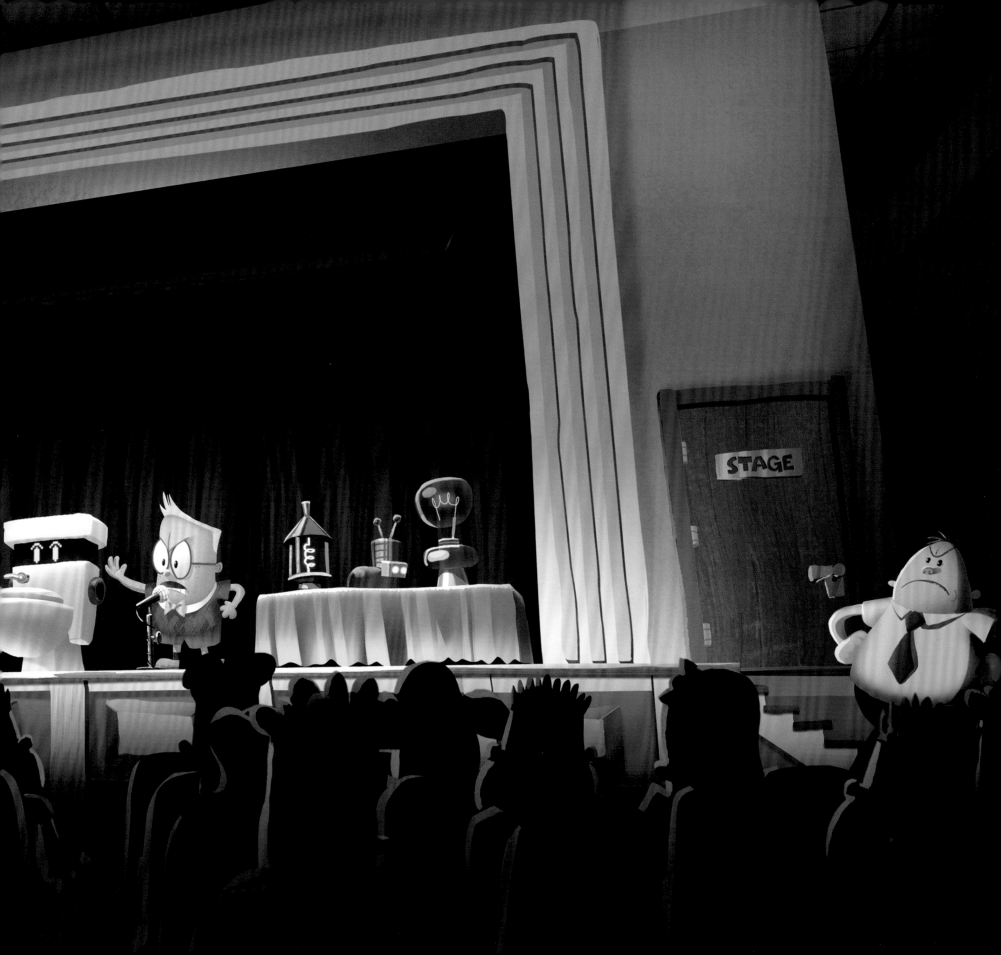

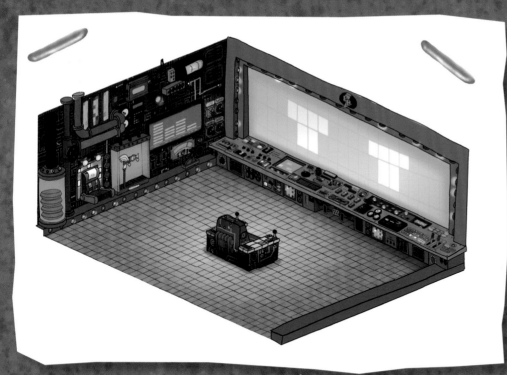

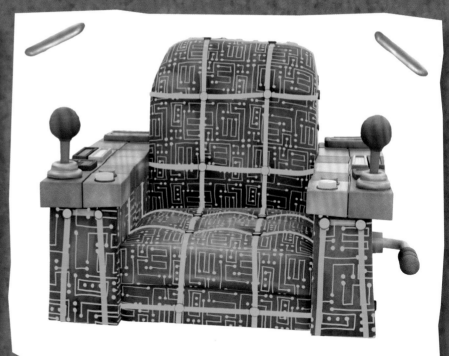

[ABOVE AND BELOW]
Christopher Zibach

[ABOVE RIGHT] *CG RENDER* by
Laëticia Theret and Samuel Guiraudou

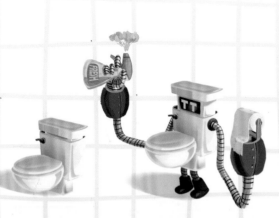

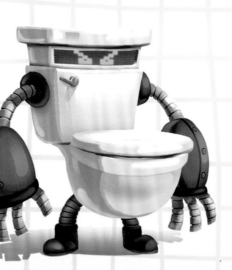

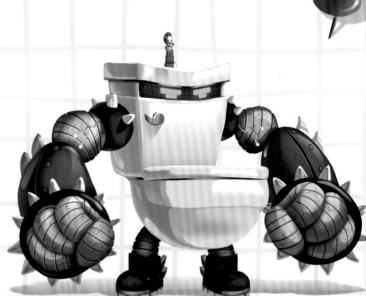

OFF

ON

TURBO TOILET 2000

TURBO TOILET 2000 – BATTLE MODE

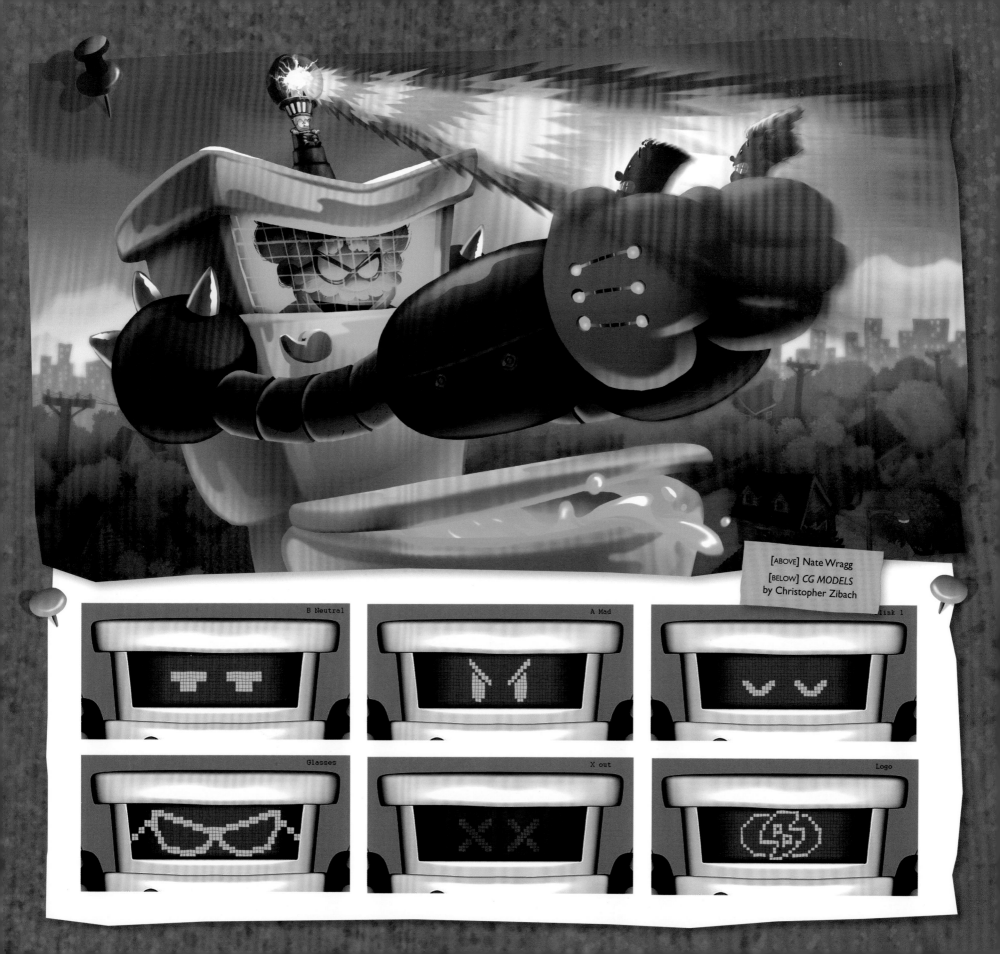

[ABOVE] Nate Wragg
[BELOW] *CG MODELS*
by Christopher Zibach

[BELOW AND BOTTOM] Christopher Zibach

[RIGHT AND PAGES 136-137] Christopher Zibach and Rune Bennicke

134

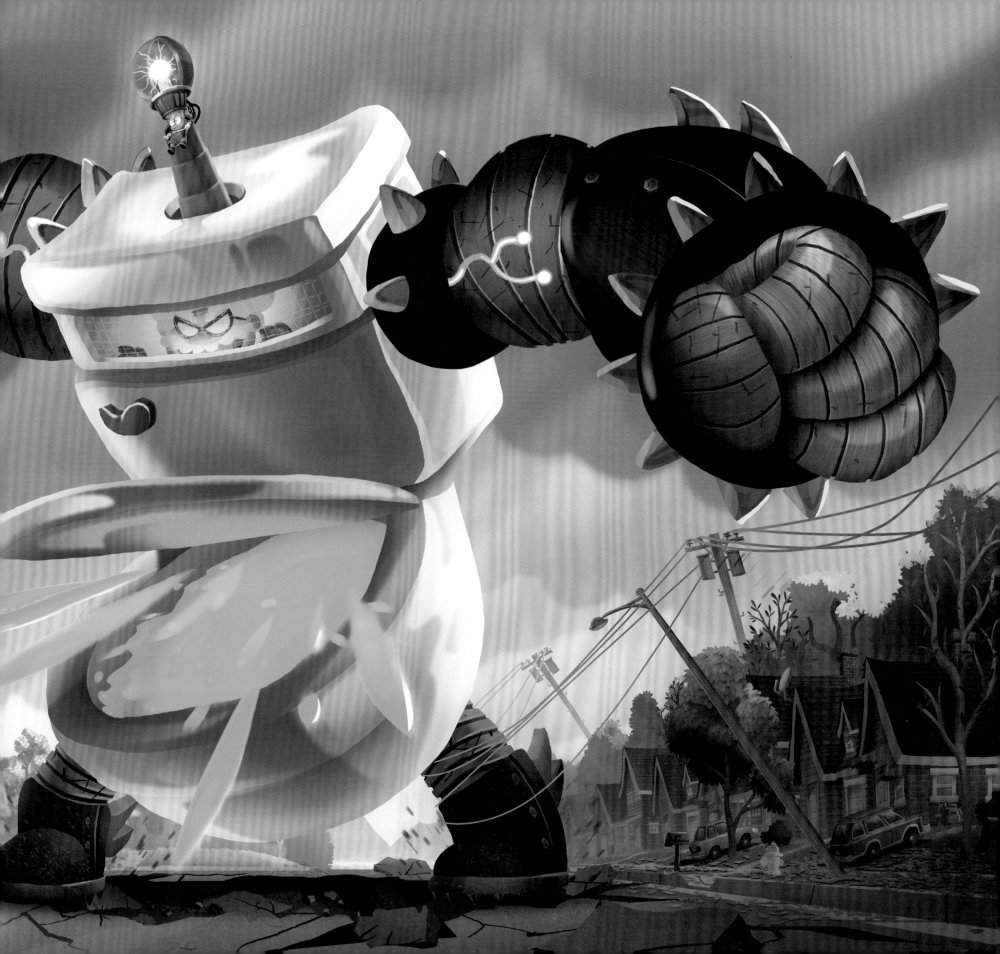

Seq. 1300

KRUPP GETS
HYPNOTIZED

> "Mr. Krupp tore down the red curtain from his office window and tied it around his neck. Then he took off his shoes, socks, shirt, pants, and his awful toupee. 'Tra-La-Laaaaaaaa!' he sang."
> — THE ADVENTURES OF CAPTAIN UNDERPANTS by Dav Pilkey (1997)

One of the key sequences in the movie, which really sets the tone for the whole project and triggers the zany plotline, is the one in which George and Harold hypnotize their principal. It's also one that involved close collaboration between all the different departments, both at the DreamWorks studio in Glendale and Mikros Image in Montreal.

"This sequence has stayed consistent throughout the production," says producer Mark Swift. "For us, it has been about trying to explain the magic that happens, how this Hypno-Ring introduces this fantastic element, and the performances are a lot of fun throughout it."

The sequence enabled everyone to see great new possibilities in Krupp. "Up to this point, we've only seen him as a bullying, slightly buffoonish man, but here we have him acting like a monkey, a chicken, and finally as Captain Underpants," says Swift. "Watching him

transform is a lot of fun, and we have a fantastic vocal performance from Ed Helms."

"The entire premise of the movie is summed up in this one sequence," notes director David Soren. "It needed to be a memorable set piece. Krupp is in the middle of signing a form that will put the boys in separate classes. George and Harold are convinced, if they allow this to happen, it will be the end of their friendship. Out of desperation, George pulls out the plastic Hypno-Ring and threatens to hypnotize Mr. Krupp. To everyone's surprise it starts to work… Logic and reality disappear. As the ring works its magic, they all start levitating, and everything goes crazy for a few minutes. Then the dust settles and to everyone's shock, Krupp is now under their spell!"

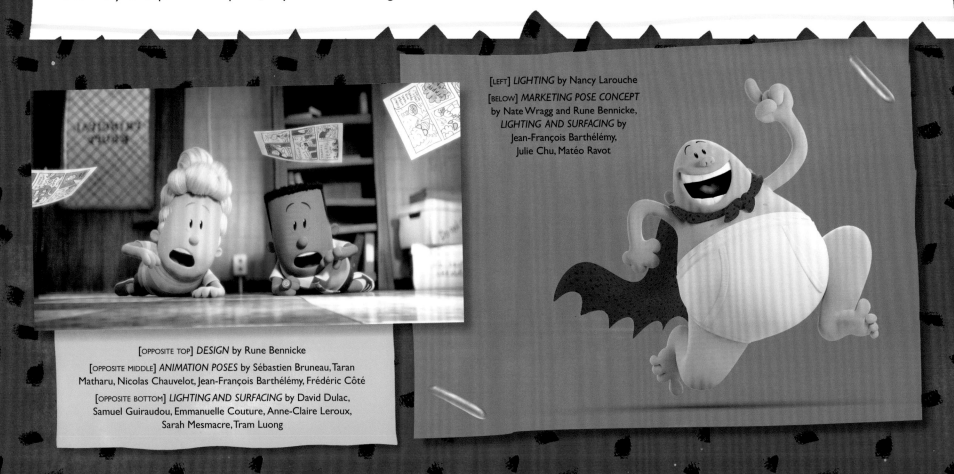

[LEFT] *LIGHTING* by Nancy Larouche
[BELOW] *MARKETING POSE CONCEPT* by Nate Wragg and Rune Bennicke, *LIGHTING AND SURFACING* by Jean-François Barthélémy, Julie Chu, Matéo Ravot

[OPPOSITE TOP] *DESIGN* by Rune Bennicke
[OPPOSITE MIDDLE] *ANIMATION POSES* by Sébastien Bruneau, Taran Matharu, Nicolas Chauvelot, Jean-François Barthélémy, Frédéric Côté
[OPPOSITE BOTTOM] *LIGHTING AND SURFACING* by David Dulac, Samuel Guiraudou, Emmanuelle Couture, Anne-Claire Leroux, Sarah Mesmacre, Tram Luong

Design

Animation Poses

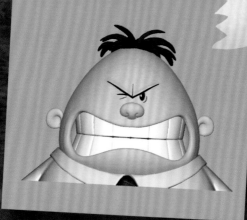 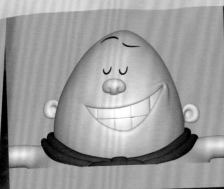 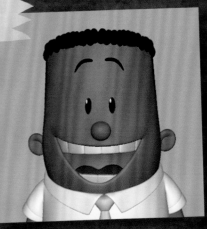 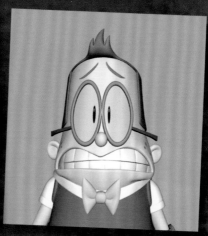

Lighting and Surfacing

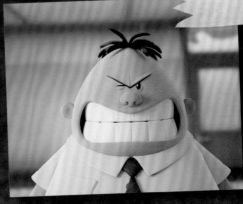 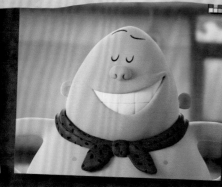 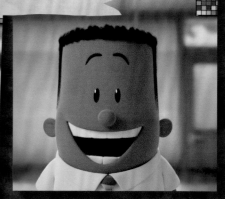

Hypnosis!

The filmmakers set out to express the magical quality of the scene in bright blue and red colors. "According to George, the ring comes from a mythical factory in China, where only the most powerful toy cereal box prizes are made," adds Soren. "So we used special art direction to convey this—that this is where fantasy and reality become one. This was a pivotal moment in the first Captain Underpants book, so we pulled out all the stops to make this sequence as cinematic and visually striking as possible."

For production designer Nate Wragg, the scene offered a fun range of possibilities in terms of design and lighting choices. "If you look at the books, you will notice that Pilkey has a fun way of drawing effects, whether it's someone being hypnotized or something being shrunk, enlarged or frozen by a ray," he says. "We worked closely with the team at Mikros to translate those silly effects to a 3D, CG environment. We worked hard to match the lighting and to create effects that really complement the designs that were already established."

The design team took the opportunity to use fun, stylized animation and introduce clever effects for the hypnosis sequence. "It is the first time we see the title character—the superhero who is on the cover of all the books," says Wragg. "It's a very exciting reveal as the classroom opens up and starts spinning, but then everything goes back to normal."

Wragg says this specific scene proved to be one of his favorites. "It's always fun when you're watching a movie, and you feel that the introduction is finished, and now the movie can really begin," he says. "After they manage to hypnotize Krupp, the boys think they've defeated their principal and given life to their greatest superhero creation, but that opens up a whole new series of problems. They have let the genie out of the lamp!"

[BELOW LEFT] Floriane Marchix, [BELOW] Rune Bennicke, [OPPOSITE TOP] *STORYBOARDS* by Andrew Erekson and Hamish Grieve, [OPPOSITE BOTTOM LEFT] *STORYBOARDS* by Andrew Erekson, [OPPOSITE MIDDLE RIGHT] *LIGHTING* by Shibo Xiao, [OPPOSITE BOTTOM RIGHT] *LIGHTING* by Justine Beaupré

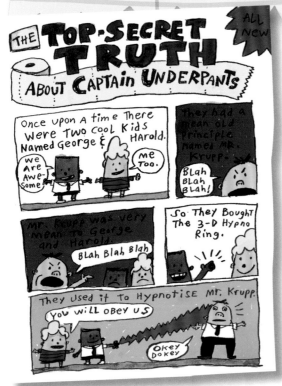

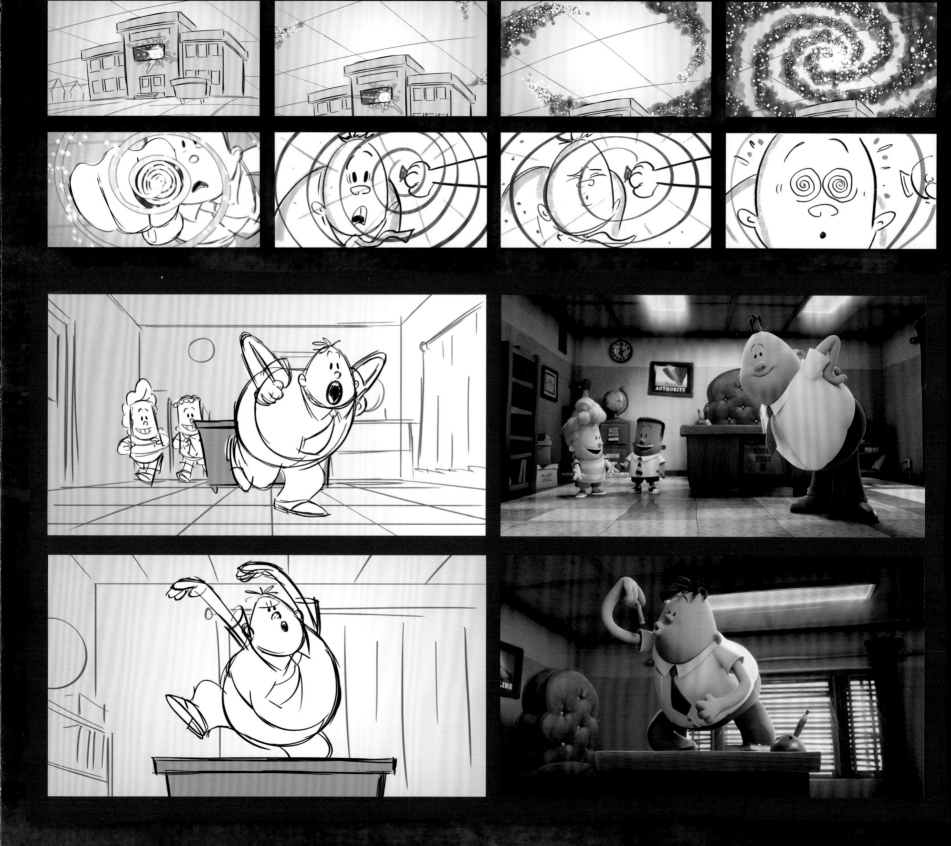

Rigging and Animation

The team at Mikros set up the rigging pipeline for the movie with the characters' specific physical needs in mind. "We had to find solutions that addressed the 2D cartoony nature of the characters," says CG supervisor Guillaume Dufief. "For example, when the characters are smiling, the facial deformations are huge, so we had to approach everything in a very precise and detailed manner. In this movie, when a character smiles, it goes all the way near the eyebrows. It's very easy when you draw it in 2D, but in CG, it can look creepy if it's not handled perfectly. You have to cheat a little bit to make it work."

As Dufief further explains, "We needed to be able to scale all the parts of the body and redraw the silhouette when we had to. Another issue was that Captain and Krupp are the same character, but they don't have the same hip positions. It's more complex to create a fat guy!"

The hypnosis scene had its share of character animation challenges for the team at Mikros. As head of character animation at Mikros Sébastien Bruneau points out, "We needed to present this new Captain Underpants to the audience in a clear and exciting way."

Bruneau and company took a page from traditional 2D animation to highlight the scene where the boys are hypnotizing Krupp. "We used 2D tricks to illustrate the hypnosis, with everything spinning around, and the desk falling," he notes. "There is a spiral spinning in his eyes, but after it's done, everything settles down. Then we see him act like a chicken and a monkey, and then, the boys turn him into Captain Underpants."

Bruneau says the main goal was making the scene funny and charming without going off model. "The shapes are so simple," he explains. "The boys are like soup cans and Krupp is pear shaped. As

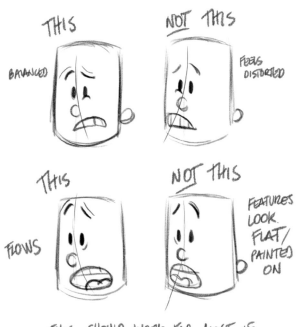

THIS — BALANCED

NOT THIS — FEELS DISTORTED

THIS — FLOWS

NOT THIS — FEATURES LOOK FLAT/PAINTED ON

THIS SHOULD WORK FOR MOST, IF NOT ALL, OF OUR SHOTS.
NO NEED TO REINVENT THEIR FACE FOR EVERY SCENE.

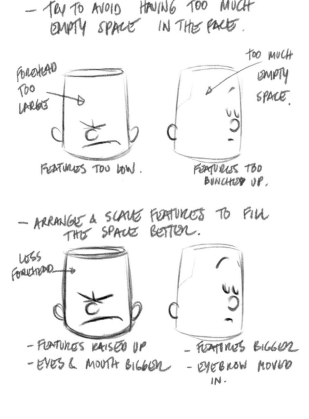

— TRY TO AVOID HAVING TOO MUCH EMPTY SPACE IN THE FACE.

FOREHEAD TOO LARGE — FEATURES TOO LOW.

TOO MUCH EMPTY SPACE. — FEATURES TOO BUNCHED UP.

— ARRANGE & SCALE FEATURES TO FILL THE SPACE BETTER.

LESS FOREHEAD
— FEATURES RAISED UP
— EYES & MOUTH BIGGER

— FEATURES BIGGER
— EYEBROW MOVED IN.

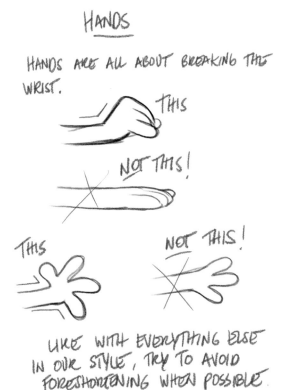

HANDS

HANDS ARE ALL ABOUT BREAKING THE WRIST.

THIS

NOT THIS!

THIS

NOT THIS!

LIKE WITH EVERYTHING ELSE IN OUR STYLE, TRY TO AVOID FORESHORTENING WHEN POSSIBLE.

soon as we stray away from those shapes, it looks off model, ugly, or not as funny as we want it to be. We have to be careful when the expressions transform the faces. The transitions have to look smooth, crisp and graphic."

To create this special look, the team at Mikros used the studio's own proprietary tools in addition to the Maya package. They used special software to add rigs on top of the default ones. "We use a tool that helps us push the geometry and take our poses to the next level," says Bruneau. "We employ a sculpt tool that modifies the geometry of the characters. We also bank poses and expressions in the beginning of the project as a reference point. We relied a lot on Bennicke's original 2D tests for the characters."

[THESE PAGES] Rune Bennicke

BALANCE THE FEATURE TO FILL THE EMPTY SPACES.

- TURNED TO THE RIGHT
- STRETCH ON THE RIGHT
- SQUASH ON THE LEFT
- MOUTH MOSTLY ON LEFT SIDE
- EXTRA LINES MOSTLY ON LEFT SIDE

DOING THE OPPOSITE MAKES THE FACE MESSY AND UNBALANCED.

ARMS

THE ARMS ARE TUBES. THERE SHOULD BE VERY LITTLE VARIATION IN SHAPE AND WE SHOULD TRY TO AVOID CREASES AND SHARP BENDS.

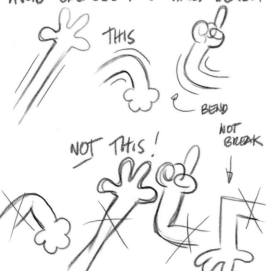

THIS

BEND

NOT THIS!

NOT BREAK

THE ARMS CAN AND SHOULD STRETCH BUT WHEN STRETCHING THE ARMS TRY TO KEEP THEM AS SHORT AS POSSIBLE.

INSTEAD OF DOING THIS

DO WHAT YOU CAN TO MINIMIZE THE STRETCH.

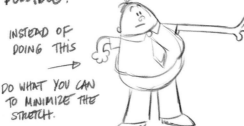

MOVE BODY CLOSER

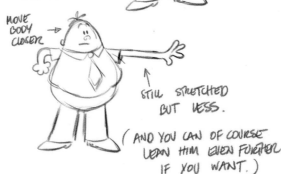

STILL STRETCHED BUT LESS.

(AND YOU CAN OF COURSE LEAN HIM EVEN FURTHER IF YOU WANT.)

SQUASH & STRETCH & SEEING ELEMENTS MOVING AGAINST (OPPOSITE TO) EACH OTHER HAS AN INHERENT APPEAL (AND IS THE SECRET TO MILT KAHL'S ANIMATION.)

IT IS WHY WALKS & RUNS ARE ALWAYS FUN TO WATCH - ARMS & LEGS ARE MOVING OPPOSITE TO EACH OTHER AND TO THEMSELVES.

AND...

OF COURSE, WHENEVER YOU CAN GET AWAY WITH IT,
— BREAK ALL THE RULES —

143

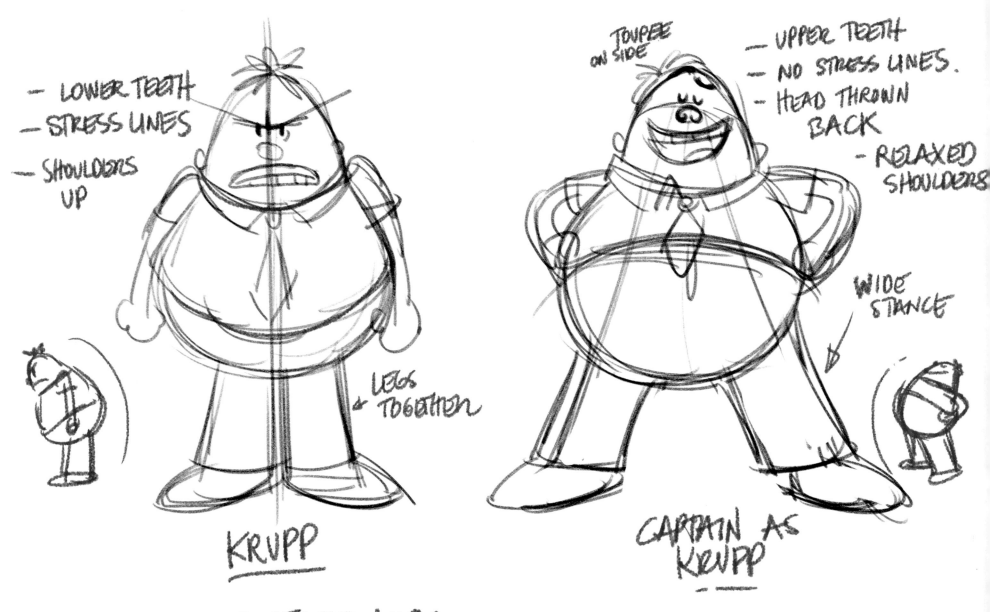

- LOWER TEETH
- STRESS LINES
- SHOULDERS UP

LEGS TOGETHER

KRUPP

TOUPEE ON SIDE
- UPPER TEETH
- NO STRESS LINES.
- HEAD THROWN BACK
- RELAXED SHOULDERS

WIDE STANCE

CAPTAIN AS KRUPP

— VICTIM OF STUPID KIDS RUINING HIS LIFE.
— BENT OVER, RIGID, MORE STRAIGHT UP & DOWN.

— HEAD IN THE CLOUDS
— SUPER CONFIDENT
— IDIOT!

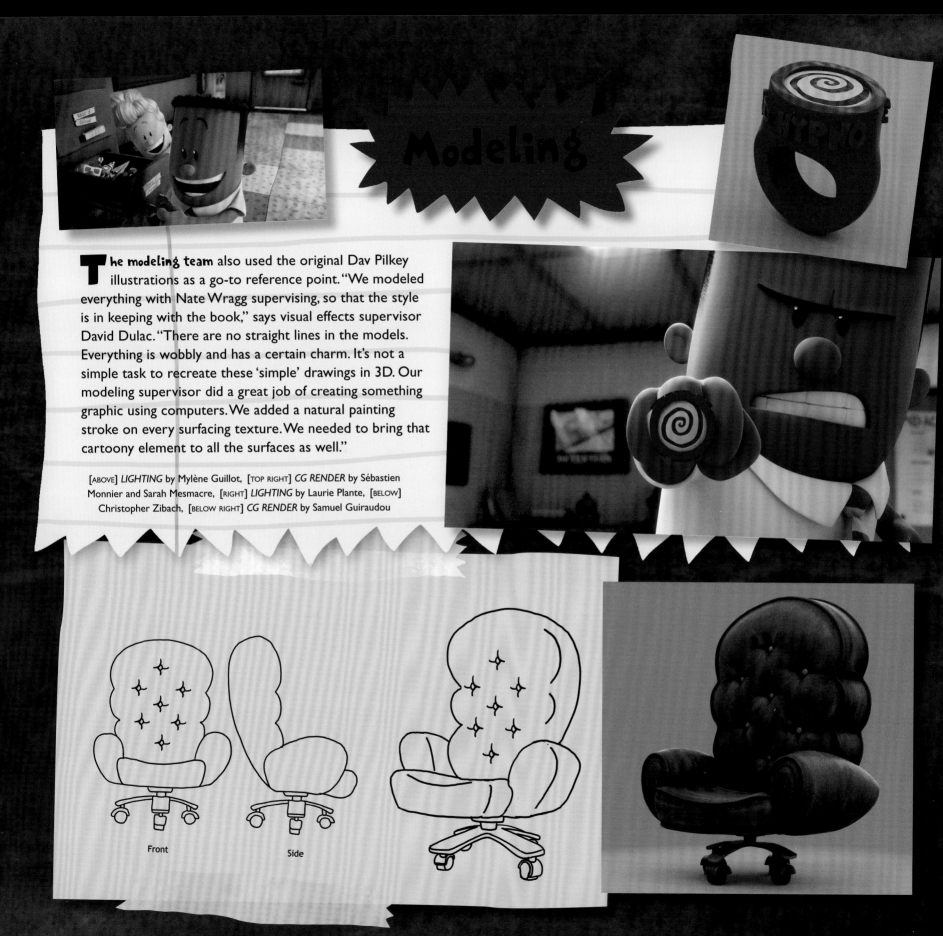

Modeling

The modeling team also used the original Dav Pilkey illustrations as a go-to reference point. "We modeled everything with Nate Wragg supervising, so that the style is in keeping with the book," says visual effects supervisor David Dulac. "There are no straight lines in the models. Everything is wobbly and has a certain charm. It's not a simple task to recreate these 'simple' drawings in 3D. Our modeling supervisor did a great job of creating something graphic using computers. We added a natural painting stroke on every surfacing texture. We needed to bring that cartoony element to all the surfaces as well."

[ABOVE] *LIGHTING* by Mylène Guillot, [TOP RIGHT] *CG RENDER* by Sébastien Monnier and Sarah Mesmacre, [RIGHT] *LIGHTING* by Laurie Plante, [BELOW] Christopher Zibach, [BELOW RIGHT] *CG RENDER* by Samuel Guiraudou

Front

Side

Visual Effects

[BELOW] *SIZERATOR FX* by Éric Maltais

[BOTTOM] Christopher Zibach

The scene's key special effects work involves the hypnosis visuals and the way objects are made to spin around the room in a fantastic manner. "Nate Wragg designed the special spiral effect we see in the sequence," explains visual effects supervisor David Dulac.

Wragg says the scene provided him with a special opportunity to really move away from reality and push towards imagination. "Computer effects programs are so good at simulating reality that in many ways, they can be easier to do than to create a cartoony take on the same effect. For our movie, we wanted to avoid having our very cartoony and stylized characters interacting with effects that would look too realistic—purely because it wouldn't be a good stylistic match," he notes. "We took a page out of Pilkey's design language in the books and really looked at how cartoony he drew the special effects. We modeled the majority of our effects to get the cartoony shapes that we wanted instead of using a simulated realistic effect."

[OPPOSITE TOP LEFT AND BOTTOM LEFT] *STORYBOARDS* by Andrew Erekson and Hamish Grieve

[OPPOSITE TOP RIGHT AND BOTTOM RIGHT] *HYPNOTISM FX* by Laurie Plante and Gregory Peczinka

[OPPOSITE MIDDLE] Nate Wragg

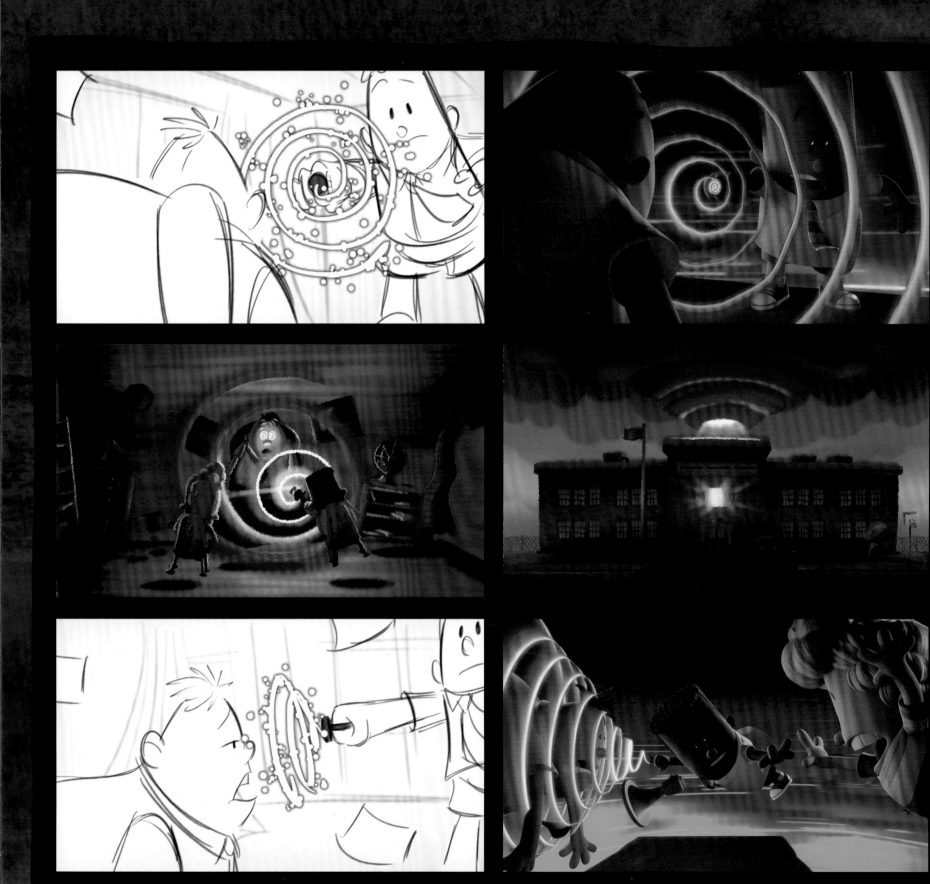

Lighting

When a scene involves two mischievous boys using a magical Chinese Hypno-Ring to transform their foul-tempered principal, you just know there will be lots of lighting tricks involved. As Mikros lighting supervisor Matthieu Rouxel explains, "Since this was the most cartoony movie I had ever worked on, I knew we didn't have to follow the realistic rules of our world. The lighting and effects had to look like what we have all seen and loved in comic books."

According to Rouxel, the ambience of the room changes a lot during this sequence. In the beginning, George and Harold are looking for their box of confiscated goods and the shades are drawn. "The room has to be dark, and afterwards, when Krupp enters the room, we had to make it scary," he notes. "Then you have the hypnosis scene, and we add lots of magical effects with objects flying around the room. The key light is coming from the ring, which is red, and the background is blue, offering a sharp contrast. Soon, the dream-like quality fades into reality, and everything goes back to normal—sort of."

As visual effects supervisor David Dulac points out, "We are used to having the light source illuminating the characters, but we have to remind ourselves that in this cartoony universe, we can cheat a little bit. We don't have to stick with the light source if it serves the story and the purpose of the scene."

Rouxel, who grew up loving European comic books such as *The Adventures of Tintin* and *Asterix*, says the colorful and creative aspects of the project made it a highlight of his career. "We were allowed to be very creative and to experiment until we made it as funny as the books."

[BELOW AND OPPOSITE] Nate Wragg, [OPPOSITE BOTTOM LEFT] *LIGHTING* by Laurie Plante

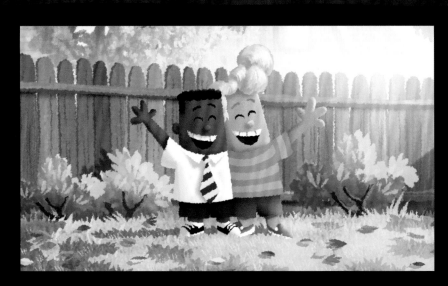

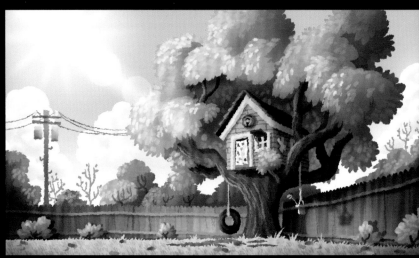

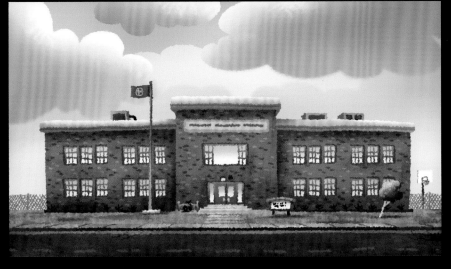
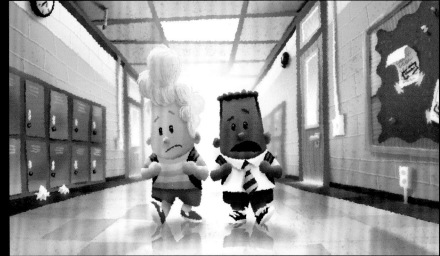
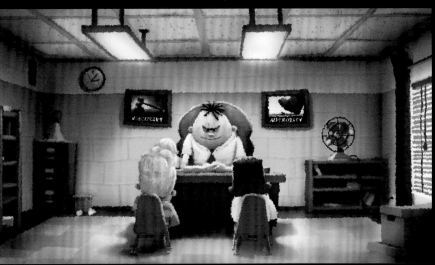
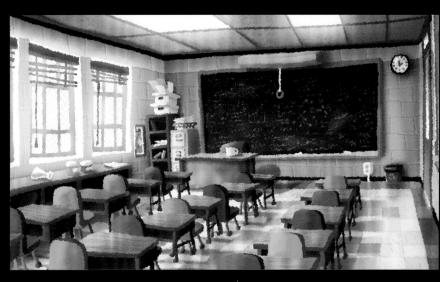
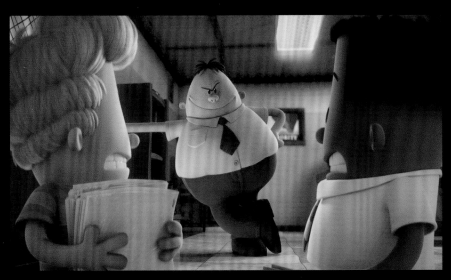

"For the hypnosis sequence, the key light is coming from the ring—which is red—and the background is blue, so this creates a sharp contrast. Soon, the dream-like quality fades into reality, and everything goes back to normal—sort of."

MATTHIEU ROUXEL, LIGHTING SUPERVISOR

Conclusion

Back when author and illustrator Dav Pilkey was only eight years old, he would often get in trouble because he was the class clown and often drew comic books in class to entertain himself and his friends. Imagine how happy that mischievous second grader would have been if he had known that his creations would one day play, laugh and create havoc on the big screen in a hilarious DreamWorks movie.

Now thanks to the hard work and artistic vision of producers Mireille Soria and Mark Swift, director David Soren, production designer Nate Wragg, character designer Rune Bennicke, visual development artist Christopher Zibach and the rest of the talented team at DreamWorks and Mikros, George and Harold will find new legions of fans all over the world.

Transferring Pilkey's seemingly simple illustrations to a much more complicated CG-animated world has had its share of challenges. Yet, the devoted filmmakers were careful to stay as close to the creative origins of the project as possible. As producer Mireille Soria points out, "We knew that the fans would look very closely at every decision that we made, because Pilkey's world means so much to them. We wanted to break the usual rules that we see in so many CG animated movies today. Our animators did a wonderful job of capturing really believable performances with the rigs that we had. More than anything else, I'm very pleased that we were able to retain the charm of this wonderful world."

This sense of playfulness and natural charm is also what DreamWorks Animation co-president Bonnie Arnold hopes audiences will take away from the movie. "Being faithful to Dav's vision and original sense of humor has always been a key goal for us," she says. "Like many of the other literary properties that we've brought to animated life in the past thirteen years, *Captain Underpants* is a memorable combination of the creator's ideas and those of our talented director, producers, artists and animators who have added their own special magic to this universe."

Now that George, Harold, Krupp, and Captain Underpants have made the leap to the big screen with such success, there is no doubt that we will witness more of their animated madcap adventures in the future. It's great to know that these memorable characters will continue to inspire mischievous, artistic kids and fuel their imagination for many, many years to come.

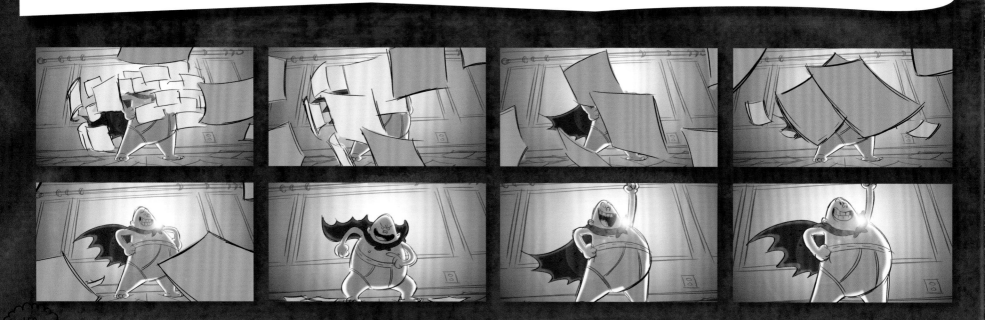

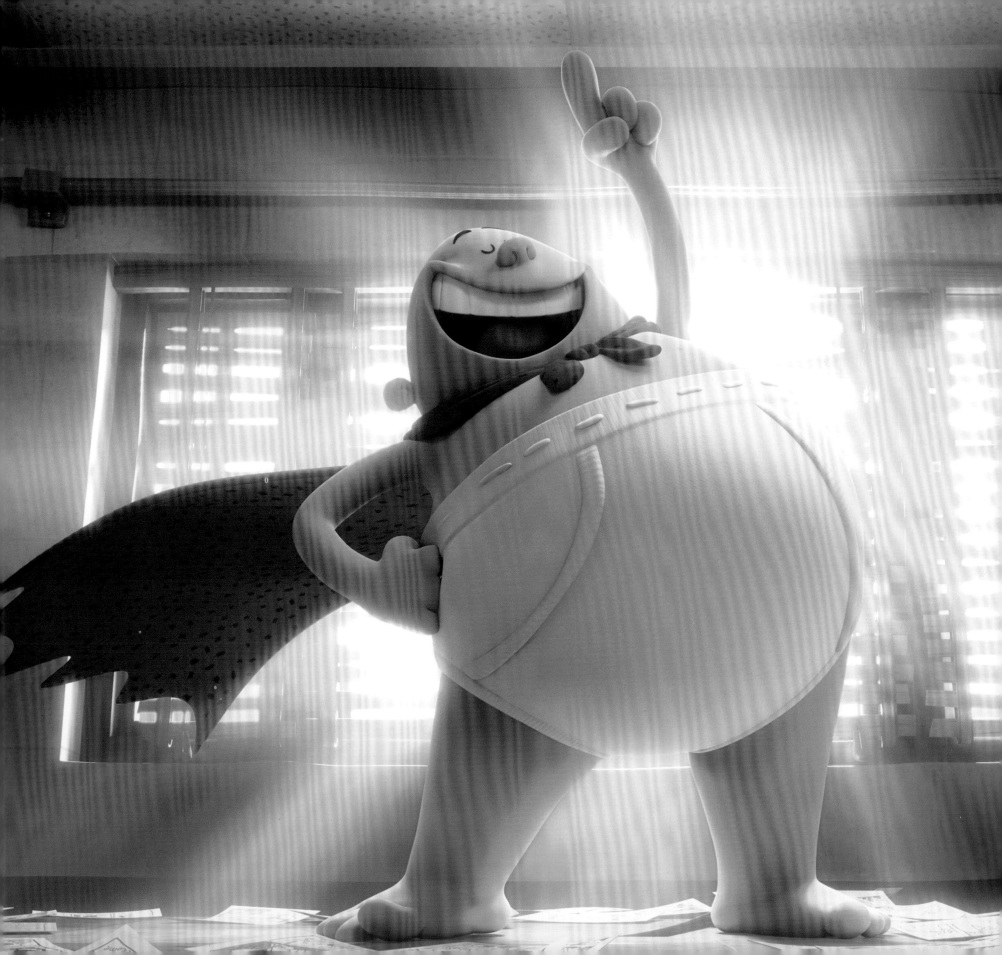

Bravo!

MIKROS MONTREAL CREW

Magnifique!

MIKROS PARIS CREW

153

Acknowledgments

Special thanks to all the wonderful and talented folks at DreamWorks Animation, especially Debbie Luner, Lisa Baldwin, Sarah Maines and Paige Newman, and the movie's brilliant creative superheroes Mireille Soria, Bonnie Arnold, Mark Swift, David Soren, Nate Wragg, Rune Bennicke, Christopher Zibach, David Dulac, Guillaume Dufief, Matthieu Rouxel and Sébastien Bruneau. Thank you for being my kind and insightful guides through your magical secret lab.

A special hooray and a super-strength cheer are in order for brilliant mad genius Dav Pilkey for his unique vision and beautifully illustrated Foreword to the book. You make us all wish we lived in the underwear capital of the world.

My heartfelt thanks also go to my wonderful editor Jo Boylett and super talented art director Iain R. Morris who brought this book to life.

— **Ramin Zahed**

DreamWorks would like to thank David Soren, Mirielle Soria, Nate Wragg, Mark Fitzgerald, Paige Newman, Emma Berger, Mark Swift, Rune Bennicke, Christopher Zibach, Emily Nordwind, Hamish Grieve, Ryan Naylor, Jean-Phillipe Saucier, Damien Simonklein, Bonnie Arnold, Jim Gallagher, Terry Curtin, Damon Ross, Michael Garcia, Debbie Luner, Lisa Baldwin, Sarah Maines, Adria Munnerlyn, and special thanks to Dav Pilkey.

Titan Books would like to thank everyone at DreamWorks Animation and Mikros Image who contributed art and interview time to this book, and whose creative talents crafted this "pant-tastic" movie. Special thanks must go to Debbie Luner and Lisa Baldwin at DreamWorks Animation for all their hard work to make this book happen. And an extra special thank you to Dav Pilkey for his wonderful Foreword, and for giving us Captain Underpants. Tra-La-Laaaa!

[BELOW] Perry Dixon Maple and Rune Bennicke
[OPPOSITE TOP LEFT AND BOTTOM] Nate Wragg
[OPPOSITE TOP RIGHT] Perry Dixon Maple
[PAGE 156] Stevie Lewis

FIELD TRIP

When : All day Friday

Where :

CANCELLED

Please submit all parent signed permission slips to Mrs. Anthrope if you want to miss a day of school for a really boring field trip.

DON'T PUT UNNECESSARY

OBJECTS IN TOILETS

AFTER SCHOOL FUN CLUB

CANCELLED

ART

CANCELLED

CLUB

Wednesdays after school @ 4pm

KRUPP

Appreciation Day

May 1st

STILL ON!!!

155